and if I devoted
my life to one of its
feathers?

For Jim Denomie
(1955–2022)

A generous friend,
a community builder,
and a visionary Ojibwe painter
who fearlessly explored history,
spirituality, eroticism,
and the ongoing struggles
of Native Americans.

Your electrifying paintings were
a driving force of this project.

Your art will continue to inspire
for many generations to come.

kunstHalle wien

**WIENER
FEST
WOCHEN**

and if I devoted my life to one of its feathers?

Aesthetic Responses to Extraction, Accumulation, and Dispossession

EDITED BY **Miguel A. López**

Sternberg Press

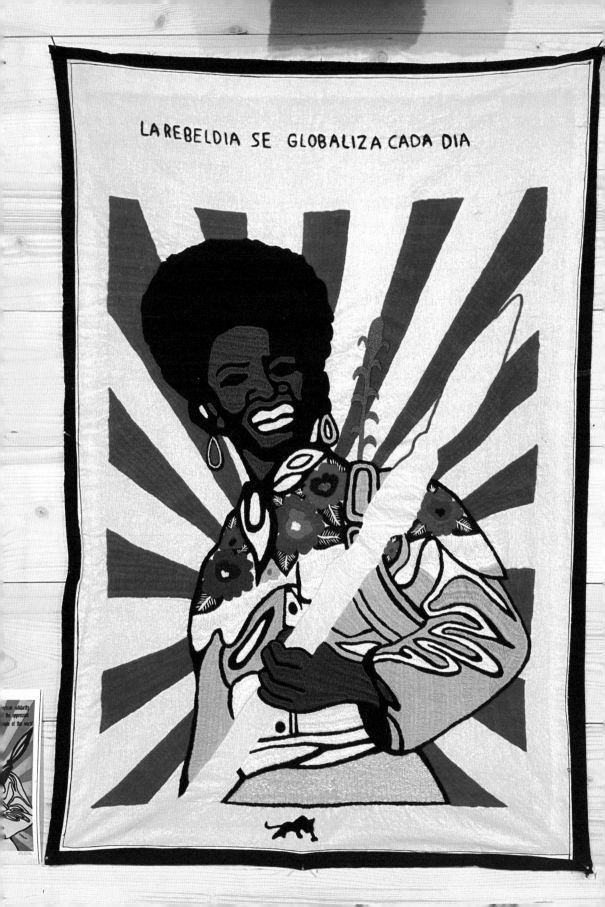

LA REBELDIA SE GLOBALIZA CADA DIA

ARTISTS & AUTHORS

Babi Badalov · *Denilson Baniwa* · *Patricia Belli* ·
Amoako Boafo · *Anna Boghiguian* · *Victoria Cabezas* ·
Marisol de la Cadena · *Quishile Charan* ·
Manuel Chavajay · *Chto Delat* · *Rosa Elena Curruchich* ·
Annalee Davis · *Vlasta Delimar* · *Jim Denomie* ·
Denise Ferreira da Silva · *María Galindo & Danitza Luna* ·
Nilbar Güreş · *Sheroanawe Hakihiiwe* · *Hiwa K* ·
Inhabitants with Margarida Mendes ·
Karrabing Film Collective · *Miguel A. López* ·
Germain Machuca · *Daniela Ortiz* · *Prabhakar Pachpute* ·
Amanda Piña · *Roldán Pinedo / Shöyan Sheca* ·
Elizabeth A. Povinelli · *Naomi Rincón Gallardo* ·
Victoria Santa Cruz · *Olinda Silvano / Reshinjabe* ·
SPIT! (*Sodomites, Perverts, Inverts Together!* /
Carlos Maria Romero, Carlos Motta & John Arthur Peetz) ·
Salmo Suyo · *Sophie Utikal* · *Cecilia Vicuña* ·
Castiel Vitorino Brasileiro · *What, How & for Whom* and
Christophe Slagmuylder · *Anna Witt* · *Bartolina Xixa* ·
Santiago Yahuarcani · *Zapantera Negra*

Table of Contents

Bartolina Xixa, *Ramita Seca, La colonialidad permanente* [Dry Twig, The Permanent Coloniality], film still, 2019 • COURTESY MAXIMILIANO MAMANI / BARTOLINA XIXA

Bartolina Xixa, *Ramita Seca, La colonialidad permanente* [Dry Twig, The Permanent Coloniality], film still, 2019 • COURTESY MAXIMILIANO MAMANI / BARTOLINA XIXA

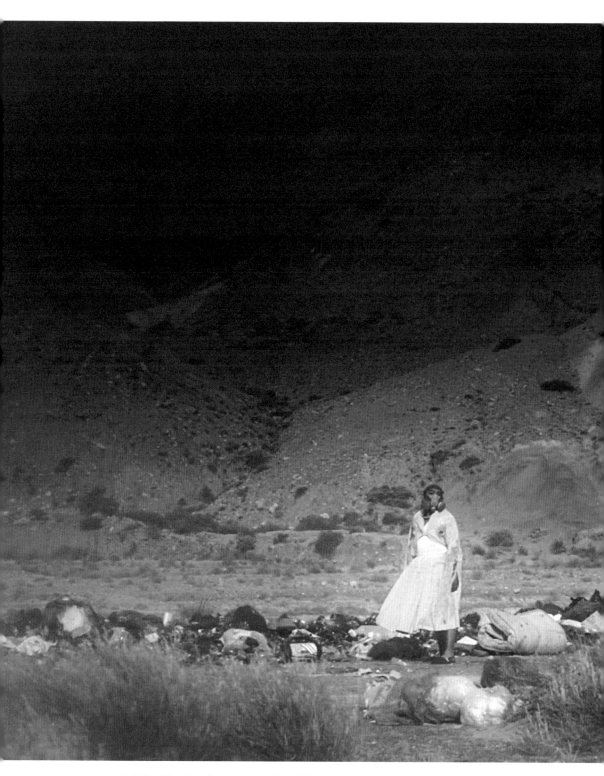

Bartolina Xixa, *Ramita Seca, La colonialidad permanente* [Dry Twig, The Permanent Coloniality], film still, 2019 • COURTESY MAXIMILIANO MAMANI / BARTOLINA XIXA

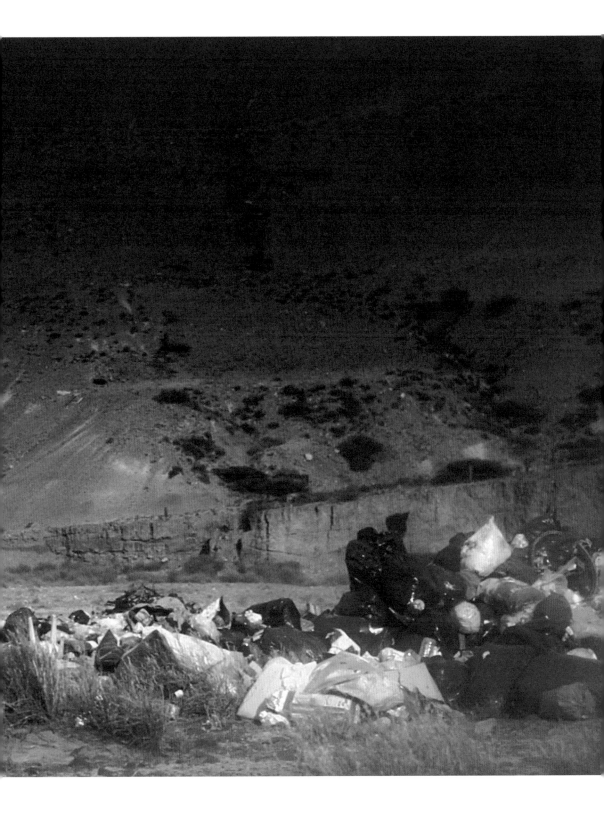

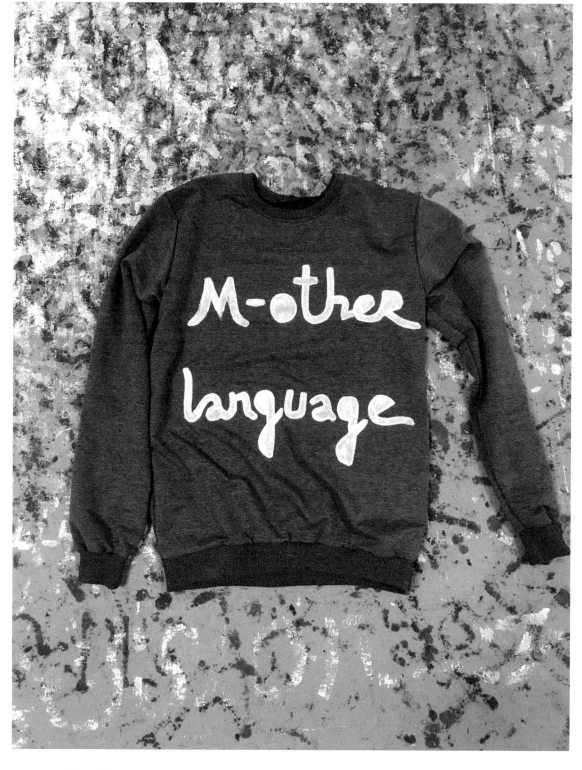

Babi Badalov, *M—other language*, 2021

We are very happy that *And if I devoted my life to one of its feathers?*, a joint exhibition of kunstHalle wien and **Wiener Festwochen**, curated by **Miguel A. López**, took place from May 15, 2021 until September 26, 2021 and that the dialogue that was started there is continued within the framework of this publication. The exhibition was originally scheduled to open in May 2020, but had to be postponed because of the worldwide Covid-19 crisis.

If the situation wasn't so alarming, it would seem ironic that this exhibition—one that examined artistic practices that counter the destructive ways in which the legacies of colonialism, entangled with patriarchy and extractive capitalism, continue to produce suffering and environmental disaster on a global scale—was put on hold by Covid-19. After all, the virus at the heart of the current pandemic is but one example of several recently emerged zoonotic diseases, whose spillover from the animal world into the human, as scientists agree, is often triggered by deforestation and the destruction of wildlife-rich habitats.

Our current plight sheds a bright light on the inseparability of human and nonhuman life: a topic at the very core of this exhibition. It has become all too clear that environmental destruction, especially the degradation of the Amazon rainforest—the largest rainforest habitat in the world—has profound consequences, most apparently on climate change and global health, which affect all of humanity.

While there are no easy solutions to these crises, there is a growing awareness that by honoring Indigenous knowledges, we can gain valuable insights into how to reset our relationships with the earth and with each other. In this exhibition, Indigenous epistemologies were the starting point to explore the possibilities of interweaving the poetic gesture with radical political action. Through their works, the more than thirty-five exhibiting artists—who are located everywhere from the Amazon region to Australia, from Guatemala to India—sought not only to awaken public consciousness to the realities of environmental exploitation and destruction, but also to deconstruct traditional Western patriarchal models, gender roles, and enduring colonial and racist discourses. As it sparked conversations as to what a truly inclusive, non-patriarchal, degrowth society could look like, *And if I devoted my life to one of its feathers?* made it clear that degrowth is not only about ecological sustainability but also intrinsically linked with social justice, self-determination, and a good life for all. Such a path forward requires a shift in common values toward care and solidarity, not only elsewhere but also right *here*.

When this exhibition was unable to take place in 2020, we were glad to instead initiate a public intervention as its prologue: six artistic statements were produced specifically for the advertising-billboard format and mounted at 250 locations all over Vienna throughout June and July 2020. We would like to express our sincere gratitude and appreciation to curator **Miguel A. López** and all the artists and contributors who took part in the prologue in public space as well as in the exhibition and this book—we hope that their invitation to take a more attentive view of the current situation and to reimagine the ways in which we live together will be widely received and accepted. ●

— **What, How & for Whom / WHW**
ARTISTIC DIRECTORS
KUNSTHALLE WIEN

— **Christophe Slagmuylder**
ARTISTIC DIRECTOR
WIENER FESTWOCHEN

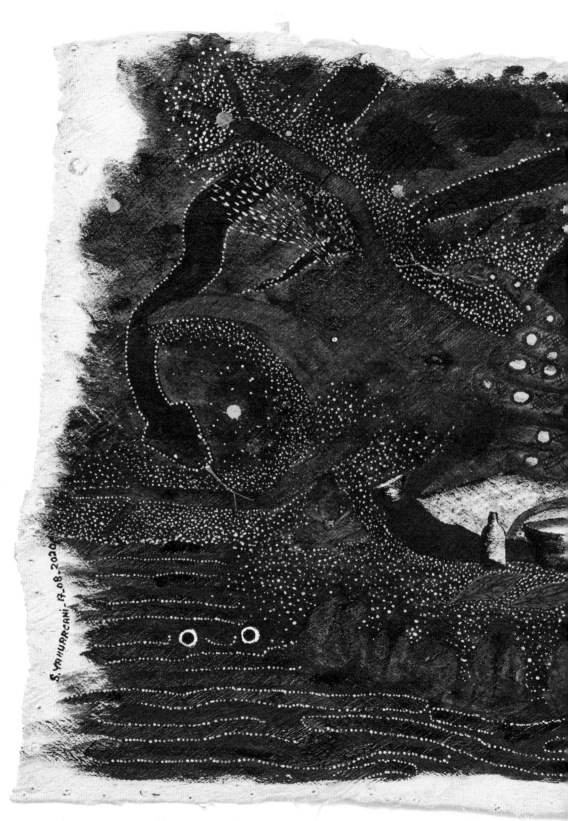

Santiago Yahuarcani, *Sesión de ajo sacha* [Garlic Vine Session], 2020 •
COURTESY THE ARTIST AND CRISIS GALLERY, LIMA

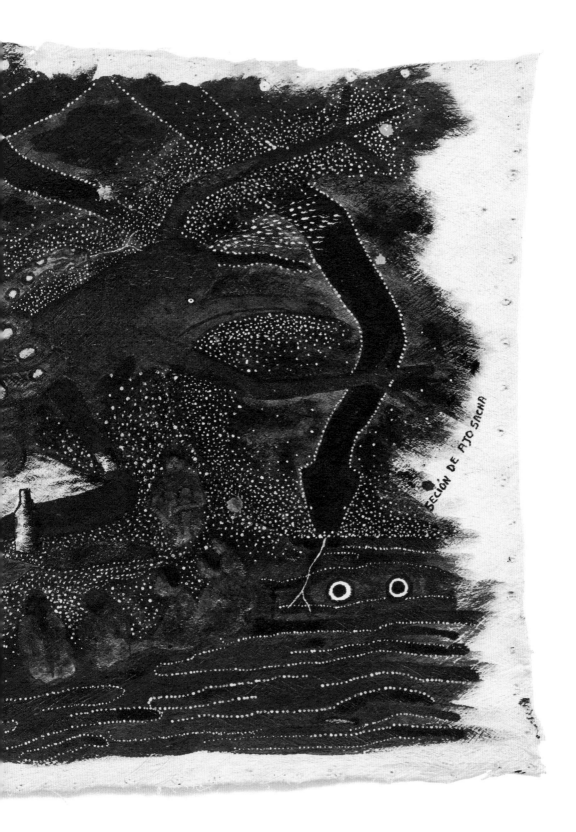

SECIÓN DE PTO SACHA

Sheroanawe Hakihiiwe, from the series *Hihiipere himo wamou wei* [These Trees Give Fruits to Eat], 2018 •
COURTESY THE ARTIST, GALERÍA ABRA, CARACAS, AND MALBA, BUENOS AIRES

Untitled

Cecilia Vicuña

And if I devoted my life
to one of its feathers
to living its nature
being it understanding it
until the end?

Reaching a time
in which my acts
are the thousand
tiny ribs
of the feather
and my silence
the humming the whispering
of wind in the feather
and my thoughts
quick
sharp precise
as the non-thoughts
of the feather?

ca. 1969–71, TRANSLATED BY Eliot Weinberger

Worldmak
Worldmak
Magnades
Metodies
Metodies
Magnades
Destudion
Destudion

Destruction

Worldmaking Imaginaries Against Extraction, Destruction, and Dispossession

Miguel A. López

I NEED A EUROPEAN CULTURAL INSTITUTION WHERE I CAN RETURN TO THEM THE UNIVERSAL HISTORY OF PHILOSOPHY, THE UNIVERSAL HISTORY OF ART, AND THE UNIVERSAL HISTORY OF HUMANITY BECAUSE THEY ARE NOT UNIVERSAL BUT PARTICULAR, ANDROCENTRIC EUROCENTRIC AND COLONIAL

María Galindo & Danitza Luna, *La piel de la lucha, la piel de la historia* [The Skin of the Fight, the Skin of History], 2019

"*And if I devoted my life / to one of its feathers / to living its nature / being it understanding it / until the end?*" wrote **Cecilia Vicuña** sometime between 1969 and 1971. Her poem is a call to weave aesthetic and spiritual threads between human and more-than-human entities and worlds. It also evokes the *precarious* sculptures that she began to create in the mid-1960s: a series of small objects made out of things she found on the beach, which she would place on the sand at the water's edge in a humble act of communication with nature. Like sacred offerings, these fragile articulations—pieced together out of feathers, driftwood, pebbles, and string—played a role in a larger dialogue. These creations, fated to disintegrate and blend into nature, represented a way of honoring the reciprocity of the natural world, without submitting it to violence of any kind.

Vicuña's poem bears witness to a relationship, a desire to dissolve the separation between the human and more-than-human. The writer seems to distance herself from modern Western thinking, which usually equates knowing with apprehending, or dominating, something. She doesn't want to possess the feather, but to *be with* it, suggesting that "to know" is not a destination but an interrelationship.

The exhibition *And if I devoted my life to one of its feathers?* revolves around this vision of interconnectivity that the artist portrays in her poem. However, **Vicuña**'s poetic and material creations are not mere abstract, ontological reflection on the entanglement of existence. Her work reminds us that all assertions of interdependence and relationality are irrelevant if they fail to account for the past and present effects of Western colonialism. This appears even more clearly in **Vicuña**'s reclamation of the quipu, an ancient Andean record-keeping technology made from camelid fiber strings and knots that was banished after the European conquest of the Americas, which she transforms into large-scale installations. The installations stress the processes of resource extraction, destruction, and dispossession, experienced first by Indigenous communities and other colonized peoples. Rather than an idealized representation of conviviality, **Vicuña** highlights historical violence towards a rearticulation of

anti-colonial forces. As the critical theorist and filmmaker **Elizabeth Povinelli** points out, "All theories of existence matter only insofar as they direct our energy toward altering the *ancestral present* of colonial power."[1]

Taking as a point of departure how colonialism has shaped social existence, this exhibition sought to create a collective dialogue around power, sovereignty, self-representation, and social and ecological justice. The exhibited works critically examined the breakneck pace with which raw materials are mined and the environmental destruction inflicted by neoliberalism. Indigenous positionalities burst through colonial legacies to remind us of the history of ancestral genocide and the continuation of extractive logics in the twenty-first century. Works exploring solidarity-based and anti-colonial feminisms highlighted the struggle against patriarchal capitalism and state oppression, while others told stories of reverse migrations and forms of affective belonging.

The existing global logics of economic obedience and military control are clearly an updated version of historical imperialist and colonialist systems. The model of infinite growth is incompatible with a finite planet and the systems that make life sustainable and possible. Our ecosystems are on the brink of collapse. Wildlife continues to be annihilated. The persecution and assassination of Indigenous leaders and communities with impunity is a living legacy of settler-colonialism. The forests are burning—in Brazil, Indonesia, Australia, the Arctic. Hurricanes in the Caribbean are not natural disasters but a major example of climate injustice. The destruction of the Caribbean

1 Elizabeth Povinelli, *Between Gaia and the Ground: Four Axioms of Existence and the Ancestral Catastrophe of Late Liberalism* (Durham: Duke University Press, 2021), 16. The concept of ancestral present used by Povinelli emerged from the work of the Karrabing Film Collective, who are also included in this exhibition. "Karrabing began to experiment with visual overlays and narrative loops that demonstrate that their human and totemic ancestors struggle to stay in place in ongoing colonialism. [...] The ancestral present, like survivance, refuses settler colonial lamentations of Indigenous loss and cultural recession and instead points to the strategic, creative, and sometimes cranky nature of totemic and human existence." Povinelli, *Between Gaia and the Ground*, 134.

islands points out how the Global South always ends up paying for the extraction and pollution produced by the North. The economy is raising its speed limit. No wonder the technological magnates are dreaming of colonies on Mars and new methods of sucking resources out of other planets for human survival. A new billionaire space race has just begun right in front of our eyes. The dick-rocket launched by **Jeff Bezos** amidst the pandemic, in July 2021, made clear that we are witnessing again a white patriarchal race with similar aspirations to those of the colonial era: conquest and capitalist extraction cemented on slave labor.

And if I devoted my life to one of its feathers? was initially conceptualized in 2019 to address the destructive consequences of the hegemonic Western models of development and neoliberalism, without foreknowledge that a few months later a pandemic would make evident again how colonization is about controlling resources and infrastructure. The peoples who experienced the historic devastation of colonization—racialized and Indigenous communities—were the most vulnerable to Covid-19, due to unequal access to natural resources and essential services, such as water, housing, or health care.

In various conversations I had with **Cecilia Vicuña**, she described the neoliberalism paradigm as the expropriation of joy and the capture of the desire for revolution and social change. It involves the violent imposition on people of a docile lifestyle and an economy-driven narrative. Against that backdrop, this exhibition delved into how beauty and joy can provide awareness and a sense of political urgency to disrupt the present. When reflecting on her *precarious*, **Vicuña** said, "Politically, they stand for socialism; magically, they help the liberation struggle; and aesthetically they are as beautiful as they can be to comfort the soul and give strength."[2] These political, magical, and aesthetic dimensions, accompanied with a historical perspective of colonial violence, were some of the aspects gathered in the exhibition.

In trying to initiate a more poetic conversation rather than a theoretical statement, this exhibition looked at how artists from different localities are engaged in opposing the normalization of capitalist social relations and capitalism's embeddedness in racist, sexist, and homophobic structures as well as a model of liberal democracy sustained in neoliberal values and a rhetoric of absorption. In diverse ways, the works responded to the violence and devastation from ritualistic, emotional, and sensitive perspectives rather than a purely rational one. Against widespread cynicism, they upheld various forms of commitment and transformative political desire.

The exhibition

Environmental colonialism, toxic contamination, and the destruction of ecological diversity were heavily represented in many of the works. The psychedelic film *Mermaids, Mirror Worlds* (2018), by the Indigenous media group **Karrabing Film Collective**, is a surreal exploration of the industrial toxicity and the future of poisoned land- and seascapes. **Annalee Davis's** *The Parasite Series* (2018–19) is part of a series of graphic interventions on twentieth-century ledger pages that began in 2014 in an attempt to elaborate on the memory of the plantation as a site of trauma. The parasites evoke a history of infection, exploring through five drawings the post-plantation economies, erosion of the soil, contamination, and the raced, classed, and gendered realities of the Caribbean. **Manuel Chavajay's** *Iq'am* (2014) and *Keme* (2016) series are paintings and drawings made with petroleum on paper that speak to the colonialist attempts to reduce Maya Indigenous populations within the framework of neoliberal policies and national discourses of progress and growth. One fierce piece is the video *Ramita Seca, La colonialidad permanente* [Dry Twig, The Permanent Coloniality] (2019) by the Andean drag performer **Bartolina Xixa**, whose name is a tribute to **Bartolina Sisa**, an Aymara anti-colonial leader who fought against Spanish occupation in the Americas in the late eighteenth century. In the middle of a large garbage dump, surrounded by fog, she appears dancing to vidala, a form of traditional Argentinean folk music. The choreographic piece and lyrics capture the constant exposure to forms of violence from white capitalist culture and the way brown, Indigenous culture can subvert that system of exploitation. These works not only

2 Cecilia Vicuña quoted in Lucy R. Lippard, "Spinning the Common Thread," in *The Precarious: The Art and Poetry of Cecilia Vicuña*, ed. Catherine de Zegher (Middletown, CT: Wesleyan University Press, 1997), 9.

point out how the globalized economy relies extensively on extractive industries (including the unsustainable use of fossil fuels, for example) but also foreground the physical and emotional effects on the bodies of those displaced or forced to do precarious labor because of this economic model.

The recent forest fires in the Amazon and the profound global consequences of climate change appeared in powerful pieces such as the monumental dyed-wool installation *Burnt Quipu* (2018) by **Cecilia Vicuña**. The failure to protect Indigenous lands and the devastation of the Amazonian rainforest are central to the paintings *Bye Bye Brazil* (2020) and *Mártires Indígenas 2* [Indigenous Martyrs 2] (2021) by **Denilson Baniwa**, both commissioned for the show. In earlier work, also included in the show, **Baniwa** depicts the portrait of the Guarani leader **Marçal Tupã´Y (de Souza)**, who since the 1970s has denounced extractive activities, the enslavement of Indigenous peoples, and human trafficking in Brazil's Mato Grosso do Sul state. The painting includes de Souza's most famous phrase, said shortly before his assassination at the age of sixty-three in 1983: "I am a person marked for death." The Indo-Fijian textile maker **Quishile Charan** creates counternarratives of female resistance during the Girmitiya system, the colonial regime of Indian laborers who were transported to Fiji by the British. Combining archival images, representations of flora and fauna, and various forms of craft, **Charan**'s textile works, such as *Ee ghaoo maange acha ho jai* [These Wounds Must Heal] (2019) or *Burning Ganna Khet* [Burning Sugarcane Farm] (2021), are forms of protest but also of affective reconnection with her ancestors through storytelling. As in the case of **Charan** and **Vicuña**, various types of textile practices—including embroidery, quilting, and weaving—had a strong presence in the exhibition, creating a dialogue between experimental and traditional techniques, as well as reclaiming respect for women's labor and highlighting its uses as a form of feminist activism.

Other works tackled human exceptionalism—the idea that humans are unique and superior in relation to other animals and nonhuman forms—and anthropocentric arrogance through theatrical settings that portray uncertainty or destruction caused by imperialism, slavery, and war, as in **Anna Boghiguian**'s cutout works and paintings. **Hiwa K**'s *Pre-Image (Blind as the Mother Tongue)* (2017) shows the artist balancing a long handmade pole assembled with more than a dozen rearview mirrors, retracing on foot the journey he took as a child when fleeing Iraqi Kurdistan for Europe. **Babi Badalov** produced the site-specific installation *M–otherland* (2021) at the entrance of the Kunsthalle Wien. Using a process akin to automatic writing, **Badalov**'s painted fabrics and visual poetry turn absurdity into a political tool, addressing his condition as a political refugee, the everyday misinterpretations of language, and structural racism based on pronunciation and phonetics. Other works stressed interdependency and vulnerability through soft bodies, material entanglements, and physical movements, as we see in the fabric sculptures *Nidos de lágrimas* [Nests of Tears] (1997), *Máscara ojos* [Eye Mask] (2004), and *Máscara boca* [Mouth Mask] (2004) by **Patricia Belli**. In the film *Das Radikale Empathiachat* [The Radical Empathiarchy] (2018) by **Anna Witt**, a group of people develop a manifesto for a potential youth movement in the form of choreography in public space, reshaping the idea of utopia. The commissioned work *A New World Is Coming* (2021) by **Sophie Utikal** evokes the anti-racist demonstrations and the destruction of monuments and other symbols of white supremacy and colonial power. The exhibition also included a collage by **Vicuña** made in response to the 1973 military coup in Chile, where a delicate tree made of hands is envisioned as a monument to connectedness, solidarity, and caring.

Similarly, **Shöyan Sheca**'s *La cosmovisión de los tres mundos Shipibos* [The Cosmovision of the Three Shipibo Worlds] (2018) and **Sheroanawe Hakihiiwe**'s *Hihiipere himo wamou wei* [These Trees Give Fruits to Eat] (2018) embrace ecological relationships between different species, and a future organized around a pluralistic view of life that goes beyond the human. The twenty-one small, delicate acrylic paintings by **Hakihiiwe**, a sort of affective inventory of the various fruits offered by the trees in his surroundings, remind us of the entanglements and interactions across species and beings. **Amanda Piña**'s *Danzas Climáticas* [Climatic Dances] (2019–21) is part of the long-term project *Endangered Human Movements*, begun in 2014. The artist presents two dances—*Tipekajomeh* and *Wewentiyo*—from the northern highlands of Puebla, Mexico, to visualize other forms of

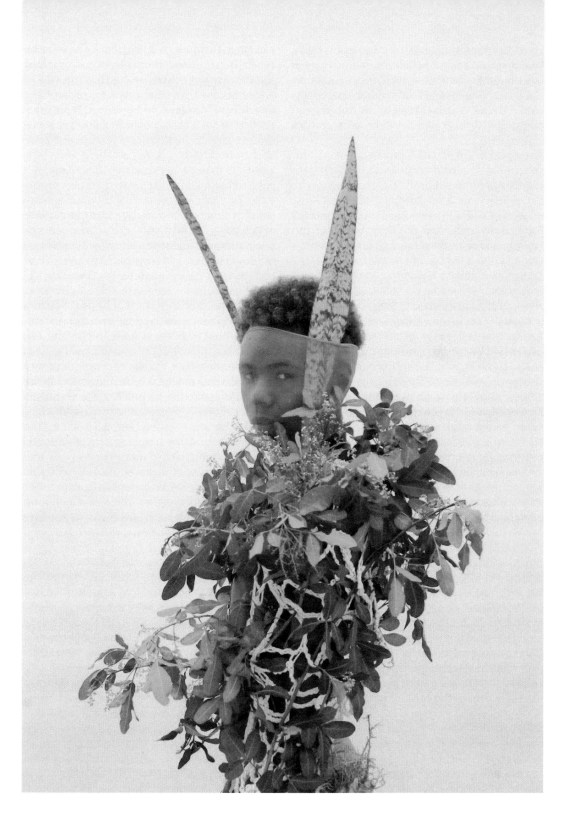

Castiel Vitorino Brasileiro, *Comigo-ninguém-pode*, 2018 • COURTESY THE ARTIST

socio-environmental relations and interactions. The impressive paintings by the late Ojibwe artist **Jim Denomie** capture the ongoing fight of Native Americans for the right to self-determination and to occupy their constantly threatened homelands. Deploying a critical sense of humor and a caricatural style using vibrant colors applied in rapid brushstrokes, **Denomie** counters white supremacy. In *Standing Rock 2016* (2018), **Denomie** represents the Standing Rock Sioux's fight, since 2016, to block plans to run the Dakota Access Pipeline straight through Sioux territory, posing a major environmental contamination risk. The artist connects these forms of contemporary aggression with a long history of settler-colonial violence, including the Wounded Knee Massacre of 1890.

Some of the exhibited works also explored affinities and intersections between various social and political movements struggling against racial capitalism and state repression, such as the intersection between the Black Panthers in the US and the Zapatista Army of National Liberation in Mexico, which is at the center of the **Zapantera Negra** project, begun in 2012. A new textile work by the collective **Chto Delat** likewise takes up the Zapatistas' principles of autonomous governance and participatory democracy; this piece, which emerged out of the collective's visit to Chiapas, in southern Mexico, explores the movement's relation to the emergence of new leftist forces in Europe. For the exhibition, **Zapantera Negra** produced a new version of their beautiful casita Zapatista, *Flower of the Word II: "Digna Rebeldía"* ["Dignified Rebellion"], which contained a collection of textile pieces, graphics, photographs, and other objects and materials produced by an intergenerational group of people of the Zapatista community in Chiapas. The new installation **Zapantera Negra** produced for this show was commissioned in early 2020 without knowing that their presence would anticipate the Journey for Life campaign, the Zapatista mission advocating for solidarity and rebellion across the world. Announced as a kind of reverse "invasion," a delegation of Zapatistas sailed to Spain in late June 2021 to kick off the tour. The first member to disembark, **Marijose**, a nonbinary individual, promptly changed the name of Europe to *Slumil K'ajxemk'op* (Tzotzil for Insubmissive Land), reminding us of the long history of Indigenous forms of communal politics.

Patriarchal white-nationalist structures, systemic criminalization, and the cruelty these perpetrate are denounced in **Daniela Ortiz**'s *The ABC of Racist Europe* (2017) and the drawing series *La piel de la lucha, la piel de la historia* [The Skin of the Fight, the Skin of History] by **María Galindo** and **Danitza Luna**, of the anarcha-feminist group **Mujeres Creando**, based in La Paz, Bolivia. "I return my passport and renounce my belonging to any national state, I want to belong to a *salar* [salt flat], a highland, a jungle, a river, a desert, a mountain" states one of the pieces by **Galindo** and **Luna**. Commissioned for this exhibition, **Ortiz** also prepared the hand-drawn children's book *Papa, with P for Patriarchy* (2020), which explores the legal mechanisms behind racist and patriarchal abuse and violence.

The powerful choreographic piece *Me gritaron negra* [They Called Me Black] (1978) by **Victoria Santa Cruz** is based on a childhood memory of a group of girls refusing to play with her due to their racist bias. The wordplay in the musical rendition and the screamed repetition of the word "Black" dismantle the scorn associated with racialization, turning the word instead into one of affective recognition and political resistance. In this work movement and body language are key but they also present the possibility to transform pain into a collective force against white oppression. The exclusion of racialized people and migrants is addressed by **Prabhakar Pachpute** in his large-scale painting *A Plight of Hardship II* (2021). The work depicts a character who is made up of human and animal parts, personal belongings, and volcanic vents. The artist explored the flip side of the global slowdown under Covid-19, which appears as a direct reference to the essential workers who kept things moving during the pandemic, often with no access to benefits like paid leave and health insurance. The character's movement evokes the thousands of people who had to migrate from densely populated cities to rural areas, as happened in India or Peru during the first months of the pandemic.

The possibilities of countering toxic masculinity and macho culture appeared in works that tackle normative gender standards that uphold political disenfranchisement. Through rich and voluptuous nonbinary imagery in the new sculptures commissioned for this exhibition, *Monitor*

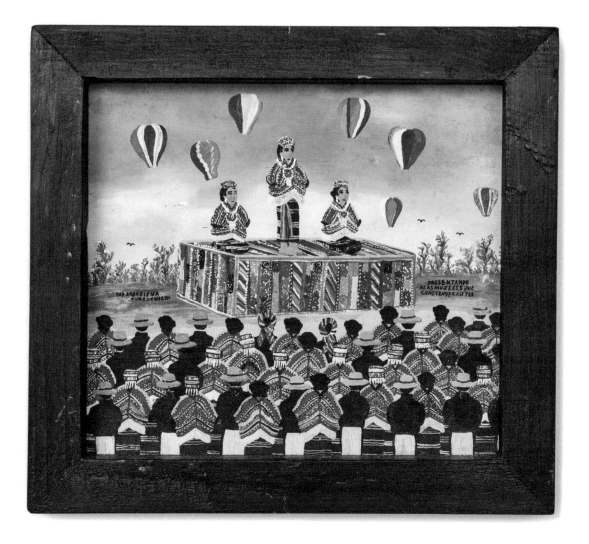

Rosa Elena Curruchich, *Presentando a las mujeres que construyen casitas* [Introducing the Women Who Build Houses], ca. 1980s • COURTESY PRIVATE COLLECTION

Head (2021) and *Unmasking* (2021), **Nilbar Güreş** explores her Kurdish Alevi origins, the parallels between Kurdish and Aymara culture, and the forms of oppression and forced assimilation that this religious minority has experienced. **Victoria Cabezas** responds to the exoticization of Central America, which is rooted in patriarchal views, through parodic hand-colored photographs of bananas from the 1970s. Disrupting stereotypical representations of Black masculinity, **Amoako Boafo** offers a series of paintings devoted to self-care, while **Vlasta Delimar** confronts misogyny through performative photo-collages from the early 1980s that claim control of her desire and sexuality.

In yet other works, drag practices and the operations of reconstruction and self-fashioning one's body appeared as a useful model for thinking through how to bring together diverse moments in history and to create connections differently. For artists such as **Germain Machuca**, this means acknowledging the body as a tool to investigate the past, through which he traces and reclaims alternative queer genealogies. In dialogue with Macumba and other Afro-Brazilian religions, **Castiel Vitorino Brasileiro** creates powerful rituals and photo-performances that dismantle the white gaze and reclaim a genealogy of Black transgender spirituality. **Salmo Suyo**'s series of ceramics *Genitales* [Genitals] (2016–2017) and *Disforia* [Dysphoria] (2019) abandon biologistic anatomy to propose new and improved variations for a nonbinary physical development and functioning of the body. In the video *We The Enemy* (2017), the collective **SPIT! (Sodomites, Perverts, Inverts Together! / Carlos Maria Romero, Carlos Motta & John Arthur Peetz)** compiles a litany of insults used to exclude and persecute queer people as a way to reassemble those made into enemies as a new *we*.

Indigenous positionalities and voices interrupt colonial legacies and complicate Western epistemological frameworks. The miniature paintings by the late Maya Kaqchikel artist **Rosa Elena Curruchich** document religious festivals, family, community ties, and artisan traditions such as the production of candles, bread, kites, and *perrajes* [blankets], which she painted in meticulous detail. Produced in the 1980s and 1990s, during Guatemala's civil war, her work was not well

received in her community due to the misgivings and prejudices surrounding a woman working in what was considered to be a strong masculine tradition. Her paintings reclaim the transformative power of communal work and acknowledge that the struggles of Indigenous women have a history of their own that is different from institutionalized Western liberal feminism. Stressing their spiritual, energetic, and social connections with their lands, artists such as Uitoto painter **Santiago Yahuarcani** and Shipibo embroiderer and activist **Olinda Silvano / Reshinjabe** embrace the spiritual worlds of the Amazon, communal life, and the medicinal and sacred knowledge of plants and leaves, such as ginger, *mucura* (*anamu* or garlic guinea weed), *matico* (spiked pepper), wild garlic, eucalyptus, among others. In his paintings, **Yahuarcani** also poignantly exposes a long history of colonial violence against the Uitoto and the current destruction of the rainforest under Western models of privatization and development. Furthermore, **Yahuarcani** and **Silvano** both address their personal experiences with Covid-19, calling for the reparation of the relationship between people and the land and highlighting how exposure to the pandemic's damage is closely linked to the history of colonialism that formed the racialized hierarchy of existence.

The book

This book accompanies and expands the ideas proposed by the exhibition. The texts gathered here explore the possibilities of worlds beyond the human and forms of restoring the ecological and social balance broken by the imposition of an extractive, colonial, and monocultural logic. Sixteen texts are intermingled together with a selection of artworks included in the exhibition, creating a transdisciplinary conversation that combines inputs from artistic research, environmental justice, transversal queer solidarity, history, Indigenous epistemologies, philosophy, multispecies storytelling, and anti-colonial thinking.

The written contributions include two poems, four speculative essays, and ten short stories by participant artists and collectives, who were invited to answer the exhibition title's question—what it would mean for them to dedicate their lives to a feather. In newly commissioned essays from the artist **Naomi Rincón Gallardo**, the academic and visual artist **Denise Ferreira da**

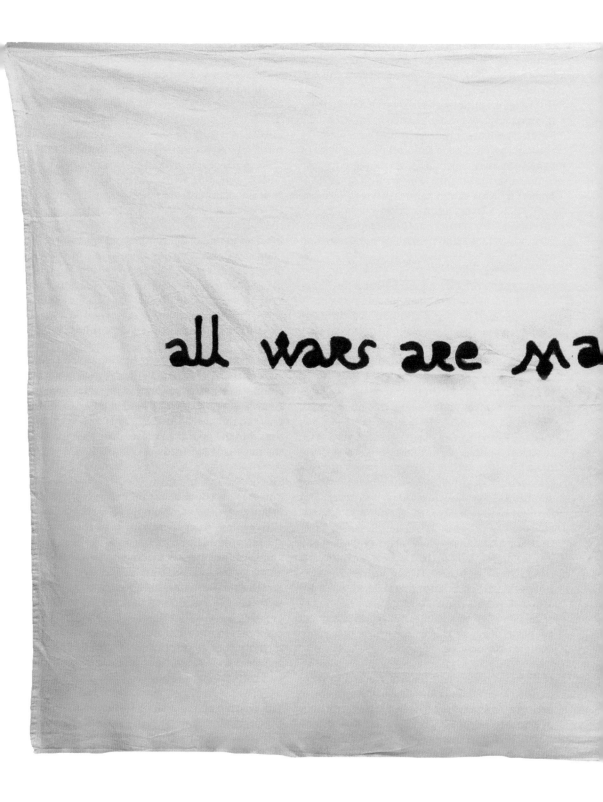

Babi Badalov, *All Wars are Made by Men*, 2019 • COURTESY THE ARTIST AND GALERIE POGGI, PARIS

Silva, and the aforementioned scholar **Elizabeth Povinelli**, as well as in a revised conference paper by the anthropology professor **Marisol de la Cadena**, the authors confront colonial power and explore the challenge of creating alternative world-making imaginaries against extraction and appropriation—the active effects of a history of slavery and human supremacy. In ten short stories, artists **Daniela Ortiz**, **Quishile Charan**, **Amanda Piña**, **Olinda Silvano/Reshinjabe**, **Prabhakar Pachpute**, **Jim Denomie**, **Annalee Davis**, **Chto Delat**, **Manuel Chavajay**, and **Zapantera Negra** offer more intimate accounts that not only examine the situation of systemic collapse but unearth personal narratives and new meanings regarding the feather as an aesthetic symbol, spiritual power, ornament, tool, medicine, and technology. Two poems by **Cecilia Vicuña** and **Victoria Santa Cruz** remind us of the power of words to decolonize and call for rebellion.

The book collects documentation of the "Prologue in Public Space," a series of artistic statements produced for the advertising-billboard format in Vienna, showing the first stage of the exhibition project developed during June and July 2020, right after the pandemic interrupted our everyday lives and forced the closure of art institutions. The six guest artists and collectives—**Manuel Chavajay**, **Chto Delat**, **Inhabitants with Margarida Mendes**, **Daniela Ortiz**, **Prabhakar Pachpute**, and **Sophie Utikal**—were invited to reflect on the sanitary crisis from the perspective of their own experiences, concerns, geographies, and political communities. Their visual statements were installed at 250 locations across Vienna. Finally, the book also includes installation shots of the project at Kunsthalle Wien.

And if I devoted my life to one of its feathers? brings together artists, thinkers, and activists whose practices engage in the struggle for collective survival and the processes involved in restoring disrupted social bonds. The exhibition and this accompanying book provide the place for a conversation aiming to reconnect scattered parts of what we might call ecological justice—an assembly of many worlds and multiple forms of awareness. ●

— **Miguel A. López**
CURATOR

Installation view: *And if I devoted my life to one of its feathers? –*
A prologue in public space, 2020

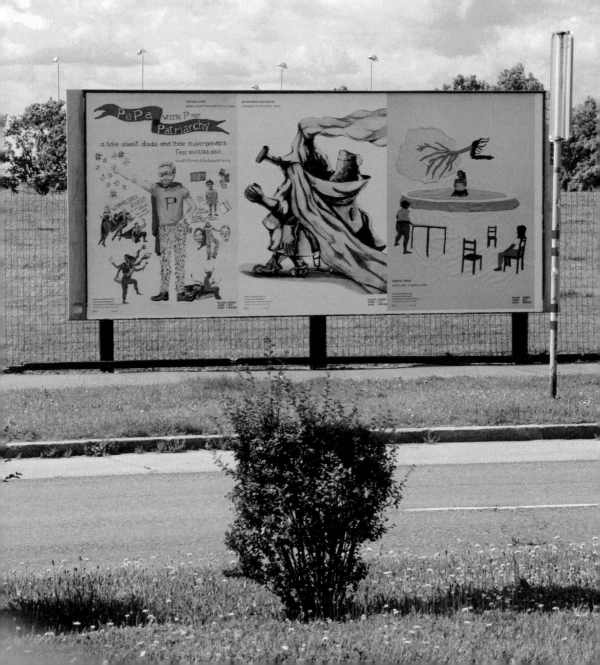

A Prologue in Public Space

Understanding the importance of keeping a collective, transnational conversation going beyond the closing of borders and doors brought about by the lockdowns in 2020, *A Prologue in Public Space* aimed to translate some of the exhibition's voices and topics into billboard format interventions mounted at 250 locations all over Vienna throughout June and July 2020.

This "prologue in public space" brought together the artists and collectives **Manuel Chavajay, Chto Delat, Inhabitants with Margarida Mendes, Daniela Ortiz, Prabhakar Pachpute, and Sophie Utikal.** They were invited to reflect on the current pandemic from the perspective of their own experiences, concerns, geographies, and political communities.

Ru k'ayewaal

Manuel Chavajay, *Tz'ikin*, 2020 • COURTESY THE ARTIST

Chto Delat, *Eine Feder* (visualized by Dmitry Vilensky), 2020 • COURTESY THE ARTISTS

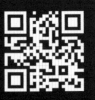

Underseas, four km below sea level,
along the Mid-Atlantic Ridge and on the
Clarion Cliperton Zone new mines the
size of Europe are being planned.

Why is the European Raw Materials
Initiative allowed to overrule the EU
Sustainable Development Goals?

cobalt-rich
ferromanganese
crusts

Located: 800–2,500 m
below sea level, in
seamounts

massive
sulphide
deposit

Located: 1,000–4,000 m
below sea level, in
hydrothermal vents
and other sites

polymetalic
nodule
deposit

Located: 4,000–6,500 m
below sea level, in
different geological sites

Inhabitants with Margarida Mendes, *What is Deep Sea Mining?*, 2018–2020,
commissioned by TBA21-Academy • COURTESY THE ARTISTS

Daniela Ortiz, *Papa, with P for Patriarchy*, 2020 • COURTESY THE ARTIST AND ÀNGELS BARCELONA, BARCELONA

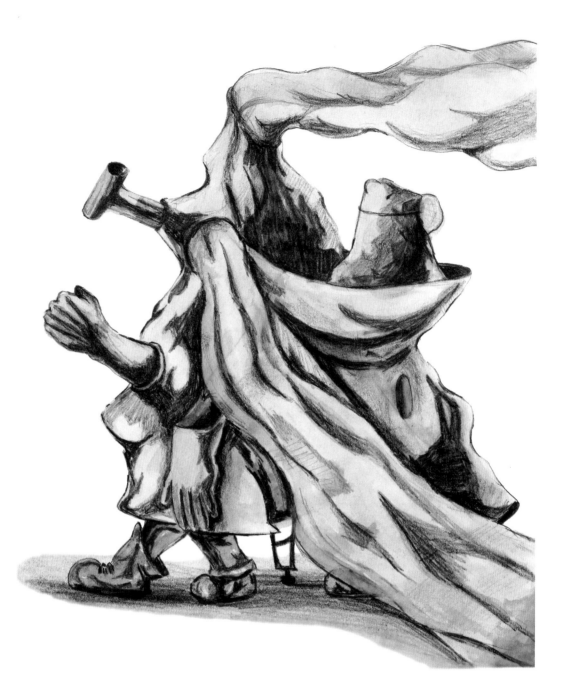

Prabhakar Pachpute, *A plight of hardship*, 2020 • COURTESY THE ARTIST

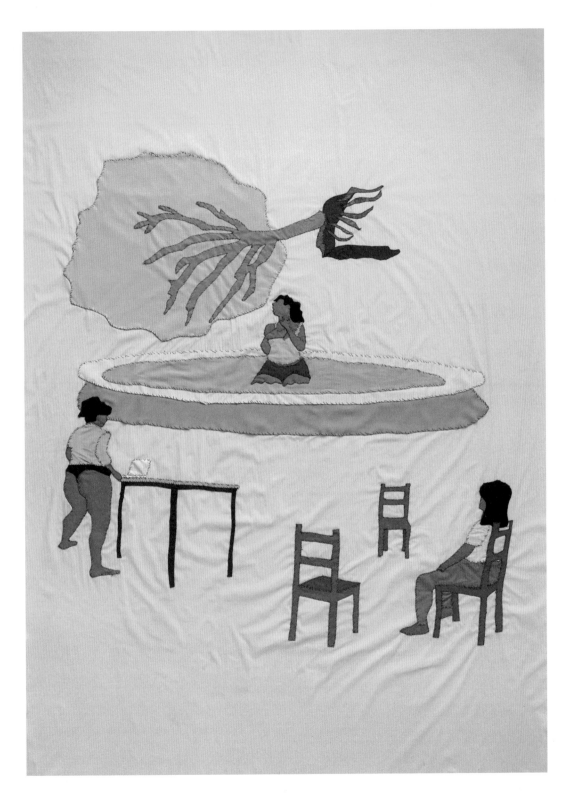

Sophie Utikal, *what was, is gone*, 2020 • COURTESY THE ARTIST

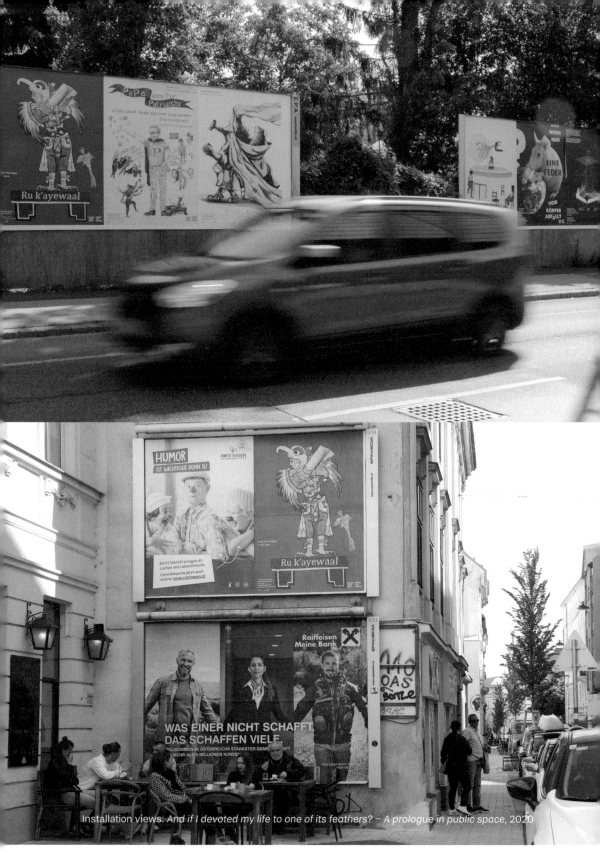

Installation views: *And if I devoted my life to one of its feathers?* – *A prologue in public space*, 2020

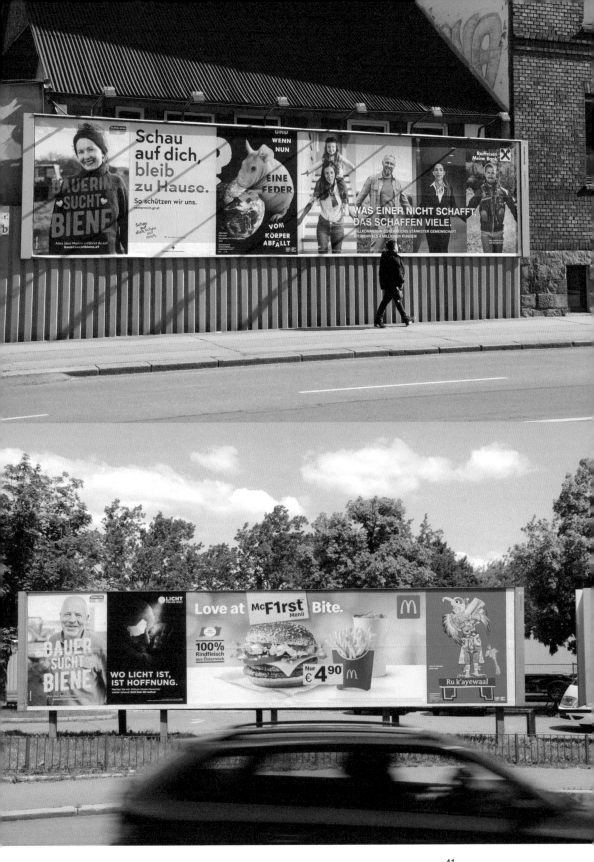

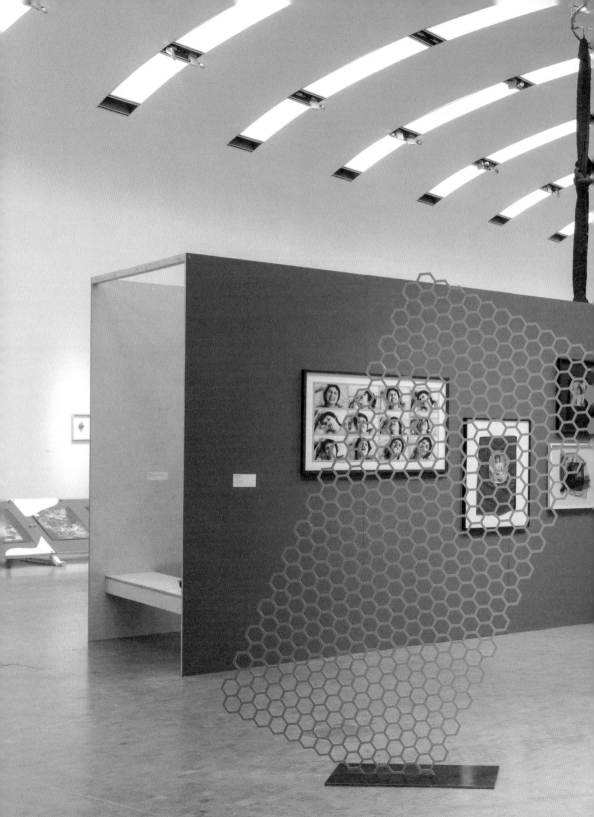

Installation view: *And if I devoted my life to one of its feathers?*, Kunsthalle Wien, 2021

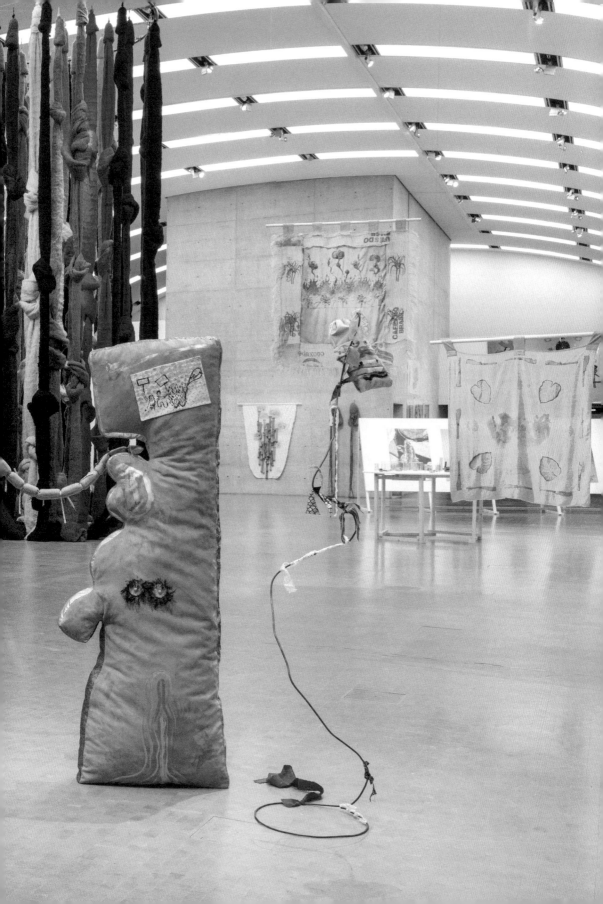

BORDERS can be decided, **BUILT** and crossed by European white people, but not by racialised people coming from former colonies, who must undertake risky crossings hiding in a **BUS** or a **BOAT.**

COLONIALISM created the global **CONDITIONS** for having detention **CAMPS** for migrant people from ex-**COLONIES** in European **COUNTRIES.**

Daniela Ortiz, from the series *The ABC of Racist Europe*, 2017 •

Daniela Ortiz

Achtung, Marcos, el penacho

Achtung! Achtung!

Marcos, stop distracting the others! We are here in the Welt Museum of Vienna to learn about the Penacho of Moctezuma. What is the Penacho, kids?

A helmet! A hood! A feather headdress!

The Penacho is a sacred featherwork crown from the Aztecs that we brought here to keep safe in our museum.

Marcos! You again, I'm telling you, stop making trouble in the back, you have to listen, we all want to know about the Penacho, and you're not letting us learn!

Frau Dorothea, it was not me, it was Horst who is bothering me.

Marcos, you and Horst will have to make up and stop the noise.

Frau Dorothea, Horst said that I should go back to my country.

Come on, Marcos, don't be so sensitive.

You see, Marcos, Frau Dorothea says you shouldn't be so sensitive, you are like a feather.

Y a veces lo único que quiero es irme de acá, irme con el Penacho, volver a mi tierra, volver a mi abuela, volver con mis plumas, mis plumas del Penacho, volverme sensible, volver a mi tierra, volver a vivir su naturaleza, a serla y comprenderla, volver a escuchar a mi madre recitar aquel hermoso poema que Cecilia nos hizo respirar.

Quishile Charan

This Name Holds the Memories of Your Ancestors

"I remember the day, sitting in my Aaji's[1] lounge in Nawaicoba, she explained the significance of my name, 'I will always live on through you.'[2]"

There are often moments where I feel so overcome by my emotions, by sadness and grief. These moments are triggered by knowing or being reminded that I will never know my dead, their names or their lives and stories. The names have become forgotten, buried deep in memories as life has had to keep moving forward; across generations, through military coups, cyclones, migrations, and the rapid escalation of climate change impacting Viti.[3] There has been no time for lingering thoughts about plantations and what happened to my ancestors. Being born to abusers has drastically shifted that relationship to knowing, as has coming from a working-class background and having family still in the ganna[4] fields. We have—collectively—had to focus on our survival. I wonder where my ancestors are now; somewhere in the Vanua,[5] Aaji once said, the ganna will always remember, I think so too. Sometimes when it is quiet and I look across my family's farm in Nawaicoba, the wind blowing through the rows of ganna, I wonder if they can see me. These moments are peaceful. Sometimes I will get glimpses from stories, a name at the tip of the tongue, usually elders will remember in passing thoughts and stories. These glimpses, these moments have always been precious to me.

When I was born, I was given my Aaji's name, Shila or Sheela. Shila became (Qui)shile and for the last twenty-six years I have carried her with me. It is only recently that I have grown into my name, grown and understood my responsibility in upholding our histories and ancestors. We have a shared relationship, her craft, and for the longest time that was what kept me moving forward, my making. Out of being a namesake, I was bound to Aaji and through this relationship I met my chosen mother, Roshni. Within our cultural framework of family she is Fua, my biological father's older sister. Somewhere between conception and the naming, my ancestors birthed me for her. For so long it was me and then she was there, my Amma.[6]

1
Paternal grandmother

2
Text from project: http://runway.org.au /quishile-charan

3
Fiji

4
Sugarcane

5
Vanua can be roughly translated as land but it encompasses much more than that. The Vanua for iTaukei (Indigenous Fijians) is land and its people and is interwoven into their culture. As an Indo-Fijian, a non-indigenous pasifika woman whose ancestors were brought to Fiji for plantation labour, it is an honour knowing my ancestors rest and are protected by the Vanua.

6
Mother

47

Lately I cannot help but linger on these thoughts of ancestors. I thought I needed a name, to hear their stories, to know what love and coming from them meant. The truth is, it is so ingrained and embedded within my body, I think it started with my name. My Aaji is a bridging point, to family members, to elders, to ancestors gone. Maybe I will never hear all my ancestors' stories from my elders, from Aaji. They are lost to memories of other times, but within my name they continued living, just like her craft. I wonder who I would have become if I was named after someone else. In this name— Quishile—time, history, and ancestors have and are living with me, these things are not stagnant, they are living and breathing. I thought for the longest time that I was alone, but in reality I had them with me, in my hands while I made, as I grew into Quishile. Every time I say my name, every time my name is spoken, it is their names that echo within mine. I am bound to my Aaji as she is bound to them and to ancestors gone and ancestors to come.

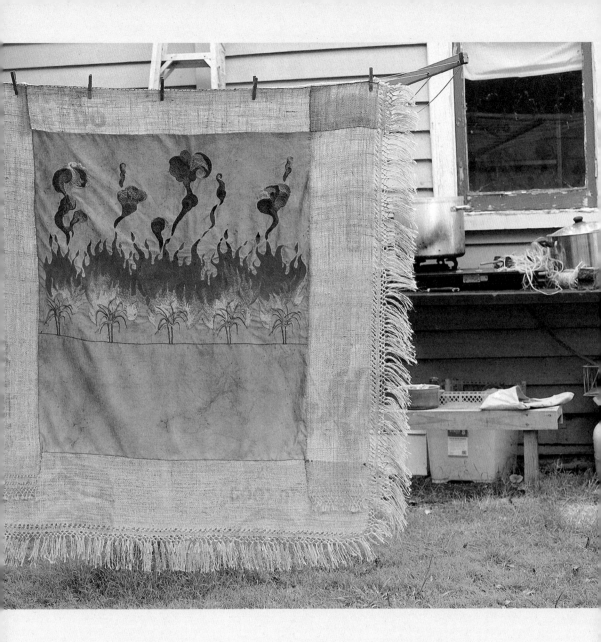

Quishile Charan, *Burning Ganna Khet* [Burning Sugarcane Farm], 2021 • COURTESY THE ARTIST

A Letter to Stained Subjects Who Persist in the Labor of Worldmaking Regardless

Naomi Rincón Gallardo

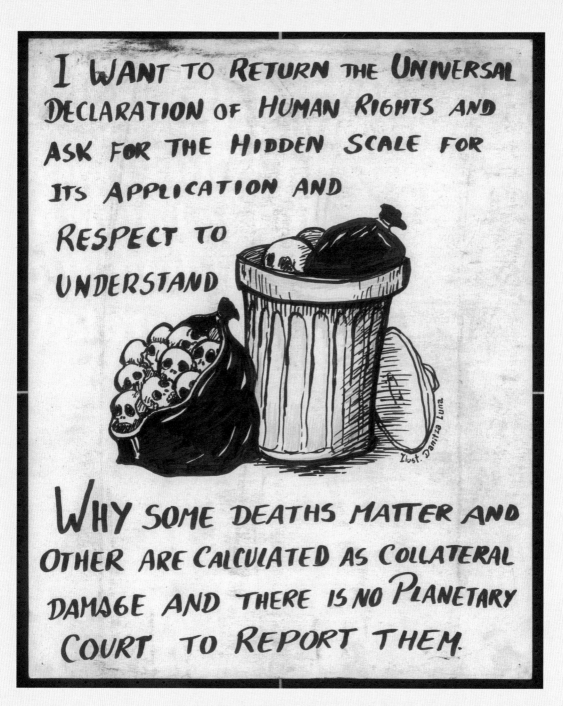

I WANT TO RETURN THE UNIVERSAL DECLARATION OF HUMAN RIGHTS AND ASK FOR THE HIDDEN SCALE FOR ITS APPLICATION AND RESPECT TO UNDERSTAND

Ilust. Danitza Luna

WHY SOME DEATHS MATTER AND OTHER ARE CALCULATED AS COLLATERAL DAMAGE AND THERE IS NO PLANETARY COURT TO REPORT THEM.

María Galindo & Danitza Luna, *La piel de la lucha, la piel de la historia*
[The Skin of the Fight, the Skin of History], 2019 • COURTESY THE ARTISTS

Stop speaking in tongues, stop writing left-handed.
Don't cultivate your colored skins nor tongues of fire
if you want to make it in a right-handed world.
(Gloria Anzaldúa)[1]

I write you this unrequited letter as a sign of recognition of our common efforts to entwine and bridge heterogeneous worlds from below in this moment of planetary cataclysm. The signs of the systemic collapse were here long ago, but the Covid-19 crisis has made it more explicit and intensified its exclusionary structure. The system collapses, but it does so in an enraged tantrum attempting to reassert its old tenets of whiteness, heteropatriarchy, authoritarianism, neo-nationalism, and racial capitalism. This dangerous moment also teaches us how to turn our gazes to the importance of our close bonds with others—human and nonhuman—, the urgency to foster local and small economies, the centrality of reproductive labor, the necessity to nourish forms of autonomy and food sovereignty, and our interdependency with the land. In the terminal phase of a world system, cracks appear and multiply: where can one live a life focused on smallness, slowness, and what happens in the margins.

We, the ones marked by those forces with the stigma of inferiority —the colonized, the racialized, the backward others, the migrants from the Global South in the Global North, the queers—, know very well that the systemic collapse will harm us, that the rubble will fall on us too. We are immersed in a dangerous moment in which this transnational tantrum is ready to make the world even more unbreathable for many of us. Under these transnational forces, always ready to make destruction profitable and the world inhospitable, the planet has been understood as a vacant corporate bio-territory for commodification, penetration, extraction, and data capture. In return, the living planet responds to the multiple inflicted tortures in unexpected ways. We have already been trained to live in territories which as a result of centuries of colonial appropriation, have become zones of disorder, terror, and necropower. We have been increasingly exposed to all forms of vulnerability: toxicity, impoverishment, danger, violence, the precarity of labor and lower wages, and premature or slow death. While regions of the Global North keep the profit, regions of the Global South put up the corpses, the carcasses, the labor, and the natural resources. In spite of the injustice, we keep creating obstacles for development. We count on plentiful repertoires for living in close intimacy with danger. We are tenacious and enduring: we have hardened. And we want more than just survival: we want to play hard, in ecstasy.

(Sound of drums, trumpets, saxophones, and guttural voices yelling:)

Among the ruins
We lie in wait.
Because of the devastation

1
Gloria Anzaldúa, "Speaking in Tongues: A Letter to Third World Women Writers," in *The Gloria Anzaldúa Reader*, ed. AnaLouise Keating (Durham, NC: Duke University Press, 2009), 28.

We are carriers of waste
Among the ruins
Enduring the ransacking
Among the ruins
We defend and drive out.

Heavy blood
Resisting, persisting
Heavy blood
Hanging tough, twerking
Heavy blood
More desiring than desirable
Heavy blood
Enduring and indomitable.

Breathe in! Breathe out! Sip! Spit! Swallow! Bite! Destroy!

Blue grabbing!
Land grabbing!
Pussy grabbing!

Though parched, we keep spitting
Though toothless, we bite ravenously
Though exploited, living in excess.
Hunkering down, licking our fingers
Failed corpses, chewing our fingernails
Drunk on our hunger revenge![2]

Let me make a detour here to clarify that I am not attempting to gloss over the tremendously different violent histories that have defined, in contrasted degrees, the scope of what I refer to here as "the stigma of inferiority"; from now on I will call this the "stain." José Esteban Muñoz argues that brownness surfaces against a white backdrop as a stain of enduring historical violence.[3] He calls for a brown commons, which can be described as a sort of subaltern trans-relational solidarity provoked by various experiences of harm. In this understanding, the stain is a non-identitarian commonal-ity of being marked down—for your skin color, for your belonging to the landscape of the conquered, for linguistic affiliations and your accent, for your migration trajectory, for your sexuality, for the ideological erasure and the collapse of the systems of belief you grew up with, for your affective attachments, for the devalued currency in which you calculate your expenses.

For stained subjects who have managed to "make it" to the White West, aka Global North, there is an experience that I like to call a Fanonian epiphany. You come to realize that the certain status that you may have elsewhere turns into a sense of illegitimacy under the white gaze, and that self-worth is something that must be constantly achieved. Rita Laura Segato claims that if there is an expertise in the Western European gaze, it is an expertise in racialization, because it looks at the position of bodies in a history of subordination.[4] Case

2
From Naomi Rincón Gallardo's *Heavy Blood* (2018), Video HD, 18 min. 45 sec.

3
José Esteban Muñoz, *The Sense of Brown* (Durham, NC: Duke University Press, 2020).

in point: When someone grabs her purse in the metro when you sit in the next seat, or when your seat neighbor—an elderly woman, why not?—pushes you with her stick. When you are asked for your passport instead of for your medical insurance card when you go to the doctor. When, at the opening of your art show, one of the institutional board members cannot keep his racist joke to himself. When there are only white professors teaching at the academy. When you go to a show and the white visitors pass you their empty glasses or give you their coat, expecting you to hang it—because why would you be there if not to be available for servitude? When you feel thankful that you haven't learned their language well, so you don't fully understand the racist slurs directed at you in the streets. Enough autoethnographic impetus. I just find it helpful to illustrate that this marking down is a detailed racialized and gendered technology of dismissal that drains your energy both physically and psychically. These technologies of dismissal keep the colonial wound open. It hurts, so you might try to heal the wound, to deny it, or to domesticate your difference and assimilate into a context that would rather like to eradicate you. But there is also the possibility that the Fanonian epiphany leads you to embrace this wound, even though it feels like bleeding out.

Silvia Rivera Cusicanqui reminds us that colonial wounds still bleed, but they also incubate fury and desire for revenge: they are charged with undigested indigenous pasts that still haunt us.[5] Her take on the stain is useful here: as colonized subjects, we are impure and stained by multiple temporal and spatial horizons simultaneously. The stain is a marker of ancestral information juxtaposed with colonial and liberal pasts that altogether become a lived continuum. We count on a chaotic cosmic ecology of knowledges that have allowed us to survive and to walk paths that run counter to the logics of accumulation and productivism.

> *Each day there're more of us,*
> *we're an infection of residual bodies—an epidemic*
> *A striking array, gorgeous blasphemy*
> *issuing from the lips of omens*
>
> *Crusts in the eyes of development*
> *we crack the pavement like stubborn weeds*
> *We plot unstoppable incidents*
> *an excess of minor spams*
>
> *Infatuated dissident bastard-bitches*
> *Bloated with pleasure and discord*
> *We become virulent in solidarity*
>
> *Crawling sequined urban vermin*
> *let's twist our muddy disagreements together*
> *and speak for the shaking inside us*[6]

4
Rita Laura Segato, *Contra-pedagogías de la crueldad* (Buenos Aires: Prometeo libros, 2018).

5
Silvia Rivera Cusicanqui, *Un mundo ch'ixi es posible. Ensayos desde un presente en crisis* (Buenos Aires: Tinta Limón, 2018).

6
From Naomi Rincón Gallardo's *Sonet of Vermin*, work in progress.

As stained subjects, we are not supposed to have worldmaking effects. Under the white gaze, our creations are subject to the same technologies of dismissal that render our bodies and ways of living inferior, unclean, loud, ignorant, superstitious, "painfully naïve," primitive. We are expected to be available for extraction and transparency. But we refuse. We create counter-worlds in incommensurate ways. We are not interested in fulfilling a modern/colonial anal-retentive demand for efficiency and control. We claim a theory enmeshed with the body, a knowledge intertwined with nature and matter: a theory that can be danced, smelled, touched, away from the arrogant affirmation of superiority of certain forms of abstract knowledge that create epistemic and political erasure.[7] We nurture counter-worlds that blossom from forms of sociality that are well known in the south: the stickiness of conviviality; the radical openness to the unknown; the joy of waste despite precariousness; the wonderment at contingent forms of collective belonging; the reinvigorating power of festivities that allow us to feel like cosmic creatures again; the capacity to prioritize affective relations and corporality over individualism; the reciprocity between humans, nature, and the dead.[8] We cook up remedies against obliterated history and oblivion while privileging modalities of time that propel stained epistemes into the future. We leave the wound open as a source of knowledge and transformative power.

To embrace the wound feeds a political desire for reclaiming human dignity. I am not talking here about the Enlightenment concept of the (mono)human, but something closer to Sylvia Wynter's aspiration to a humanism that fulfills its promise and renews its vision into a non-identitarian planetary humanism.[9] This aspiration requires a crafty imagination nourished by the legacies of anti-racist and anti-colonial resistances; indigenous ontologies, politics, and spirituality; feminist, communitarian, and popular alternatives to capitalist relations; queer relationality; and a pluriversal understanding of life on the planet that embraces the human and nonhuman in its unpredictability, multiplicity, and ambiguity.

> *How do you cope?*
> *Talk back*
> *Write back*
> *Take back energy*
>
> *Flourishing planet!*
> *Oppositional Ecologies*
> *Global South!*
> *Paranormal alien/digenous*
>
> *Bridge the abysses*
> *Close the gaps*
> *Learn to see*
> *From the cracks*

7
Sylvia Marcos,
"Feminismos en el camino descolonial," in *Más allá del Feminismo: caminos para andar*, ed. Márgara Millán (Mexico City: Red de Feminismos Descoloniales, 2014).

8
Naomi Rincón Gallardo, "Decolonial Queer (Under)Worldmaking in Contexts of Dispossession: A Trilogy of Caves" (PhD diss., Academy of Fine Arts Vienna, 2019).

9
David Scott, "The Re-Enchantment of Humanism: An Interview with Sylvia Wynter," *Small Axe* 8 (September 2000): 119–207.

Flourishing planet
Ecologies of care
Inter-knowledges
Scavengers of subjugated wisdom

Flourishing planet
Pre-history of the left-handed millennium
Global South
Intersectional insubordination

How do you cope?
Talk back
Write back
Take back energy[10]

Yours, in supportive virulence,

Naomi Rincón Gallardo
Oaxaca, Mexico, July 2021

PS: Have you heard? A Zapatista mountain has crossed the Atlantic Ocean. Its troops have declared that the land that its natives call "Europe" will be known as SLUMIL K´AJXEMK´OP, which means "Rebel Land," or "Land that doesn't yield, that doesn't fail." A reversed conquest propelled by desire is bridging counter-worlds from below and turns the symbolic orders of coloniality upside down right in front of our eyes.
Each day there're more of us, we're an infection.

[10]
From Naomi Rincón Gallardo's *The Formaldehyde Trip* (2017), a series of videos and performative screening.

Germain Machuca, *Las dos Fridas – Sangre / Semen – Línea de vida*, 2013 • COURTESY THE ARTIST

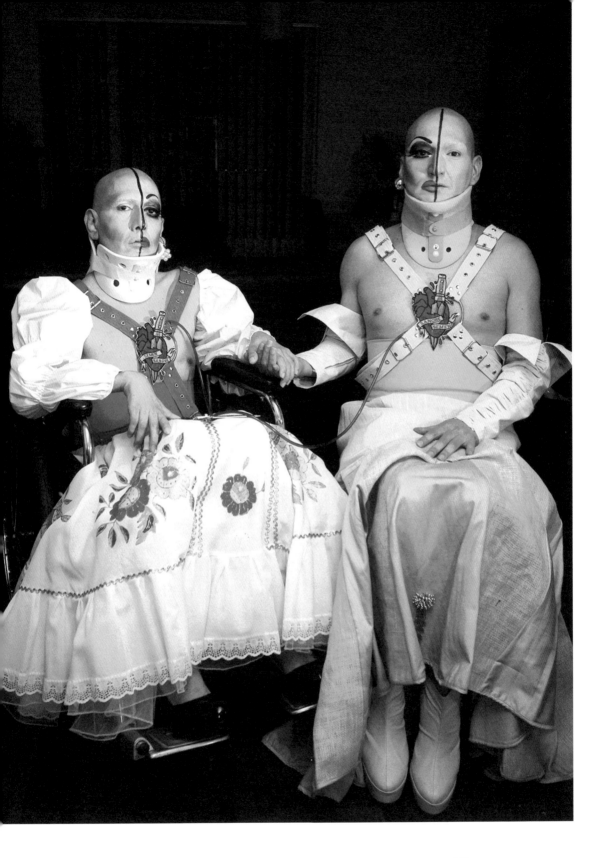

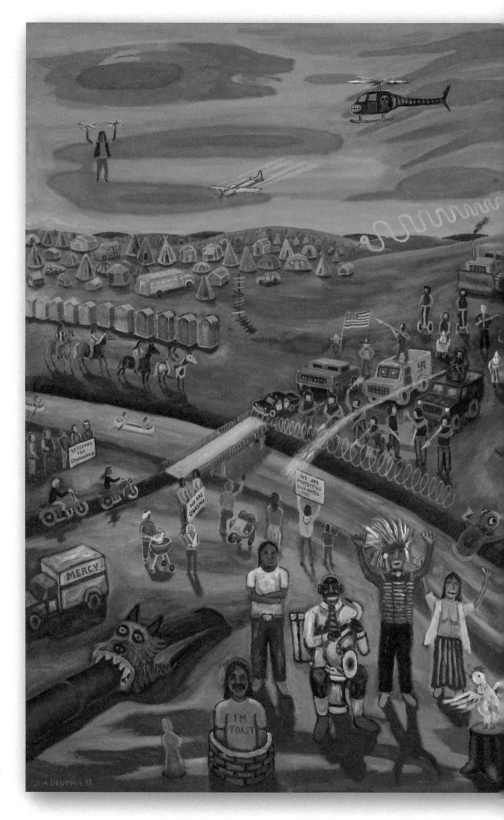

Jim Denomie, *Standing Rock 2016* (2018) • COLLECTION OF MINNEAPOLIS INSTITUTE OF ART • COURTESY OF THE JIM DENOMIE ESTATE AND BOCKLEY GALLERY

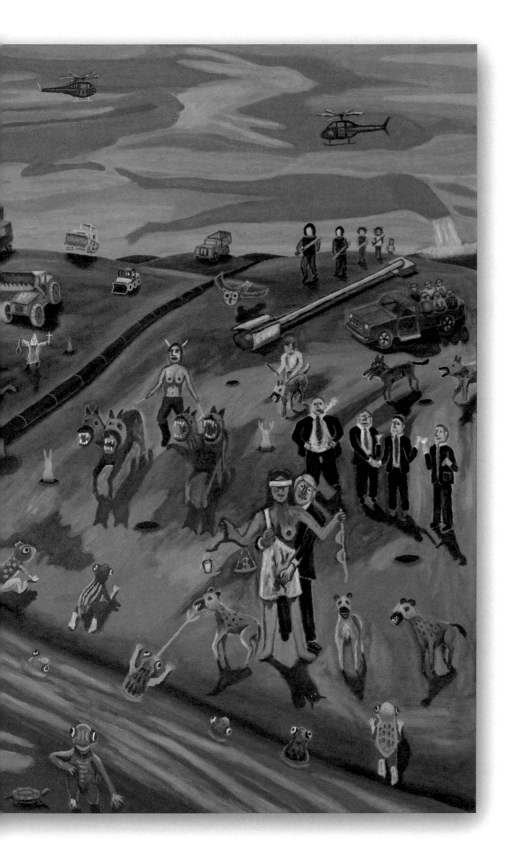

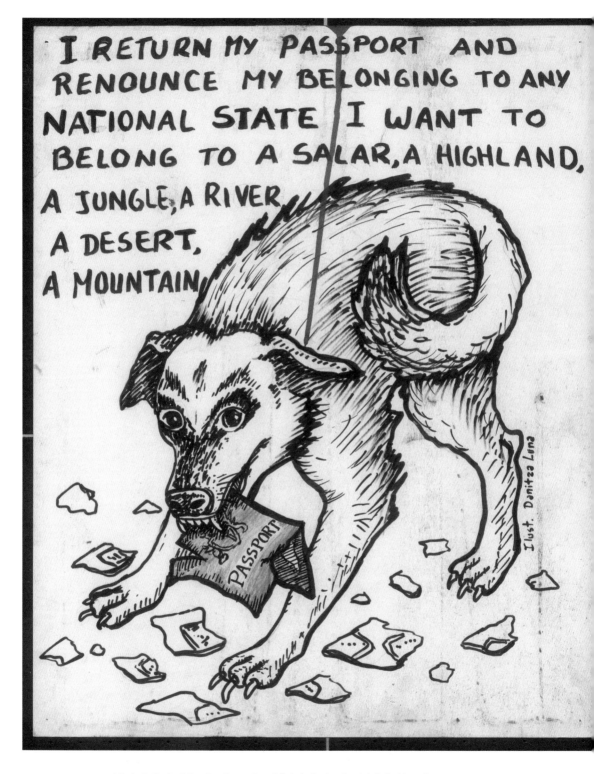

María Galindo & Danitza Luna, *La piel de la lucha, la piel de la historia*
[The Skin of the Fight, The Skin of History], 2019 • COURTESY THE ARTISTS

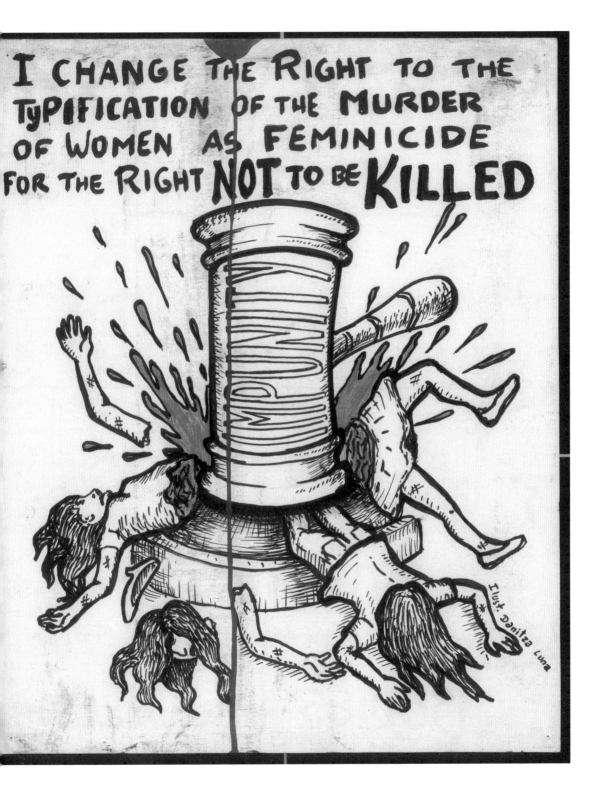

I CHANGE THE RIGHT TO THE TYPIFICATION OF THE MURDER OF WOMEN AS FEMINICIDE FOR THE RIGHT NOT TO BE KILLED

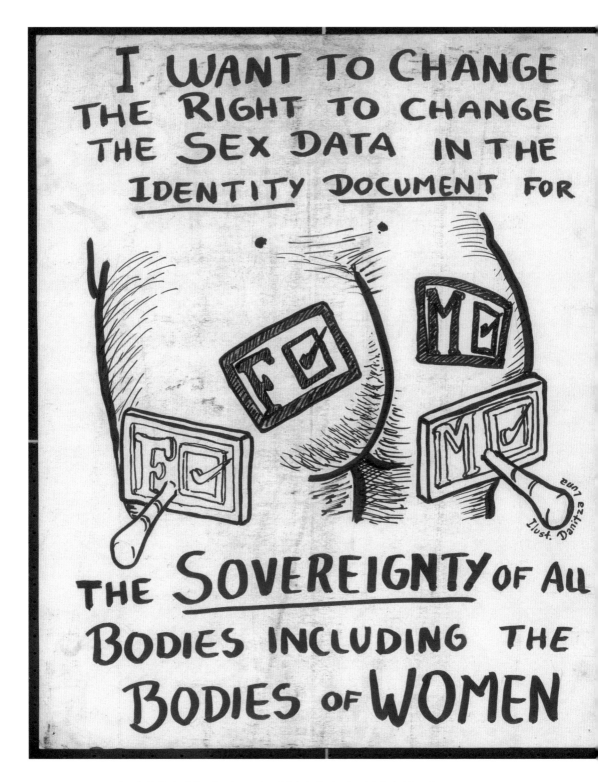

María Galindo & Danitza Luna, *La piel de la lucha, la piel de la historia*
[The Skin of the Fight, The Skin of History], 2019 • COURTESY THE ARTISTS

I WANT TO RETURN THE PACK OF THE SO CALLED WOMEN RIGHTS NOT ONLY BECAUSE THEY ARE RHETORICAL, BUT ALSO

WOMEN RIGHTS

Ilust. Danitza Luna

BECAUSE FEMINISM IS NOT A PROJECT OF RIGHTS

Patricia Belli, *Máscara ojos* [Eyes Mask], 2004, *Máscara boca* [Mouth Mask], 2004 •
COURTESY THE ARTIST AND CARLOS MARSANO, LIMA

Patricia Belli, *Nidos de lagrimas* [Nest of Tears], 1997 •
COURTESY THE ARTIST AND PRIVATE COLLECTION

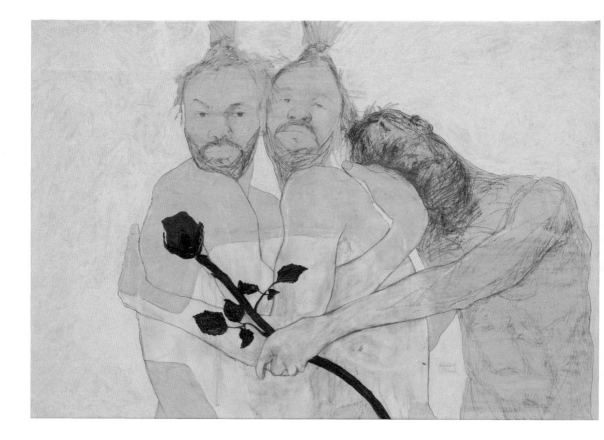

Amoako Boafo, *Me, Me and Me*, from the series *Detoxing Masculinity*, 2017 •
COURTESY AMOAKO BOAFO STUDIO, ACCRA

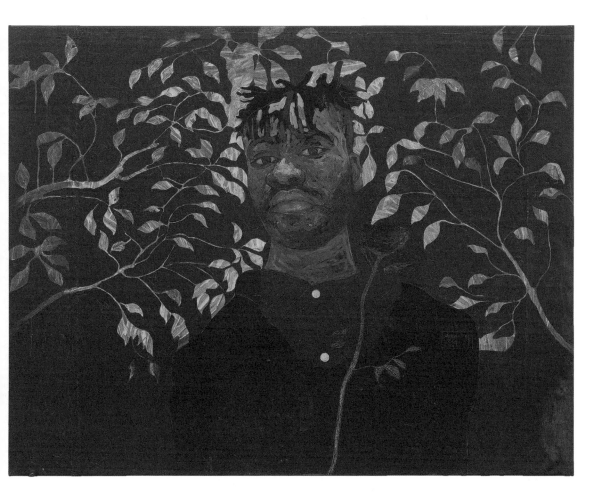

Amoako Boafo, *Gold Plant*, from the series *Detoxing Masculinity*, 2017 •
COURTESY AMOAKO BOAFO STUDIO, ACCRA

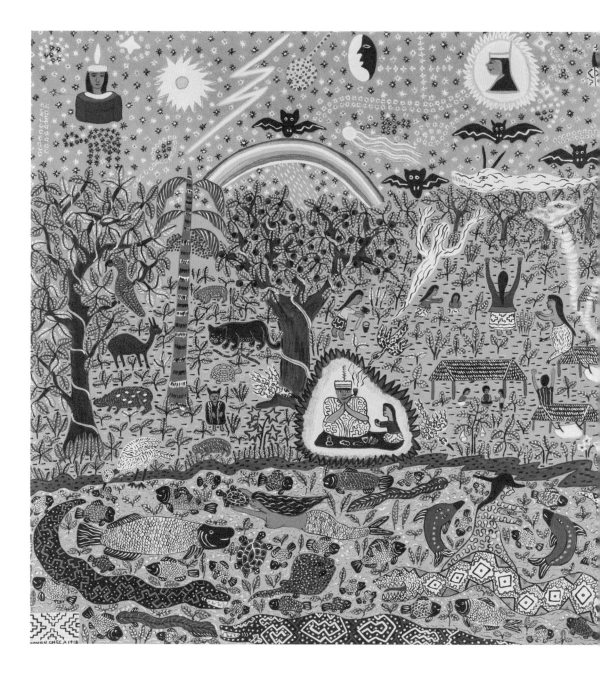

Roldan Pinedo, *La cosmovisión de los tres mundos Shipibos* [The Cosmovision of the Three Shipibo Worlds], 2018 • COURTESY THE ARTIST AND PRIVATE COLLECTION

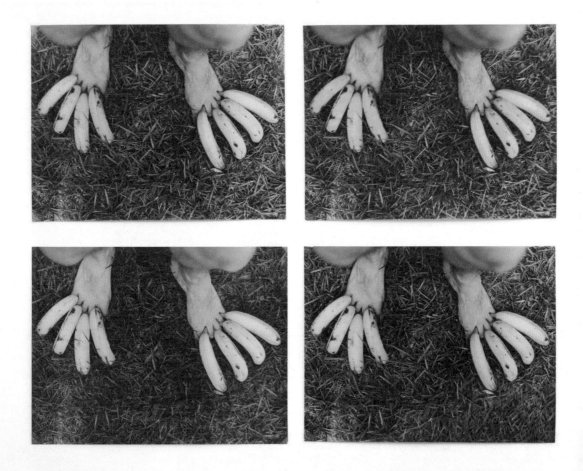

Victoria Cabezas, *Sin título* [Untitled], 1973 • COURTESY THE ARTIST AND PRIVATE COLLECTION

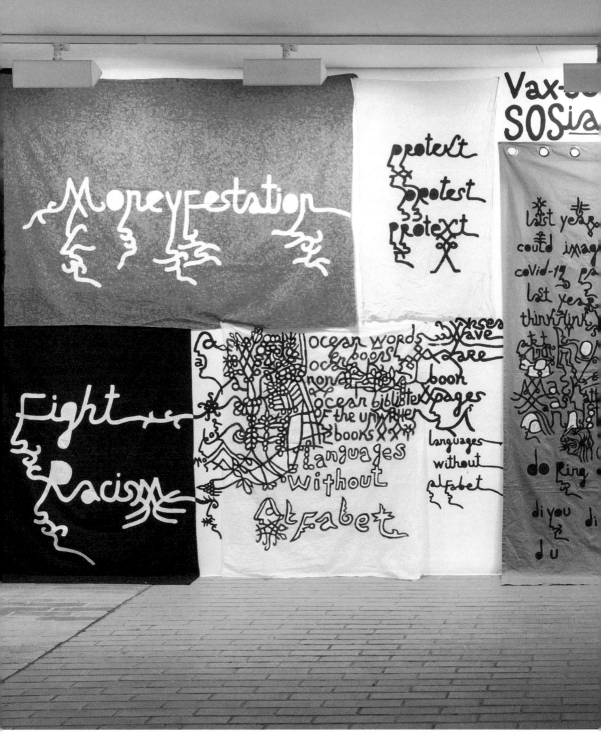

Babi Badalov, *M–otherland*, 2021

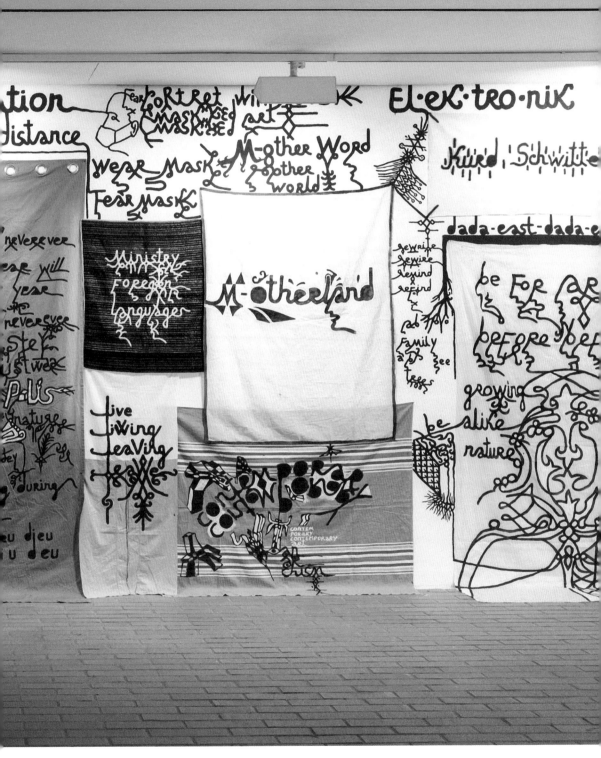

Installation view: *And if I devoted my life to one of its feathers?*, Kunsthalle Wien 2021

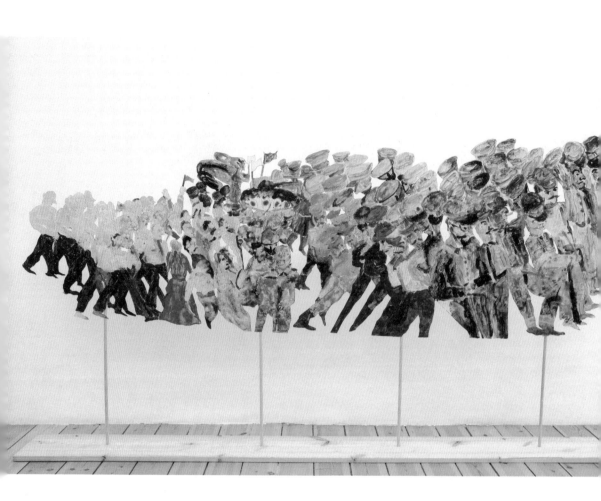

Anna Boghiguian, *Procession*, 2017
RIGHT: *Untitled*, 2016 • ALL COURTESY THE ARTIST AND KOW, BERLIN

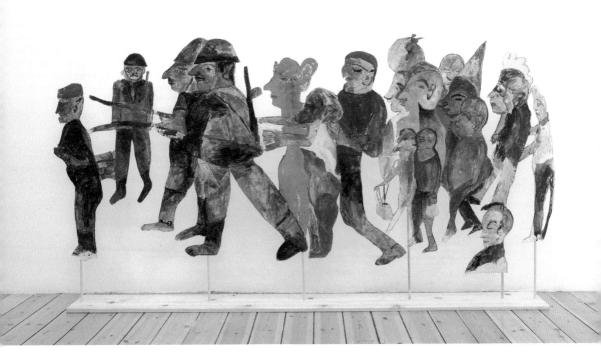

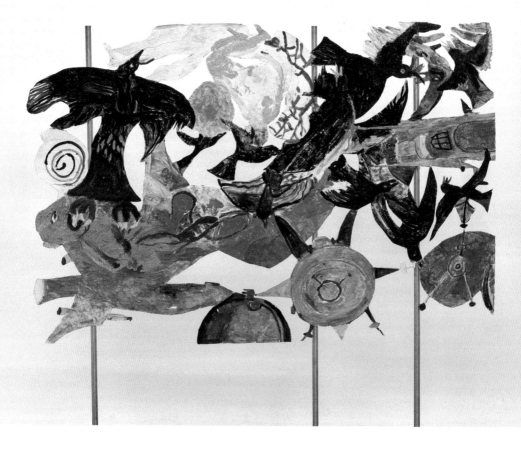

Anna Boghiguian, *Birds and men apocalypse*, 2017 • COURTESY THE ARTIST

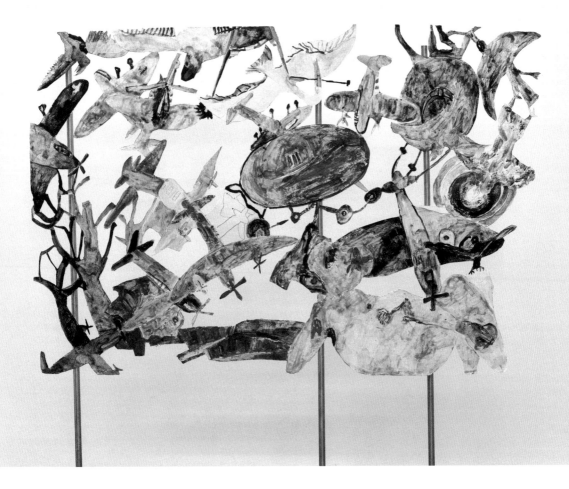

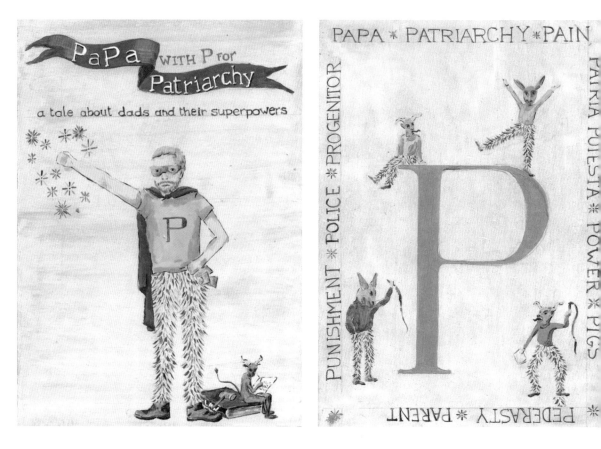

Daniela Ortiz, *Papa, with P for Patriarchy*, 2020 (selected pages) •
COURTESY THE ARTIST AND ÀNGELS BARCELONA, BARCELONA

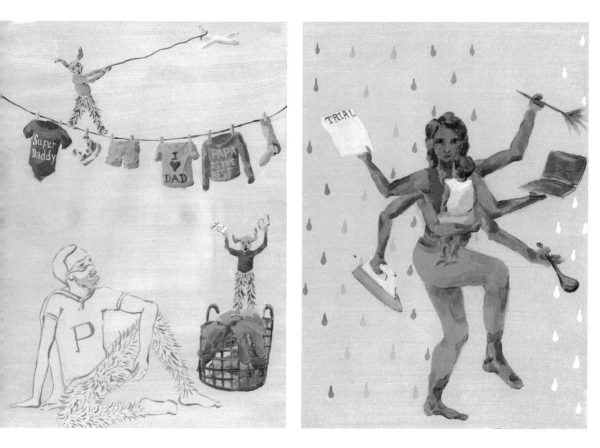

Daniela Ortiz, *Papa, with P for Patriarchy*, 2020 •
COURTESY THE ARTIST AND ÀNGELS BARCELONA, BARCELONA
Installation view: *And if I devoted my life to one of its feathers?*, Kunsthalle Wien, 2021

White European **TOURISTS** can **TRAVEL** to our **TERRITORIES** without any visa and spend little money because of the global colonial economic order. When we **TRAVEL** to their countries and try to live there they control us, and we are forced to use a **TAG** with a GPS **TRACKER**.

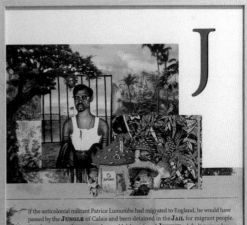

If the anticolonial militant Patrice Lumumba had migrated to England, he would have passed by the **JUNGLE** of Calais and been detained in the **JAIL** for migrant people. Or, after entering the territory, he wouldn't have found **JUSTICE** while living under the profitable housing system for asylum seekers run by the company **JOMAST**.

Amanda Piña, *Danzas climáticas* [Climatic Dances],
from the series *Endangered Human Movements*, 2019–21

Amanda Piña

The Movements of the Feather in the Hand of the Shaman

Shortly after her exhibition at the Musée des Arts Décoratifs du Palais du Louvre in 1964, a journalist interviewed Chilean artist Violeta Parra in her studio in Switzerland. In that famous video, she asked the artist:

> *"Violeta, you are a poet, a musician, you make tapestries, you paint ... If I gave you the choice of only one of these means of expression, which one would you choose?"*

When thinking about how to answer the question posed by Cecilia Vicuña's poem, the title of this exhibition and trigger for this text, this video came to mind.

What would I choose?

Inspired by these powerful artists and humbly in line with their genealogy, I call upon them, and my hands, our hands, which start moving over the keyboard and so I start writing:

If I devoted my life to one of its feathers, I would devote my work to that which is impossible to understand with human logic, with modern colonial ontologies, with scientific methods. I would devote my life to that which is not taught at the universities, the schools, the academies; to the movements of the feather in the hand of the shaman, the singer, the healer, caressing the immaterial, the invisible. I would dedicate my work, my life, to the practice of remembering those movements.

I would strive to understand or over-stand, or sense-think, taste and touch, the knowledge of our elders, the Mara'akames, the Mamos, "las abuelas," the Pajés, the Altomisayocs, the Machis. I would practice this act of remembering, by reactivating those dances as fossils of experience (warmed again, alive again, in other bodies and other places).

In art and life, with no romanticism, swimming in oceans of micro-plastic, breathing the toxic emanations

EDITOR'S NOTE:
Violeta Parra (Santiago de Chile, 1917–67) was a composer, singer-songwriter, ethnomusicologist, and visual artist. She contributed to the reinvention of Chilean folk music. In 1964, Parra presented an exhibition of paintings, arpilleras, and sculptures at the Museum of Decorative Arts Louvre, the first solo show of a Latin American artist at this institution.

of carbon and burned oil. Drinking the poisoned waters of mining extraction and even more so, even stronger then, when the earth is turning inside out, and the warmth originally inside now spreads through the atmosphere. Burning like her and with no hope, but hips, but love for the living rhythms, I would dance the old/new dances, and allow those movements to reappear, strengthening my body and soul, our bodies and souls, our will to share, to lift this dance together.

Feathers, which already existed 250 million years before birds first flew, at the beginning were small and tufty, as they were meant to keep animals warm. In the disembodied world of a technology that creates sacrifice zones, for powering the machines available as fresh blood for the white world north, I think of the feather as the warmth of communal bodies, bodies of joy, of pleasure, bodies of knowledge, of shared experiences, bodies that know through identification, sensation, dream, and touch, and not through distance and separation.

As a counterspell for the artificial warmth of this technology, powered by the extraction of gold, silver, copper, lithium, rare earth metals, I choose to embody the big condor flying over the mountain. And to devote my life to the earth-being that this mountain is returning to be: Apu Wamani.

To those forms of knowing, I would devote my life. To always return stamping the ground, dancing together, encountering through art and ritual, mostly inventing. By dreaming that which cannot be remembered. Faking it alive again (fake it till you make it!) in the future that is also the now, the time/place, in which ancestors remind us who we are: merging bodies of people, animals, plants, stone and river, ocean and forest, cave, source, estuary and fjord, volcanoes, clouds, storms, bodies of earth, bodies of water.

In the face of the monstrous war machines that are already mining the oceans, mountains, and forests. Facing the drought, the poisonous toxic future of my mother's home. In the face of all sacrificed zones, I would not choose to resist, but to escape! The logics that create this destruction. As an escapist: *Mandrake el mago*, I would devote my life to rehearsing the disentanglement from the chains of the one-world default forms of thinking.

To the people and communities that are sacrificed to fuel, the fake bonfire of progress, of technological advancement, fake smiles, fake wealth, fake progress, fake technology, fake advancement. To my people, people-earth and people-people, Tira Kuna and Runa Kuna, whose bodies are the sacrifice zone, I would dedicate this feathered dance.

"I would choose to stay with the people."

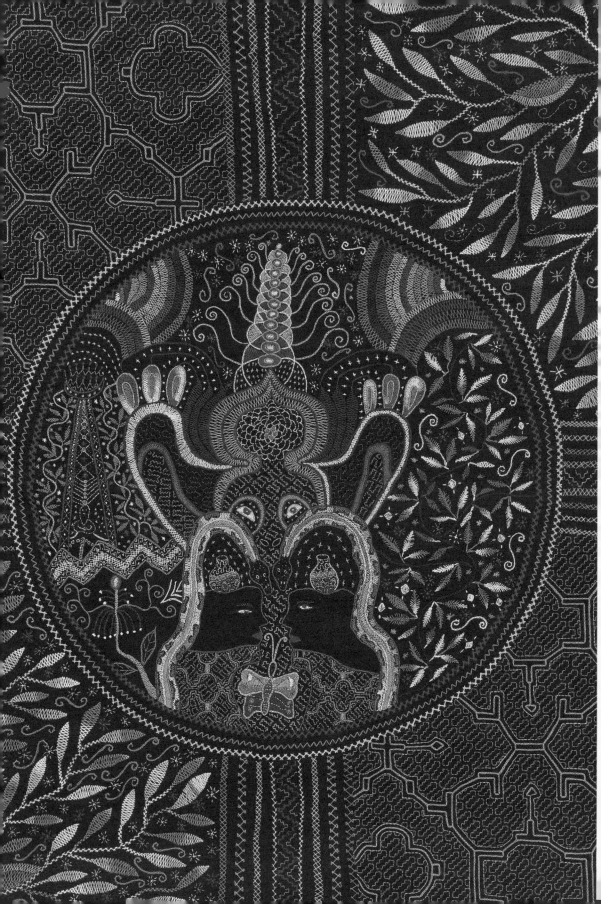

Olinda Silvano / Reshinjabe

Creating with Feathers

For me the feather is very important because we fly with feathers. This way, flying, we have reached other places, migrated to Lima: from the rainforest to the capital. And we have been able to get to know more, flying, carrying our culture.

Creating with a quill means our fingers that paint and embroider; it is the art that you breathe and that you love.

Feathers are wings. Wings make us fly. Just like birds who fly freely without anyone stopping them, singing. If you like to sing, you can sing. If you like to come down, you can come down; they are free, pure, they breathe.

Feathers are the art that we inspire, the cosmovision of the Shipibo people. We create with bravery, with courage, with love.

Devoting our life to feathers is the image of us painting with our fingers.

Feathers are also the mother plants. The forest holds a hidden pharmacy which, in times of Covid-19, is curing us. In these times, plants such as the matico tree, the eucalyptus tree, kion (in Peruvian Spanish), or ginger, but also garlic and onions, have given us drinks that have saved our lives. My son Ronin was by my side during these times.

Art has also given us a space for therapy. For this reason, we won't stop creating.

Olinda Silvano / Reshinjabe, *El espíritu de las madres plantas* [The Spirit of the Mother Plants] (detail), 2020 • COURTESY THE ARTIST AND PRIVATE COLLECTION

At the beginning of the pandemic, they told us: "don't get together, don't get together." But being hidden and tucked away at home traumatizes you even more. Instead, creating in community and in union made us stronger as we continued to ingest our plants. I was saved thanks to the people who gave me a hand.

That is what art is, what feathers are; without art we wouldn't be complete. Art completes us. And it also completes other practitioners—doctors, lawyers …, because art informs us of what we have persevered, of what we have experienced, of our past.

I believe in the power of plants because of what I have experienced in my life. My grandfather bestowed on me an invisible

crown. When I was born, Peri-Peri was placed inside my navel, so my body was hypnotized. And so, a few years later, I began to do Kené art. Kené was always with me because I was already cured.

Sometimes we don't know what talents we have, but we'll discover all of them along the way and we'll enjoy them. I like to make art by talking to people. It's the talking that gives art its value.

Feathers don't have weight, they make you feel as light as cotton. I like talking about how I feel and about how it has changed my life. It is art that has changed my life. The places where my husband had taken me, art took me as well.

Feathers are spreading all around and so am I; all of a sudden, I am in Russia, Canada, Mexico, Spain. Because I am not ashamed of my roots and of who I am. I go with my face painted, with my necklaces on, that's my ID. And when you land at the airport, you are unique and so everybody wants to take pictures. You are not like the others.

Feathers bring you to different places. But if you don't have feathers you'll stay there, you can't fly. Art is very important and that's where the feathers are. Art is life, it is joy. You may face problems in your life, but art will keep you company.

Because it keeps you alive, cures you, helps you, it saves your life. And especially for women, art has been our true loyal partner. You yourself are art; it will continue to inspire you, it will continue to lead you, it will continue to empower you. Like a chain of encounters, as Peruvian anthropologist César Ramos used to say: we have to build networks, not be selfish. We have to bear fruit like a tree that grows so that others can enjoy it too. It is for sharing. We have to bear fruit, be that fruit and its seed which grows again and again, and we have to accompany it.

I am not eternal. At any moment I will leave, but the people that have worked with me will remain in creations and knowledge. That knowledge will not perish, it will continue, it will always be present.

TRANSLATED BY Daphne Nechyba

Runa: Human but Not Only

Marisol de la Cadena

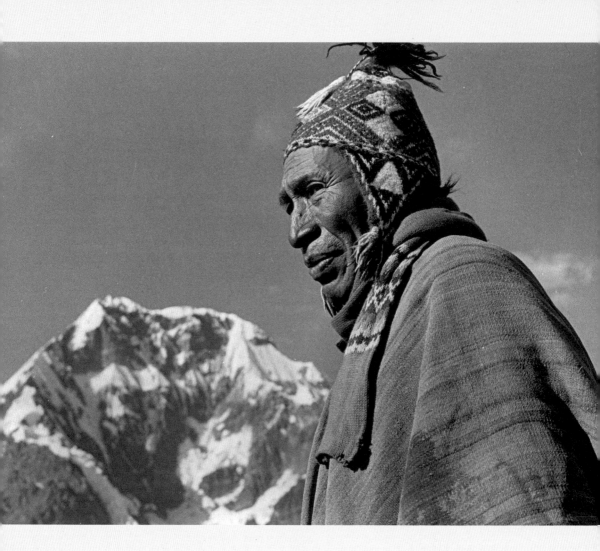

Mariano Turpo with Ausangate mountain, ca. 1960

I once told a customs agent who was quizzing me about the purpose of my presence in the UK that I was there to talk about mountains that were *not only* such. A bit taken aback, but also trying to show that he understood, he asked: "Sacred mountains?" I responded cryptically: "That too, but again, *not only such.*" He smirked, sealed my passport and I left giggling silently. An inconspicuous if common phrase, I learned to use *not only* as an ethnographic conceptual tool in conversation with Mariano and Nazario Turpo, a Quechua father and son. They insisted that what to me *was* (for example, a mountain) was *not only* that. Coming to terms with what was *not only*—what to me *was*—in addition to taking time, required working at a permanent interface (a mutually inhabited relation) where the Turpos' worlding practices and mine were both seemingly alike, yet at the same time different. And what emerged at the interface, rather than the entity or practice in question, was the awareness that our concepts and ways always exceeded each other as they also overlapped: relationally mutually other and *not only*, relentlessly so. In what follows, I will offer you the explanation that I left that customs agent without, and although I go into the sixteenth century momentarily and in speculative mode, I promise to connect it back with the ethnographic moment when I thought "sacred mountains but *not only.*"

> *It is impossible to take from them this superstition because the destruction of these* guacas *would require more force than that of all the people of Peru in order* **to move these stones and hills***.* (Cristóbal de Albornoz, 1584; emphasis added)

This sixteenth-century quote by Cristóbal de Albornoz belongs to the process I am calling the anthropo-not-seen. I conceptualize the anthropo-not-seen as the world-making process by which heterogeneous worlds that did not make themselves through the division between humans and nonhumans—nor necessarily conceived as such by the different entities in their assemblages—were *both* obliged into that distinction *and* exceeded it. The anthropo-not-seen was the process of destruction of these worlds *and* the impossibility of such destruction. It includes the practices and practitioners of the will that granted itself the power to eradicate all that disobeyed the mandates to be "human" as modernity in its early and late versions sanctioned—and the disobedient practitioners of collectives composed of entities recalcitrant to classification as either human or nonhuman.

The obvious initial makers of the anthropo-not-seen were people like Cristóbal de Albornoz—a friar well known for his activities to "extirpate idolatries," one of the practices through which the New World emerged as inhabited by redeemable humans and nature—all God's creations. Earth-beings is my translation for *guacas*, the entities de Albornoz wanted to destroy. I met them as *tirakuna*. The word tirakuna is composed of the Spanish *tierra* and the Quechua pluralization *kuna*. So *tierras* or "earths" would be a literal translation. Intriguingly, de Albornoz translated guacas as "stones" and "hills" and identified their enormousness as the cause

of the difficulty to eradicate what he considered a relationship of false beliefs. The extirpator's surprise and anxiety did not end with the enormity of the idols, for he also found out that people, while different from guacas (what de Albornoz called "stones" and "hills"), were also *in continuity with them*, and could even become one. I want us to take this surprise into consideration, for the possibility of becoming guaca (translated by colonial friars and contemporary scholars as "becoming rock") speaks of the divergence between "Spanish humans" and "Andean people," or *runakuna*, in spite of their also apparent similarity. In addition to replacing allegedly spurious beliefs with legitimate ones, the sixteenth-century practice of extirpating idolatries might have included displacing the relational possibility of Andean people/runakuna becoming *with* guacas, with a theological relational grammar that conceived of humans as distinct from nature. The friars' mission might have required *making* the human that conversion needed—for this human was not what the friars actually encountered, as runakuna could become with tirakuna (or even become one!).

The colonial European expansion denied humanity to its other—that is a usual assumption. But what if this were *not only* the case? The famous mid-sixteenth-century debate in Valladolid, let's remember, did not cast doubts about the humanity of New Worlders; the discussion was about the kind of humans Indians were and the kind of treatment that would best suit Spanish moral and economic interests as they converted them to Christianity. Neither of the two most prominent contenders, Sepúlveda or Las Casas, doubted that Indians had souls—rather, it was their having souls that made them potential preys of the Devil; defeating the danger required the eradication of Indians' idolatrous practices, including their becoming guaca. As he wraps up *The Order of Things*, Foucault writes: "Taking a relatively short chronological sample within a restricted geographical area—European culture since the sixteenth century—one can be certain that man is a recent invention within it."[1] Expanding Foucault's Europe to its recently conquered territories, my proposal is that in the Andes the emergence of Man might have implied a colonial imposition (not the denial) of Christian humanity on runakuna, which entailed "extirpating" not the idols alone, but with them, forms of personhood that could be continuous with guacas. Disobedient persons (or humans whose continuity with stones was enabled by the Devil) were persecuted and condemned to jail, death, and hell. The practice, not surprisingly, coincided with the critical period of the persecution of witches and so-called werewolves in Europe—perhaps also Christian-human-making practices.

Befuddling the friars, the Andeans' disobedience—runakuna with tirakuna—continued, while also changing historically. Today, 500 years after Cristóbal de Albornoz, earth-beings confront new eradicators: mining corporations. Agents of the Anthropocene, they translate tirakuna as mountains and a source of minerals, and therefore wealth. Unlike their colonial counterparts, they have the power to remove mountains, redirect rivers, or empty lakes. In earlier work, I explained that in protesting these extractive practices, earth-beings have broken into the public political scene as "contentious objects whose mode of presentation is not homogenous with the ordinary mode of existence of the objects

1
Michel Foucault, *The Order of Things: An Archaeology of the Human Sciences* (London: Routledge, 1989), 421.

thereby identified."[2] Earth-beings as actors in the public sphere push the ontoepistemic limits of politics—a scandalous presence, they need to be trivialized, mocked. I stay faithful to what I said then. However, today I would also extend the contentiousness to the runakuna with whom tirakuna are made public. Runakuna are also not homogenous with the ordinary mode of existence attributed to humans—they are contentious to it, for in *ayllu* they emerge inherently with tirakuna.

> The Andean ethnographic record is replete with references to ayllu, defined as the collective possession of land by a group of humans linked by kinship bonds. Obeying the grammar of conversion, ayllu here has three distinct actors: humans, land, and the relationship between them. I say that ayllu is this institution and *not only*. Thinking with disobedient grammars—ayllu is also a relation through which runakuna *with* tirakuna take place (that is, they become in time and space) as a complex entity, a more-than-one, less-than-many composition, inherent to which is the relation that enables it. As Donna Haraway says, it is important what relations think, relations that think entities![3] (She takes this phrase from Marilyn Strathern.) And now, I want to say what I had not said in earlier work: runakuna are contentious because as they become with earth-beings in the public political sphere, they are human—and *not only*. Being inherently with earth-beings, when they appear in politics, their composition is *not only* that of humans representing mountains. Contentiously, they make present the Christianity declared could not be, the anthropo-not-seen, the human with that which the person—so-called *human*—could not be.

"I firmly believe that we have *never* been human, much less man." This is a phrase in the introduction to *The Haraway Reader*;[4] "We Have Never Been Human" is also the title of the first section of *When Species Meet*.[5] Others have discussed similar ideas—for example, in 2011, Dorion Sagan delivered a talk at the American Anthropological Association with the title "The Human Is More Than Human." My title for this talk, "Runa, Human but *Not Only*," is a fellow traveler of those ideas; it bears similarities with Haraway's and Sagan's titles; yet my purpose is also other. For example, the human that Sagan's work evokes is—like in the usual ethnographic definition of ayllu—one that can be relationally separated from or brought together with the nonhumans that he also evokes. Runakuna and tirakuna are *not only* this human and nonhuman. A caveat to avoid misunderstandings: I am not saying that Sagan is wrong. My purpose is not to "correct" his statement; rather it is to contrast and genealogically connect the more than human or the nonhumans of those titles and their excess: the disobedient tirakuna *with* runakuna whose joint personhood is enabled in a way that geology and biology, respectively, do not exhaust.

I first thought "human *but not only*" when requested to write a comment for *How Forests Think*, Eduardo Kohn's inspiring book.[6] A passage in that book slowed down usual understandings of

2
Marisol de la Cadena, "Indigenous Cosmopolitics in the Andes: Conceptual Reflections beyond 'Politics,'" *Cultural Anthropology* 25, no. 2 (2010): 342, quoting Jacques Rancière, *Disagreement: Politics and Philosophy* (Minneapolis, MN: University of Minnesota Press, 1999), 99.

3
Donna Haraway, *Staying with the Trouble: Making Kin in the Chthulucene* (Durham, NC: Duke University Press, 2016).

4
Donna Haraway, *The Haraway Reader* (London: Routledge, 2004), 2; emphasis added.

5
Donna Haraway, *When Species Meet* (Minneapolis, MN: University of Minnesota Press, 2008).

6
Eduardo Kohn, *How Forests Think: Towards an Anthropology Beyond the Human* (Berkeley, CA: University of California Press, 2013).

human and nonhuman—it read: "Runa [the people with whom he worked] [...] understand *human and nonhuman sociality as one and the same thing*."[7] Confirming my need to slow down was the condition whereby a runa—a person that we would call human—could be "with jaguar"; the phrase is *pumayu* (the suffix *yu* indicates "with") and vice versa indeed since jaguars are also persons. He also wrote that "Were-jaguars—runa puma, or runa persons—are also dogs."[8] He called all these conditions "trans-species pidgins" and I agree. But *not only*—I insist because, I repeat, "it matters what concepts we think to think other concepts with,"[9] and where worlds meet. "Species" may open up to partial connections with entities whose relational becoming is *not only* as species—at least not in their biological version, no matter how complex and non-Linnean these might be. Donna Haraway writes, "in my view *people* are human in at least one important sense. We are members of a biological species, *Homo sapiens*. That puts us solidly *inside science, history, and nature, right at the heart of things*."[10] Haraway's sentence may also open up to *excesses* of science, history, and nature, and thus to other than *Homo sapiens* ways of being people or *gente*, in Spanish. The in-distinction between human and nonhuman sociality suggested by pumayu—the composition runa-with-jaguar—or, in the story I tell, earth-beings-with-runakuna, may also suggest that those entities are *not only* human and nonhuman in their Christian or biological versions.

Another example: Davi Kopenawa, famous Yanomami shaman and Brazilian politician, in his recent book writes: "today we are still the same kind as those to whom we give the name of game [...] our inner part is identical to that of game [...] [W]e *only attribute to ourselves the name of human beings by pretending to be so*. Animals consider us their fellow creatures who live in houses, while they are people of the forest. This is why they say, 'humans are the game that live in houses.'"[11]

These are neither isolated examples, nor restricted to the Andes or Amazonia. In an article suggestively titled "Not Animal, Not Not-Animal," Rane Willerslev, an ethnographer of Siberia, explains that the Yukaghir hunter (usually a man) seduces his would-be prey (let's say an elk) by becoming it—but does so *incompletely* to maintain sight of his own personhood and thus avoid becoming irreversibly the elk he is after.[12] Caveats once again: First, I am not talking about a pan-indigenous human capacity to actually become animal—rather, I rethink the relational conditions that make those notions (human and animal) distinct, and the embodied grammar that those conditions enforce, to propose that while currently hegemonic, they were also created as part of a universal order that was *not only* obeyed. Second, the Turpos, the Runa people that Kohn worked with, the Siberian Yukaghir, and Davi Kopenawa are not saying or doing the same thing—yet they all disobey human, animal, and plant taxonomic distinctions and exceed society thus made, *while also being part of it*. The human-with-jaguar pumayu, the hunter that needs to remember he is not the elk that would be his prey, or

7
Kohn, *How Forests Think*, 138; emphasis added.

8
Ibid.

9
Haraway, *Staying with the Trouble*, 118.

10
Haraway, *The Haraway Reader*, 2; emphasis added.

11
Davi Kopenawa and Bruce Albert, *The Falling Sky: Words of a Yanomami Shaman*, trans. Nicholas Elliot and Alison Dundy (Cambridge, MA: Harvard University Press, 2013), 386–87; emphasis added.

12
Rane Willerslev, "Not Animal, Not Not-Animal: Hunting, Imitation and Empathetic Knowledge among the Siberian Yukaghirs," *The Journal of the Royal Anthropological Institute* 10, no. 3 (September 2004): 629–52.

the human as the game that lives in houses are both the "we" that has never been human because it has always been an inter- or intraspecies relationship—and *not only* that "we." It may be this capacity to exceed society, to be unoccupied by it, while occupying it—even if at the margins—that makes runakuna and others like them affectively, that is politically, promising: impossible to society, yet dwelling within it and also beyond its limits, they are powerfully frightening. If we accept the challenge to think in their presence, they can offer the possibility for what I call ontoepistemic openings: in a nutshell, this means undoing the closures that make "the given," to consider it a historical event (in Foucault's sense) and open possibilities for what this event (that would replace what was thought as given) might not contain, while also being part of it. *Not only* the event human, mountain, animals as biology or geology—*also* its excesses.

To talk about runakuna as *not only* humans is disturbing—I can feel it. Anti-colonial anxiety haunts the idea and prevents further thought. Questioning the universality of nature to proceed with multinaturalism and provincialize nonhumans is easier than proposing an analogous conceptual move for humanity that avoids culture. But, in the spirit of the absolutely gargantuan task of decolonizing thought, I propose a question: could the egalitarianism intimated in the unqualified equivalence between "human" and runa—or other forms of being person—also carry the legacy of a colonial vocation that granted itself universal power to offer the human safe haven (sacred and also secular via universal rights), while banishing forms of personhood that this vocation could not recognize?

The anthropo-not-seen is a way of talking of those forms of personhood—not the invisible subaltern human, but the disobedient compound person-with-that-it-could-not-be: human but *not only*, the Yukaghir hunter that is not animal *and* not not-animal ... the elk that is not only animal, because it could also be the hunter. The anthropo-not-seen is a neologism that uses the opportunity of extractivist neoliberalism and the presence it has generated in Andean politics of unrecognizable beings, to provincialize the human and to uncommon nature, while also reckoning with the history that makes both (human and nature) globally hegemonic.

Not only—and also the anthropo-not-seen and uncommoning nature or the uncommons—are fellow travelers in what Marilyn Strathern called "negativities," the mode of analysis she used to take into consideration the absence (in Hagen, her fieldwork site) of certain categories; she then used such categorical absence to affect her analysis by creating contrasts within our own language. Absences, she said, "create spaces that the exogenous analysis lacked" and can be used to, in her words, "stop ourselves thinking about the world in certain ways."[13] Similarly, I use absences to affect our conceptual language; but I also wish to do something else, perhaps more prosaic. My use of negativities

13
Marilyn Strathern,
The Gender of the Gift: Problems with Women and Problems with Society in Melanesia, (Berkeley, CA: University of California Press, 1988), 11.

TOP: Máxima Acuña with her horse in Tragadero Grande, community of Sorochuco, Cajamarca, Peru

BOTTOM: Máxima Acuña with her daughter-in-law and granddaughter during a pottery firing by artist Aileen Gavonel, as part of the "HAWAPI 2019 – Máxima Acuña" project

—and particularly "not only"—is to indicate that epistemic assertions make presences (for example: nature and culture) that *may* (the conditional here is important) include the ontological denial, sometimes benevolent, yet always imperative, of what exceeds them. Ontoepistemic assertions—let's say nature—can *make* absent and impossible what does not fit them, while also creating room to tolerate those excesses. Once again, the historical moment is important: nature and humans are not absent from ayllu; yet in extractivist-corporate territory, their imperative assertion (by the state, the police, mining companies) makes impossible all that exceeds nature and humans and the relation that separates them. In the best of cases, that excess is made tolerable as cultural belief (a reality of second order), usually ignored but, as of late, also extirpated via its criminalization.[14] I will give you an example of the assertive will of a Peruvian ex-president to make impossible what does not fit within nature—exasperated in front of TV cameras he yelled out:

> [... we have to] *defeat those absurd pantheistic ideologies that believe mountains are gods and the wind is god.* [To believe that] *means to return to those primitive forms of religiosity that say do not touch that **mountain** because it is an **Apu** [a powerful earth-being] full of **millenarian spirit** or whatever. Ok, if we get there, we'd rather not do anything, not even mining.* (Alan García, former president of Perú, 2011;[15] emphasis added)

While speaking modern idioms that separate the sacred and the secular, the ex-president's words have uncanny resonance with the sixteenth-century extirpation of idolatries that de Albornoz practiced. A difference that the colonial friar might envy is that extractivist corporations can actually remove the object of superstition. Another difference, and this one de Albornoz might have not liked, is that current extirpators have non-indigenous opponents: Alan García's infamous remarks prompted disagreement from leading leftist politicians, who accused the then President of racism and religious intolerance, and defended the right of indigenous peoples to their spiritual beliefs. Yet when these politicians joined the defense of what they called "indigenous sacred mountains," the runakuna living in the surroundings of the endangered earth-beings, they vacillated to consider their relations with tirakuna as "religion." Were tirakuna sacred mountains? The answer was uncertain: maybe ... perhaps ... but *not only!* As you may now suspect, this was the moment I had in mind when I responded to that UK customs agent!

Negative qualifiers at the site of denials—a negation of the negation—may work as an ethnographic tool to open possibility for the presence of what the imperative assertion (of the given) made either absent or impossible. What the Peruvian ex-president and his leftist opponents asserted as indigenous religion (that is a relation between nature and humans), those that lived around the endangered earth-beings enacted *not only* as indigenous religion (that

14
Assimilation via rights of nature or personhood (of rivers, for example) is also a possibility— usually in adversarial relation with resource extraction; both positions, nevertheless, share metaphysics.

15
"Alan Garcia Perez (President of Peru 1985–90; 2006–11) against pantheistic absurd ideologies."
http://www.youtube.com /watch?v=2Vf4WfS5t08 accessed May 3rd, 2022.

is not only as a relation between nature and humans). Their intervention, even if hesitant and subordinate, disobeyed the partition that came along with the conversion of tirakuna and runakuna into mountains and humans and presented the relation between them intolerantly as superstition or tolerantly as worship of sacred mountains. The disobedience is a worlding event, a political ontoepistemic opening performing tirakuna *with* runakuna and *not only*, for such composition is also humans *and* mountains. This is a complex assemblage: each of the entities in its composition, and the worlding practices that make them, is more than just one of them—inseparably so. Dorion Sagan and Donna Haraway would say that in this assemblage, humans are more than humans and nature is more than nature—and Mariano and Nazario would add "not only." Included in the assemblage are tirakuna *with* runakuna!

Another caveat: earth-beings, or their translation into sacred mountains, are not a requirement for the emergence of disobedient political-relational processes where humans are *not only* such. In the northern Andes of Peru, a mining corporation wants to drain several lagoons to extract copper and gold. In exchange, it would build reservoirs, the company says. Organizing themselves as "guardians of the lagoons," local people defy the mining company's intentions—and many have died in the process. I have not heard of the presence of earth-beings. Yet a relation of "becoming with place" may help conceive of a situation that has been explained away as mere stubbornness.

One iconic guardian of the lagoons is a peasant woman whose plots of land the corporate mining project wants to buy to fully legalize its access to the territories it plans to excavate. The woman, whose name is Máxima, refuses to sell—and for an amount of money that she would probably otherwise never see in her lifetime. Countless times, the national police force, hired by the mine, has destroyed the family's crops and attacked Máxima and her children, even her animals. When I asked her how she can stand it, and why she stays, she responded: "What/how can I be if I am not *this*? [the word 'with' or 'land' is not uttered—instead feet are stomped, breaking apart clods of dry soil] *This is who I am, how can I go? Like they* [guards from the mine] *pull out my potato plants, they will have to pull me out. Have you seen a potato plant pulling itself out? I cannot* [pull myself out]—*I will die* [the word 'here' is not uttered] *who I am; with my bones I will be* [once again, 'here' is not uttered] *like I am now.*"

Modern politics portrays this woman as an environmentalist, and thus an enemy or an ally, depending on who speaks. Both detractors and supporters use what I have called the "grammar of conversion," albeit in a secularized way: they separate Máxima (the human) from the land (a natural resource) and then link both through a relation of property or possession, either legal or illegal. However, the "refusal to sell" may include another relation: one by which woman-land-lagoon (or plants-rocks-soils-animals-lagoons-humans-creeks-canals!) inherently become together: an entanglement of entities in need of each other in such a way that, pulled apart, they would become something else. Conceived through this relation, the refusal to sell may also imply the refusal of the grammar

that conceives entities as individual bodies, units of nature, or the environment—*which these entities are not when part of each other*. There are no earth-beings in Máxima's refusal; nevertheless, the impossibility of her separation from place also enacts what I have called "uncommon nature": an assemblage of entities intra-becoming with each other and refracting individuation in such a way that translating them into units would require the use of force—literally so. Uncommon nature simultaneously coincides with, differs from, and exceeds (also because it is *with* humans) the object that the state, the mining corporation, *and* environmentalists translate into resources—that which is exploitable or in need of defense. Thus, Máxima: she is staying because staying she *is*; the redundancy reveals the relation from which both place and Máxima emerge, one where she is not subject of the land, which in turn is not her object. Her response exceeds the logic of profit, certainly, and also that of the environment and its defense. If she is an environmentalist—and I think she is—she is *not only* such. When Máxima explains her being with the land in terms of impossible detachment, their *being together* through and with crops, rain, soil, animals—entities that make and are the relation—this explanation, I propose, exceeds the limits of the property concept, *but through which she, nevertheless, meets the mine in confrontation*. Of course, her words can be heard through a habitual subject-and-object grammar; but her silences—which in the above quote I filled in with words in brackets—also suggest that there is *not only* one grammar to her refusal to sell the land the mining company wants.

As a tool to perform ontoepistemic openings, the concept of "not only" suggests that entities, or even the order of things, may *also* be other than what they are. It is not a formula to add to a list. Rather, "not only" opens room for *presences* that could challenge what we know and the ways we know it, and that could even suggest the impossibility of knowing *without such impossibility canceling out those presences*—because "not only" allows entities to both *fold into* and *exceed* each other. Like the sacred mountain, mountain, and earth-being whose overlaps and intra-excesses made me think. Allowing for complex incommensurability, not only—and the other negativities: uncommons, the anthropo-not-seen—inhabit the a-plural vocation of Strathern's partial connections (more than one, but less than many). Yet "not only," like Haraway's cyborg, also works to indicate that *a relation can be an entity*, that is, the partial connection *as* entity: *not only* the coming together of two distinct entities—human *and* mountain, or Máxima *and* her land—but also an entity that *is not* without the relation that makes it. Máxima as an intra-*relational* becoming with that exceeds nature and human, because nature and human become together; the guardians of the lagoons (or ayllu) as uncommon nature, because uncommon nature includes humans, which, thus, are *not only* such: a monstrous emergence that challenges usual categories and opens life to possibilities beyond those categories *while also remaining with them*—imploding taxonomies, and also being with them. Relentlessly *not only*. ●

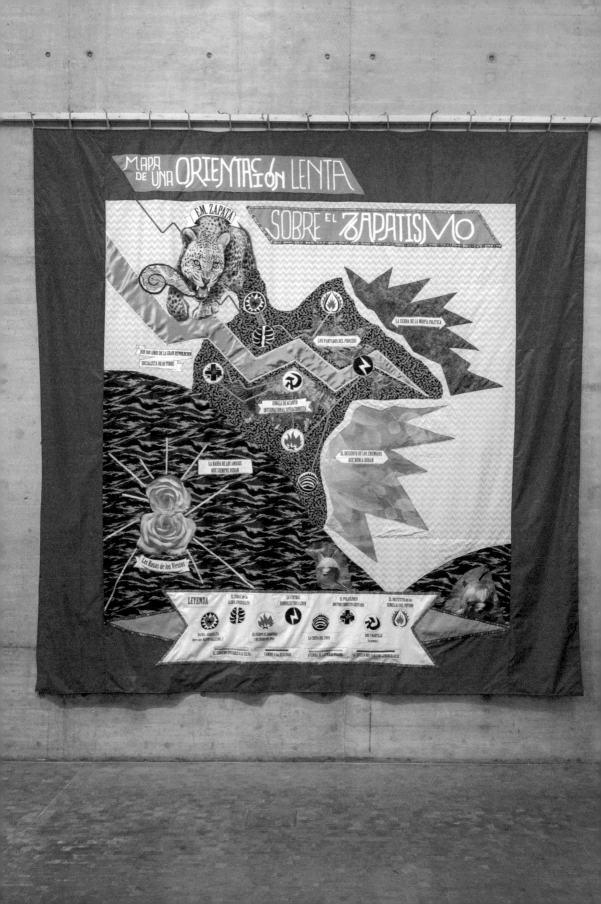

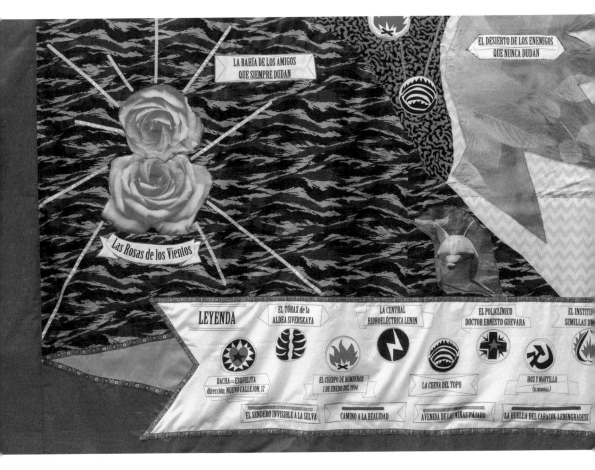

Chto Delat, *The Map for the Slow Orientation in Zapatism*, 2017
Installation view: *And if I devoted my life to one of its feathers?*, Kunsthalle Wien, 2021

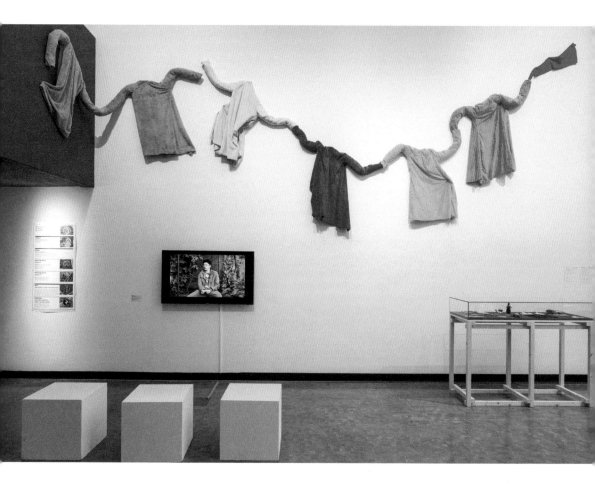

Chto Delat, *The New Dead End #17: Summer School of Slow Orientation in Zapatism*, 2017
Installation view: *And if I devoted my life to one of its feathers?*, Kunsthalle Wien, 2021

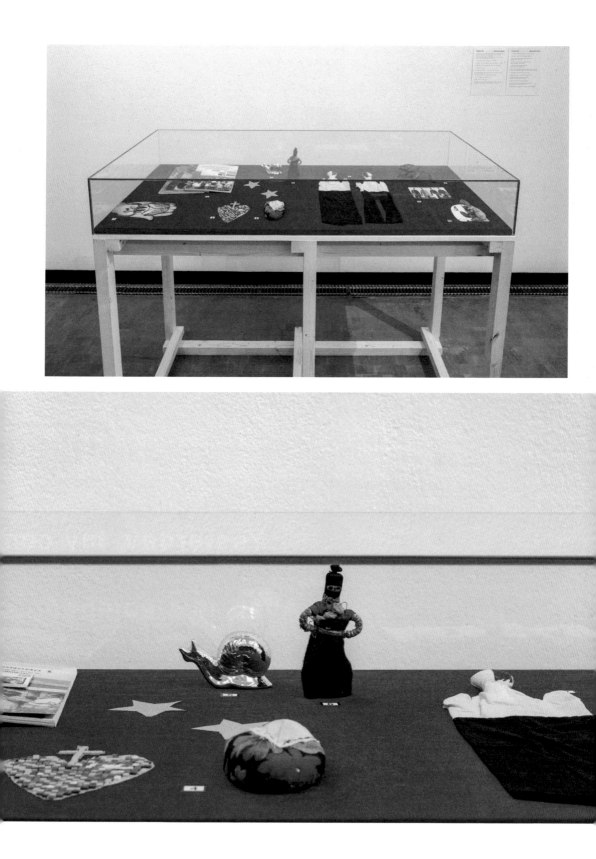

Yesterday, my com

Ayer, mis compañerc

Chto Delat, *The New Dead End #17: Summer School of Slow Orientation in Zapatism* (film still), 2017

s and I were talking

o estábamos hablando

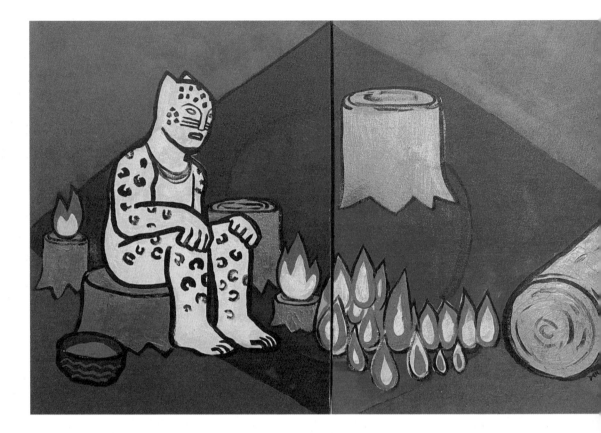

Denilson Baniwa, *Bye-Bye Brazil*, 2020 • COURTESY THE ARTIST

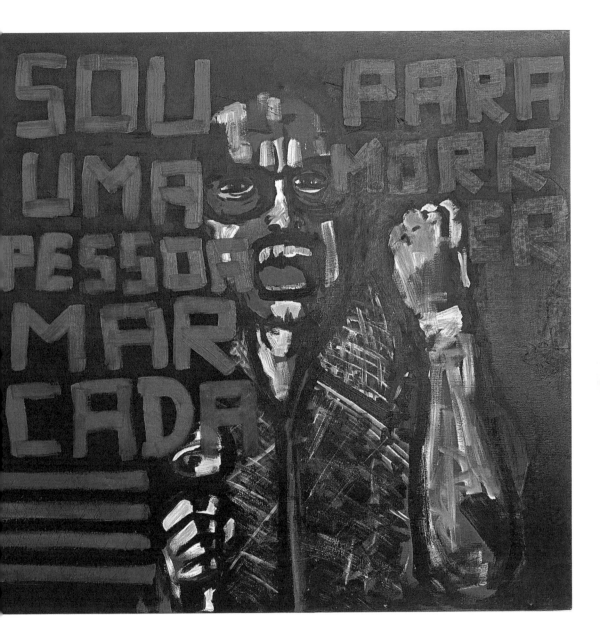

Denilson Baniwa, *Marçal Tupã ́Y*, 2017 • COURTESY THE ARTIST

LEFT: Nilbar Güreş, *Angry Palm*, 2020 • COURTESY THE ARTIST AND GALERIST, ISTANBUL
TOP: Nilbar Güreş, *Breasts by Rose*, 2020 • COURTESY THE ARTIST AND GALERIST, ISTANBUL

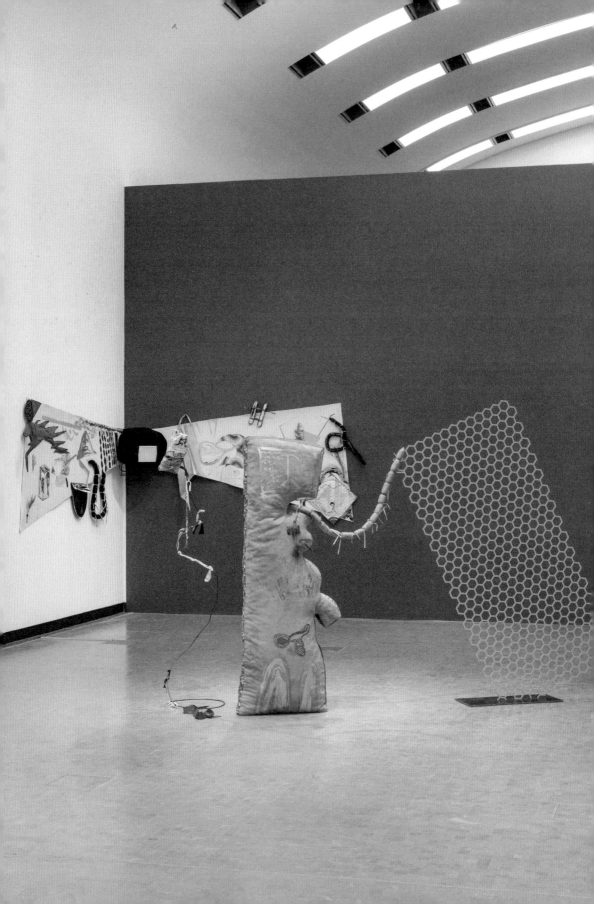

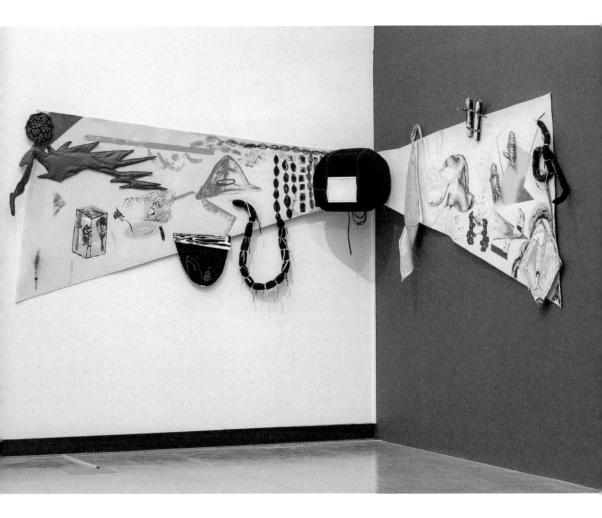

LEFT: Nilbar Güreş, *Monitor Head*, 2021; *Unmasking*, 2021 • COURTESY THE ARTIST AND
GALERIE MARTIN JANDA

TOP: Nilbar Güreş, *Monitor Head*, 2021 • COURTESY THE ARTIST AND GALERIE MARTIN JANDA

Installation views: *And if I devoted my life to one of its feathers?*, Kunsthalle Wien, 2021

113

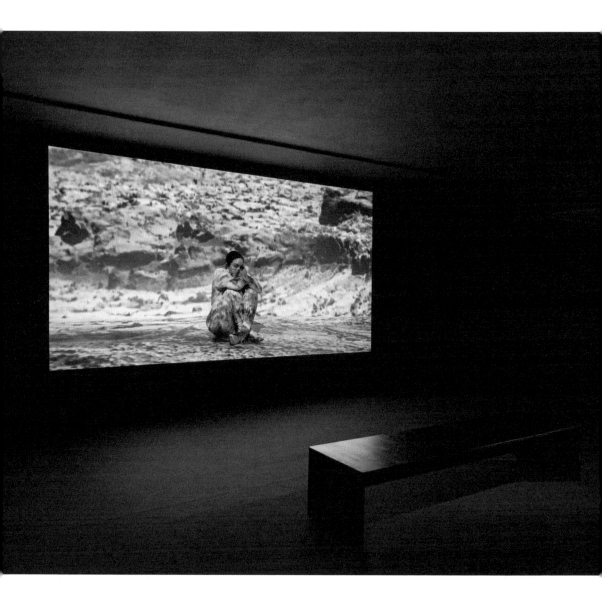

Amanda Piña, *Danzas Climáticas* [Climatic Dances], 2019
Installation view: *And if I devoted my life to one of its feathers?*, Kunsthalle Wien, 2021
RIGHT: Amanda Piña, *Danzas Climáticas* [Climatic Dances],
from the series *Endangered Human Movements*, 2019–21

114

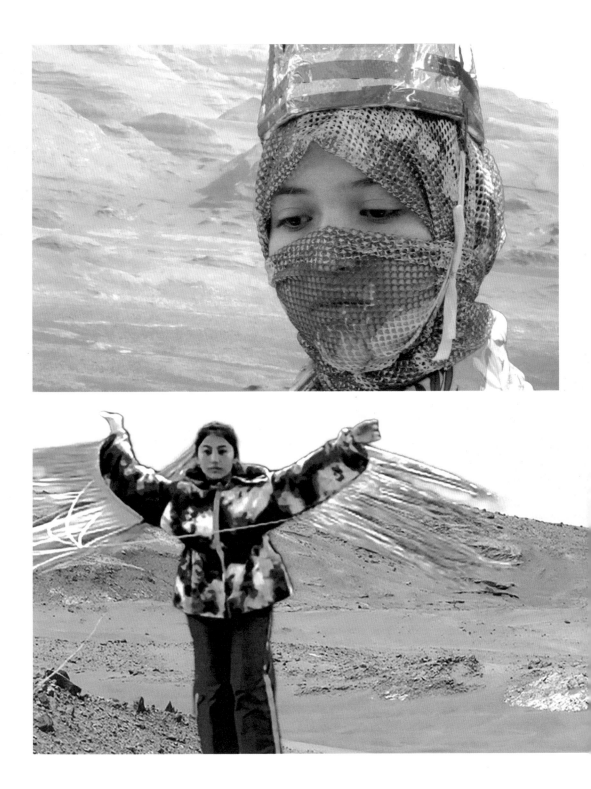

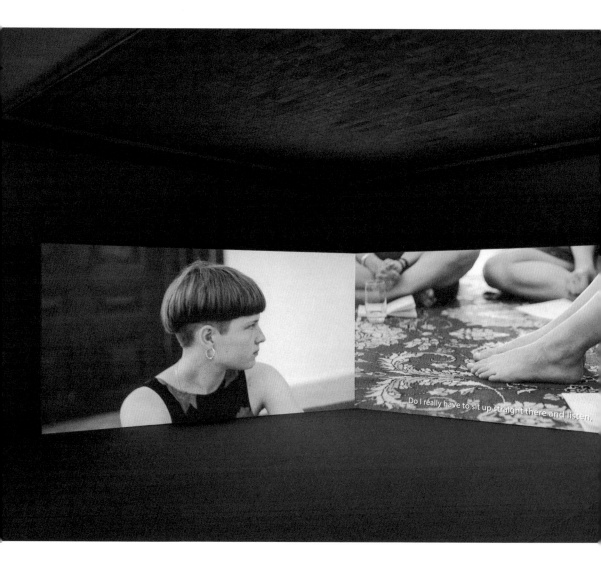

Anna Witt, *Das Radikale Empathiachat* [The Radical Empathiarchy], 2018 •
COURTESY THE ARTIST AND GALERIE TANJA WAGNER, BERLIN
Installation view: *And if I devoted my life to one of its feathers?*, Kunsthalle Wien, 2021
RIGHT: Anna Witt, *Das Radikale Empathiachat* [The Radical Empathiarchy] (film stills), 2018 •
COURTESY THE ARTIST AND GALERIE TANJA WAGNER, BERLIN

or causes shame.

Sheroanawe Hakihiiwe, from the series *Hihiipere himo wamou wei* [These Trees Give Fruits to Eat], 2018
• COURTESY THE ARTIST, GALERIA ABRA, CARACAS, AND MALBA, BUENOS AIRES

R2IIÖ

KANAAARI

SHAWACHKURRI

KEPO

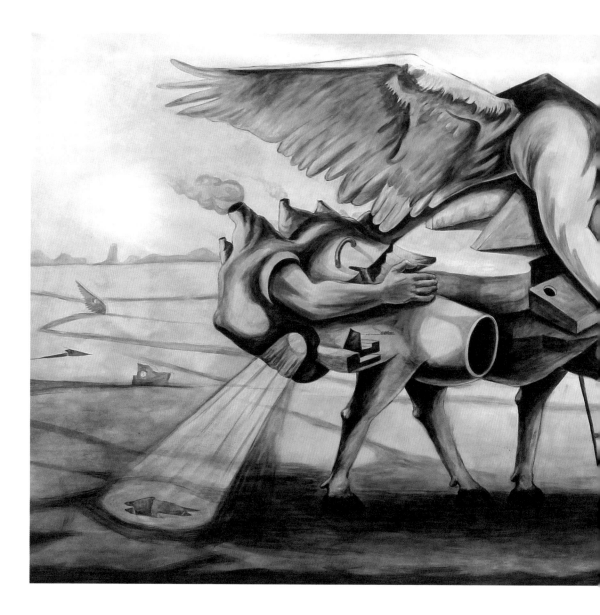

Prabhakar Pachpute, *A Plight of Hardship II*, 2021 • COURTESY THE ARTIST AND EXPERIMENTER, KOLKATA
Installation view: *And if I devoted my life to one of its feathers?*, Kunsthalle Wien, 2021

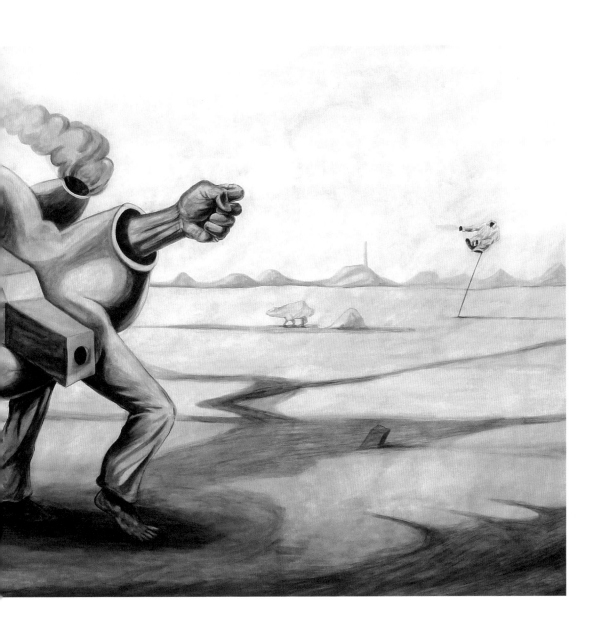

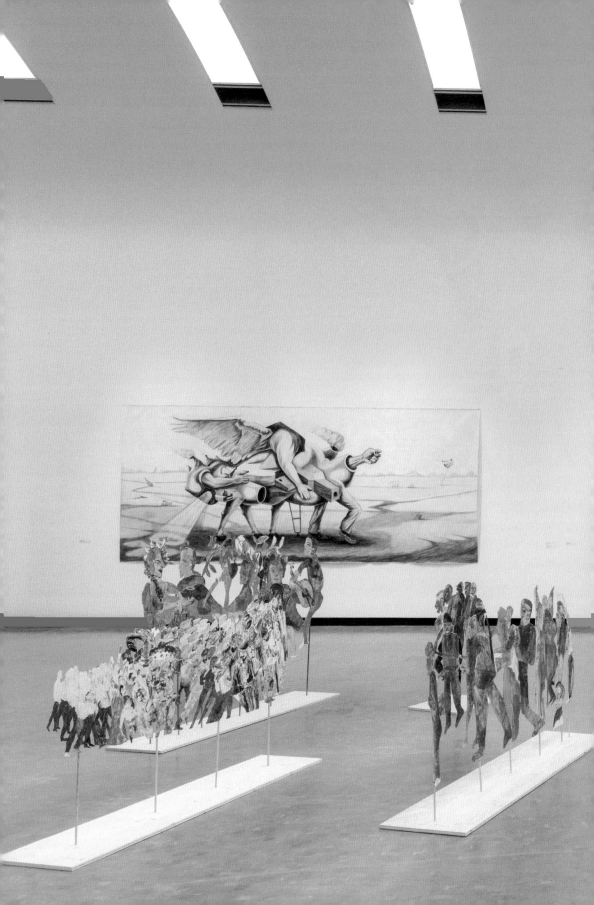

Prabhakar Pachpute

Feathers Never Die

A feather falling apart from life into a void,
Leaving the path of the world.

If we walk through a forest,
We may stumble upon plenty of feathers.

If we collect these feathers,
We may have floating mountains.

What if we sow these mountains,
Will it appear as life again?

Meanwhile, the breath is trying to conquer to uphold,
Crawling and tracing the path of the termite.

The rising fists are leading to have a voice,
Breaking the barriers, holding strong to the path of integrity.

Despite the wind indicator, the hardship of a walking ship,
Trying to hold on a track, seeking more of its reflections.

At the end moving across,
The uncertainty of judgement is scratching the lines of chaos.

So yet to walk and count on,
Can we imagine a life without its feather?

Installation view: *And if I devoted my life to one of its feathers?*, Kunsthalle Wien, 2021:

Prabhakar Pachpute, *A Plight of Hardship II*, 2021 • COURTESY THE ARTIST AND EXPERIMENTER, KOLKATA

Anna Boghiguian, *The Unfaithful Replica*, 2016; *The Unfaithful Replica*, 2016; *Procession*, 2017; *Untitled*, 2017 • COURTESY THE ARTIST AND KOW, BERLIN

Jim Denomie

Life as a Feather

I knew from an early age, six or seven, that I wanted to be an artist, more specifically, a painter. I don't recall the images of famous paintings I had seen that informed this desire, but I do remember that I liked to draw and wanted to be recognized as a really good painter. An older cousin had done a good-sized pastel drawing of President John F. Kennedy; it was spot-on and I remember admiring his skill and thought that someday I wanted to be admired for my skill too. Indeed, I was inspired.

Because of the historical consequences of government campaigns and policies of genocide and extermination—The Indian Removal Act of 1830; Allotment and Assimilation Acts; Indian Reorganization, Termination, and Relocation Acts; and boarding schools—I basically grew up a brown American. My parents were not taught everything about our Ojibwe heritage and therefore had less to pass on to my two brothers and me. When I was five, my parents moved us all to Chicago, Illinois, from our reservation, Lac Courte Oreilles (in northern Wisconsin), as part of the Relocation Act. After one year, my parents split up and my mother moved my brothers and me to south Minneapolis, Minnesota. It was a challenging upbringing living in poverty and an alcoholic environment.

I eagerly persisted in participating in any art assignments offered in school. When I was sixteen years old, I attended Minneapolis South High School. At that time, there was a terrible experiment with modular scheduling, which was meant to prepare us for college. We were given a lot of free time between classes that we were supposed to use responsibly for study. But in an inner-city school, it was a huge disaster. Many of us wasted that time goofing off and getting high and the graduation rates plummeted. Knowing after one semester that I would likely not succeed in that system, I went to my counselor and asked if I could transfer to a school where I could focus on art. She told me that that was a terrible choice, there was no money or future in art. I said it is either that or I drop out of school. So at sixteen

I dropped out of school, got a minimum-wage job, got into a lifestyle of partying and addiction, and I gave up art for twenty years.

In 1989, I came through the other side of my alcoholism. In 1990, I enrolled at the University of Minnesota intending to get into health sciences and out of construction, but two things happened that were totally unexpected. I got involved with the Native community on campus and found a group of people like me who were assimilated to some degree and who wanted to learn more about our cultural heritage. And I started to make art again.

When I began to paint again, I started to paint visual stories (which was part of my Ojibwe heritage). At the same time, I was learning the history between the US Government and the American Indians, history that was not taught in mainstream schools. So, naturally, I started to paint stories that I knew and understood. Meanwhile, I was learning about my cultural identity and so it became important to me (as a contemporary Native American male living in the twenty-first century) to paint about events, both historical and contemporary, involving Native people. Working in principles of modern art, I developed a visual language to speak about reality in an abstract way. By painting my stories, I devote my life to one of its feathers.

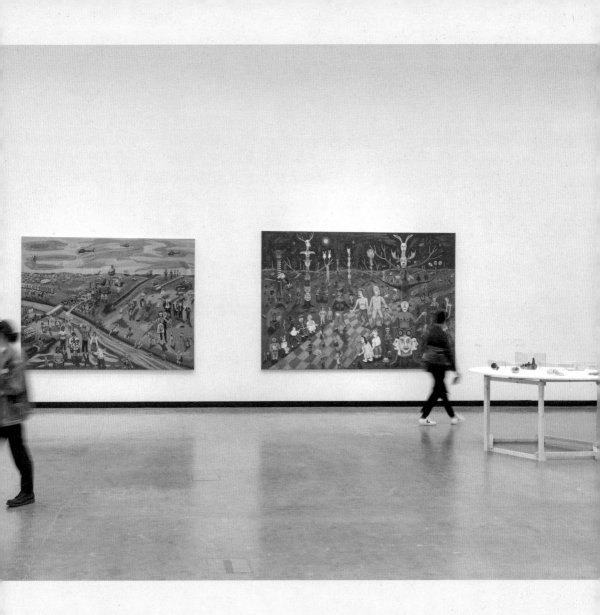

Installation view: *And if I devoted my life to one of its feathers?*, Kunsthalle Wien, 2021:
Jim Denomie, *Standing Rock 2016*, 2018; *Oz, The Emergence*, 2017 • COURTESY THE ARTIST
AND MINNESOTA MUSEUM OF AMERICAN ART

How Is the Aesthetic Imaged by Social and Ecological Art?

Denise Ferreira da Silva

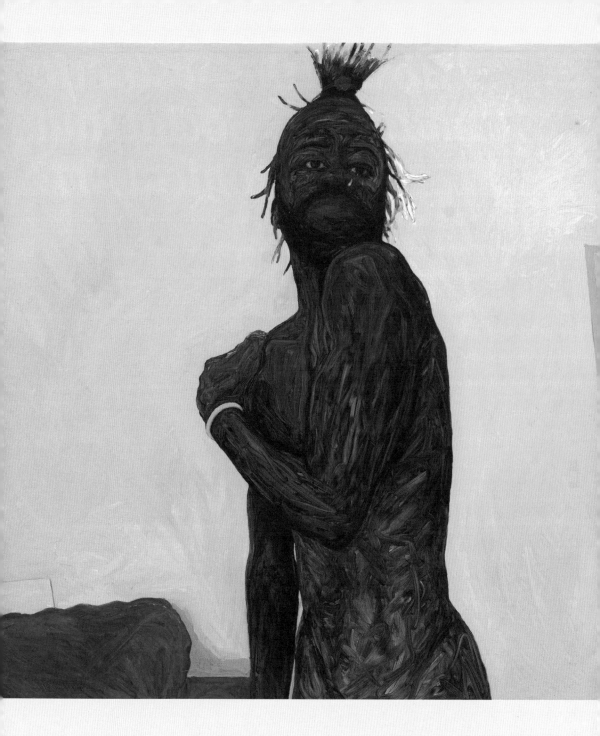

Amoako Boafo, *Blue Band*, from the series *Detoxing Masculinity*, 2017 •
COURTESY AMOAKO BOAFO STUDIO, ACCRA

1
Interest is significant here because, according to Kant, aesthetic judgment is a statement about an object that is not based on interest (in its existence) (Immanuel Kant, *Critique of the Power of Judgment* [Cambridge: Cambridge University Press, 2000], 89). Though he also postulates that this is precisely what places it beyond the faculty of desire, which is the one covered in his moral philosophy, as it turns out, Kant's own intervention in the subject is an effort to ground ethics on the concept of Humanity itself and not on the object. For the classic formulation of Kantian ethics see generally Immanuel Kant, *Critique of Practical Reason* (Cambridge: Cambridge University Press, 2015).

2
Here I am highlighting Kant's inaugural statement that locates the condition of possibility for aesthetic judgment in the operations of the human (rational) mind (Immanuel Kant, *Critique of the Power of Judgment*, 17–21).

3
Kant, *Critique of Practical Reason*.

4
The thesis of art's autonomy is a classic theme in the field. In addition to Kant's third critique, Adorno's rendering of it is also an important statement because it is tied to his theorizing of the social relevance of art. See, for instance, Theodor Adorno, *Aesthetic Theory* (Minneapolis, MN: University of Minnesota Press, 1998).

W hat becomes thinkable when one addresses the question that artworks commenting on current global (social and ecological) issues raise to the aesthetic orthodoxy? Here I explore this question by providing an account of how as these artworks and practices enter the global contemporary art scene they inflect on a classical theme, which is the thesis of art's autonomy. Now, instead of engaging in a review or discussion of this thesis, I take it as a guide for the larger and more interesting question of how social and ecological art inflect the aesthetic.

Evidently, I do not pretend that my choice of relating socially and ecologically oriented art to the question of autonomy is inconsequential. It is not. My assumption, which I elaborate on in the first section of this text, is that these artworks and practices highlight the sutures that hold together the prevailing conception of the aesthetic. They do so by raising the question of ethics, which is one that cannot be reduced to interest,[1] at least immediately. When doing so, they expose how the aesthetic occupies the place that separates the human and the nonhuman—that is, it delimits those to which ethical concerns apply, namely, the Human—and is explicitly presented in terms of a preoccupation of the latter by the former.[2] Put another way, the very idea of an aspect of human collective existence that is separated from the economic and juridical moments of political existence is only possible under the presumption that, at that level, the one in which the Human radically differs from all other existents, the relations among human beings are mediated by something that only affects them mentally, something fundamentally subjective.

Everything else, every other thing that is not human has objecthood, and as such it is also of the order of Nature, that is, something that can be desired, used, or exchanged. What is important in regard to that which is objective, in the aesthetic context, is not so much what this implies to the thing, but what that quality of the thing, objectivity that is, implies to humanity, how it threatens its distinguishing quality—dignity—which is the main concept in Kantian ethics.[3] In an attempt to escape this Kantian enclosure, of the ethic and the aesthetic, I experiment with a non-Kantian reading in this commentary on how social and ecological work and practice inflect the aesthetic. What lies ahead is a description of the context, which is a preparation for the following sections, namely, formulation of the question and a presentation of the reading in the form of ten theses on what here I will call social and ecological art.

The Context
How to avoid being caught running in circles around the thesis of art's autonomy when commenting on artworks and practices that are explicitly concerned with the social and ecological catastrophes that proliferate under global capital?[4] What is the significance of this thesis to artworks and practices explicitly critical of the colonial, racial, and cis-heteropatriarchal matrix that supports capitalist

Salmo Suyo, *Histerectomía I* [Hysterectomy I], from the series *Genitales* [Genitals], 2016–17 •
COURTESY THE ARTIST AND JUAN CARLOS VERME & PROYECTOAMIL

extraction and expropriation and their deadly consequences? How to write about these artistic interventions without reducing them to something that is not art or elevating them to something that is more (or less) than art? My point of departure is the fact that when the artwork and the artist's expressed intention comment on the colonial, racial, and cis-heteropatriarchal subjugation operative in global capital, ethical considerations become unavoidable and the thesis of autonomy of the art is troubled.[5] Let me put this differently, the ethical question is raised precisely when the art and the artist interrogate the ethical figure that sustains, respectively, the truth claims and the workings of the post-Enlightenment episteme and political architecture, namely the Human (as a natural entity) and Humanity (as a rational entity).[6]

The question of why this is the case has many answers, I am sure. Here I am interested in how artwork that comments on social and ecological issues, even if indirectly, recalls the usually ignored distinction between the Human (the natural/biological existent) and Humanity (the rational/ethical concept), which is at the basis of

5
Though the theme of autonomy seems mostly related to art's separation from juridical and economic moments, that is, from the domains where interests rule, it is all the more relevant to considerations of the political that target the ethical dimensions of the post-Enlightenment political architecture.

6
For a discussion of this distinction see generally Denise Ferreira da Silva, *Unpayable Debt* (Berlin: Sternberg Press, 2022).

7

See generally
David Lloyd, *Under
Representation* (New
York: Fordham, 2019).

8

When reading for this
question, I used the
classic Celtic Cross
spread and the Rider-
Waite Tarot deck. In
my reading, I follow
the usual procedure
I developed with my
collaborator, Valentina
Desideri, which we
call poethical reading.
For this reason, there
is no need to know
the meanings of the
positions in the Celtic
Cross or the meanings
of the cards I drew,
or even the possible
interpretations of the
cards in their positions in
the spread. Please visit
thesensingsalon.org
where you will find links
to videos and texts
that describe poethical
readings.

the very possibility for a notion of the aesthetic that has prevailed in the post-Enlightenment period. For the aesthetic—since Kant, that is—in the expanse of the post-Enlightenment episteme, which still rules today, has been squarely and systematically located in the region covered by the ethic (moral) concept of Humanity. As dimensions of existence, which refer to objects of scientific knowledge—the social (as generally comprehended but specifically the categories of the racial, sexual, and patriarchal) and the ecological (as another name for nature or the nonhuman surroundings) refer to the scientific (natural) concept of the Human. Since the nineteenth century, the sciences of man and society have fostered projects of knowledge that assemble what I call the political-symbolic, in which the analytics of raciality and the cis-heteropatriarchal matrix operate as sites of production of categories and formulation that produce variations of the Human natural, which distinguish between transparent (white/European, property owner, heterosexual, cisman) and affectable (everybody else) social subjects. There is also the given presupposition that critical artworks that violate this separation by extending ethical claims to nonhumans raise questions about art's autonomy, which refers us to the super sensible itself and its role in our conception of the aesthetic. Another way of saying this is: artwork that comments on the social questions art's autonomy and the transcendentality of the rational (the super sensible) because it exposes and interrogates the operation of the Human (the natural) in the political architecture that, as David Lloyd argues, has been enabled by the very idea of the aesthetic subject. For instance, artistic practices that attend to social and ecological catastrophes recall how Human interest—which animates the orientation to extraction—is what is rendering the planet uninhabitable for its human and nonhuman organic existents.[7]

In this short essay, I experiment with a commentary on social and ecological art that does not return to this split—between the Human and Humanity, aesthetic and economic, ethical and natural, and so on. The split, as noted above, is the very condition of possibility for conceiving of art as having an autonomy over the political conditions under which the works are created and the practices take place. To do so, I made use of a tool I used in my own artistic practice, The Tarot. I did so by asking a simple question: how is the aesthetic imaged by social and ecological art? This is NOT a Tarot reading.[8] This essay is, in fact, another reading, a second reading, in that it refigures the Tarot's translation of my original question; that is, it has transformed them into theses. Ten theses to be precise, each of which comment on one aspect of the question, but none provide an answer or answers for it.

The Reading
Any reading, no matter what has animated the question for it, sits somewhere and is about something. When reading the image, each of its parts and how they are related, a return to where it sits recalls the conditions or events that brought it about, that suggested, intimated, or shouted the question. A return to what it is about,

to its theme, that which hovers over the whole image and exudes from each of its parts and the visible and invisible links between them, recalls that which renders the image one, one of many possible compositions that could be made with those very same parts. When returning to the question of how social and ecological art image the aesthetic, I find an announcement, which is not merely a notice but also a small indication that something is coming about that was not there before. An announcement, however, that has very explicit ethical implications. Each and every part of the image resonates with the need to attend to the possibility that the whole regime of value may be out of sorts, upside down. That resonating image hovering over the whole composition also gives the sense that its several pieces are not to be taken as solid components of something—a signifying totality of sorts—but as other images, the meanings of which will vary according to how each resonates separately or together, sequentially or simultaneously.

I.

Ecological and social art enter the aesthetic register, where the inspirative and intuitive run more or less unconstrained. They inspire many and different reactions that have more to do with the ideas and ideals the newcomers seem to be challenging than with anything intrinsic to the works. There is a sense of movement to how these works inhabit the scene. The defensive reactions they may animate seem to be a permanent feature of the conditions under which they play the scene. However, it is not so much that they mark the spot of the battleground but that they show the aesthetic itself as an arena. What it has to do with the thesis of autonomy becomes an interesting question, as this image of a battleground troubles the very idea that sustains the thesis, namely Kant's subjective universality.[9] Because it indicates a challenge being met from a higher ground, the image suggests that ecological and social art, that is, contesting, confrontational art, enter the aesthetic with an ethical mandate.

II.

Ecological and social art recall that the scene of confrontation unfolds in an ethical landscape. Targeting ethical value in its conceptual presentation, the image indicates that this is not immediately (if at all) acknowledged. It is as if the stakes of the battle, which may indeed be its grounds, precisely that which gives these works an advantage, are hidden from all involved. Elementally, as artistic intervention, they refer to the fiery, and everything that is associated with the generous, the restorative, the joyful, and the collaborative. However, in this presentation of value in the abstract, they indicate that the shattering of the presumption of universality has opened up the possibility of appreciating that a choice can be made, that what is generative and generous, that to which value refers but the meaning of which it cannot exhaust, does not have to take the form or the sense of a discrete thing that can be exchanged or possessed.

9
Kant, *Critique of the Power of Judgment*, 96–97:

"For since it is not grounded in any inclination of the subject (nor in any other underlying interest), but rather the person making the judgment feels himself completely free with regard to the satisfaction that he devotes to the object, he cannot discover as grounds of the satisfaction any private conditions, pertaining to his subject alone, and must therefore regard it as grounded in those that he can also presuppose in everyone else; consequently he must believe himself to have grounds for expecting a similar pleasure of everyone. Hence he will speak of the beautiful as if beauty were a property of the object and the judgment logical (constituting a

cognition of the object through concepts of it), although it is only aesthetic and contains merely a relation of the representation of the object to the subject, because it still has the similarity with logical judgment that its validity for everyone can be presupposed. But this universality cannot originate from concepts. For there is no transition from concepts to the feeling of pleasure or displeasure (except in pure practical laws, which however bring with them an interest of the sort that is not combined with the pure judgment of taste). Consequently there must be attached to the judgment of taste, with the consciousness of an abstraction in it from all interest, a claim to validity for everyone without the universality that pertains to objects, i.e., it must be combined with a claim to subjective universality."

III.

When attending to that which manifests as/in the scene of confrontation, its fiery aspect becomes even more explicit. Elementally, the transformative (the announcement) message ecological and social artworks and practices embody is presented as a collective achievement, something that became realizable after many different pieces were gathered and assembled in such a way as to facilitate their best expressions. That victorious collaboration is expressed as the battleground on which ecological and social art stand and unleash their ethical charge from an advantaged position. If considered through its relation to the ground, the transformative message, it becomes all the more evident that its questioning of value has a fiery—inspirational and re/de/compositional—quality. Its positioning also indicates that it addresses precisely the prevalent view of value, which instead of collective shared joy privileges solitary enjoyment of one's possessions. If considered through its relation to the theme of the reading, that which hovers over the composition as well as all of its parts, the ethical challenge and its elemental figurings—shared joy, collaboration, restoration, and generosity—could be read as reminders or as mirrors of that which is questionable in the contemporary art scene. But, because the theme is also presented conceptually, and its elemental presentations are the same as what plays out in ecological and social art yet not immediately or even at all perceived, it could be that it is not so much present in the works and practices themselves, but that these unbecoming aspects are exposed when they enter the scene.

IV.

What has happened? Has something happened or come into existence that created the conditions for the unleashing of the battle? Was the battleground already prepared when ecological and social artworks and practices entered the stage, or is their presence what caused the transformation? What rendered them, the works and practices, possible? And, if indeed something happened to create the conditions, how has it been presented? Here again we find the form of presentation to be conceptual. The key terms are accountability and awakening. Nothing seems to have brought the situation about. The very appearance of the battleground results from the unfolding of a process. Perhaps it is that which we call history, that is, the temporal unfolding that accounts for change in things. Perhaps it is not temporal but a moment of rearranging of things that opened a crack through which a challenge could be unleashed from the aesthetic. When considered as that which preceded but which also still plays in the situation, what is very much the stuff of the battle, accountability and awakening may be thought of as belonging to the situation, and as a call to the contemporary art scene. Or ecological and social artworks and practices are causing the awakening by demanding accountability. Or, and this is what I would prefer, accountability and awakening are part of the aesthetic experience of ecological and social art, precisely because they add value to the ethical moment. In any event, that which stands on the same side as the theme and ground of the reading, below the

ethical questioning and above the announcement, could have un-
leashed the situation or be intrinsic to it because the latter would
not have come about without it. Either way, accountability and
awakening are critical to ecological and social art.

V.

If what manifests as a battleground is actually the collaborative
nature of the endeavor, it is not surprising that how it is perceived,
what it is taken to be, also recalls collaboration. It does so, how-
ever, in an unexpected way, in an imaging of power, in terms of
the capacity to control disparate impulses and to determine, that
is, the taking of a leadership position in a collective work. So this
apparent contradiction dissipates once one realizes that this is the
concept of cooperation, of what is necessary for collaboration to
be successful. Because ecological and social art seem at odds with
this image of a determination (of disparate tendencies in the self
and of others), it makes sense to highlight how the battleground
they expound provides the opportunity for a contemplation of
collaboration as a concept. From this abstract perspective, we can
also read it as a principle, which would guide existence if it was
without the deadly separation between the Human and every-
thing else (behind ecological catastrophes) and the distinctions
among them (behind the social catastrophes). To take the notion
of leadership as a correspondence to an ethical principle—think-
ing principles as guides—accords with the theme and the ground
of the image, as this principle can be taken as the content of the
announcement while at the same time as the measuring element
that exposes the perversion (as the theme) implicit in the prevail-
ing view of aesthetic value.

VI.

How does the image of the battleground unfold? What becomes of
it is indeed also the question of what it becomes, that is, what it is.
Everything that has been covered above, in terms of how to read
the battleground, seems to coalesce in the image of leadership (of
self and of others) as a referent of the workings of a principle, an
ethical concept in this case, because this is the scene of the battle.
All key terms—battle, ethical value, collaboration, clarity, leader-
ship, etc.—brought out by the question of how ecological and social
art image the aesthetic come together in the figure of a principle
that guides, not as law or as measure (basis for evolution), but as
an inspiration. Fiery leadership does not need the threat of force,
nor does it need to rank and discriminate against those under its
charge: if it is a force, it is a regenerative and generous one. Pos-
sible renderings of this outcome would be: What if the guiding
image of the aesthetic was not that of a subjectivity capable of
anticipating, because it is the ultimate cause of the order of the
world? What if the guiding image of the aesthetic were that of a
principle that always images existence as collaborative because
of renewal, endless re/de/composition? If that was the case, what
would then become of that which constitutes the context on which
this battle comments?

VII.

When commenting on the above question, in this and in the next three notes, I will cover one aspect of the context: the source of the question, the surroundings, the inner concerns, and what it may bring about. Regarding the source of the question, it is not unexpected that the question would arise from a circumstance that could be described as one in which accumulation or perhaps the mere appearance of having everything awakes a doubt, a suspicion that it is not all, that there is something missing, something that is not of the same order as that which has been accumulated. Interestingly, this acknowledgement does not take the shape of a crisis. It is as if things could just continue as they are. There is no pressure. No pain. It is just that having it all seems to accentuate the fact that one is alone in that experience. As a source of the question, in light of the image of the question discussed previously, this suggests the distinction between the capacity to acquire and the capacity to transduce or the ability to accumulate from the ability to collaborate. These are two distinct sets of oppositions: the first one has to do with distinctions between the Human and other existents and the second with distinctions among humans. Perhaps this is where the question comes from, that is, ecological and social art questioning both distinctions simultaneously.

VIII.

How it all plays out in regard to the surroundings is perhaps the most surprising aspect of this image of a battleground. What appears here is both a new beginning, as indicated by the ground but also by what is manifested in it, and a more well-defined vision of all that surrounds the questions. As if the questioning ecological and social art bring to the aesthetic enlightens aspects of the scene—which the questioning exposes as an ethical battleground—which had not yet been brought under scrutiny. This is not about causing a dramatic change, bringing out something that is out of place. Actually, it seems that what it does is allow the acknowledgement of some crucial—social and ecological—aspect of the scene of the aesthetic that has been shadowed in the prevailing picturing of it. Perhaps this is what, in the source of the question, appears as a suspicion; I mean, the shadows that must be caused by all the shiny things one has accumulated but which are not in view.

IX.

By inner concerns I do not mean that which may be at work in the interiority of a given artist, as a person. I mean something that is operative in the artwork or practice, something that may have resulted from all the many elements and moments out of which it was assembled, but that is not made explicit. Perhaps it could be called the content of the sutures that keep it all together as a composition, but it is not that which would answer the question of what it is, but of how it has come to exist. In regard to the image of an ethical battleground gathered by

Castiel Vitorino Brasileiro, *Descarrega* [Discharge], 2018 • COURTESY THE ARTIST

ecological and social art's questioning of the aesthetic, the inner sutures, appropriately, refer to the generative in two senses. As the capacity indicated by the figuring leadership in its unfolding, the inspirative, the generative as the sense of its inner concerns indicates that ecological and social art do not depart from the aesthetic, but recall the more expansive meaning of the sensible, that is, the existent, which is also a way of referring to all that exists without privileging the Human as the subject of experience. As the application of this inspirative capacity, better yet, as the effect of its infusion or diffusion, that is, regeneration, these sutures suggest that perhaps the advantage figured in the battleground has to do with how ecological and social art, insofar as they respond to or denounce violations—of extraction and expropriation—are oriented by an ethical principle that challenges the very ideal of accumulation. That is, it is not a principle to orient distribution but one that renders it unnecessary because it does not favor concentration. It could be called a restorative principle, in the sense that as extraction and exploration before regeneration is possible, restoration of its proper conditions is needed.

X.

What becomes possible or conceivable if this configuration remains undisturbed, if all pieces and their connections are not reorganized? That the image of a judging, determining gesture would come out of this was not expected. It does, however, make sense when one recalls that ecological and social art attend to and respond to the violations that allow for or result from extraction and expropriation. From the basic elements of the configuration, the image of an ethical battleground, in particular, in light of the theme, which is the denunciation of an unbecoming ethical choice and the kind of power associated with it, there is a call for discerning—judging in the intellectual sense. But a judging that considers not only the principles but all the messy, painful, impossibly tragic, and disheartening situations that inspire the work and the practice. It is as if what appears here is not the theme of art's autonomy. Let me close with further questions: What if ecological and social artworks and practices image the aesthetic in its insufficiency? What if it appears as less than or other than that which could or should be activated to bring about the needed transformation? What if this constitutive insufficiency results in art that steps in but is always somehow out of step, but also fully and competently performing what it can, which is to comment as it inspires and is inspired by a reality, the brutality of which it testifies?

* * *

As expected, this text cannot have a conclusion. For this reason, the final thesis will play this role. ●

Vlasta Delimar, *Dick on the Tongue*, 1983 • COURTESY THE ARTIST
AND GALERIE MICHAELA STOCK, VIENNA

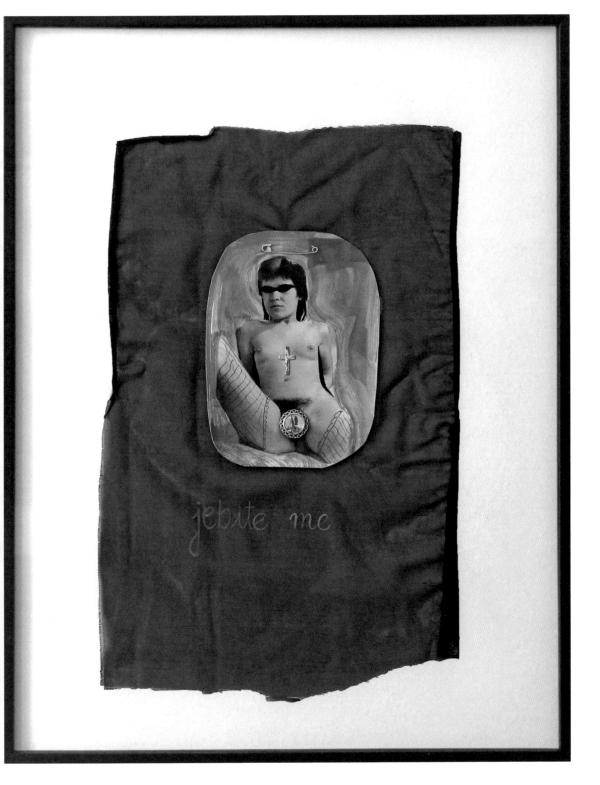

Vlasta Delimar, *Fuck Me*, 1981 • COURTESY THE ARTIST AND GALERIE MICHAELA STOCK, VIENNA

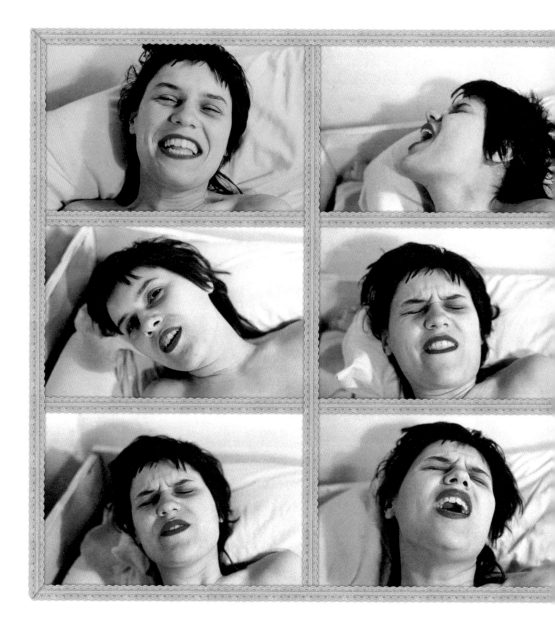

Vlasta Delimar, *Visual Orgasm*, 1981 • COURTESY THE ARTIST AND GALERIE MICHAELA STOCK, VIENNA

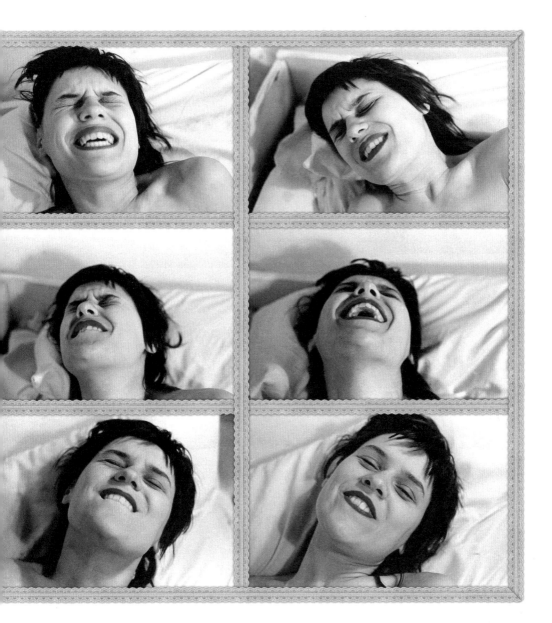

143

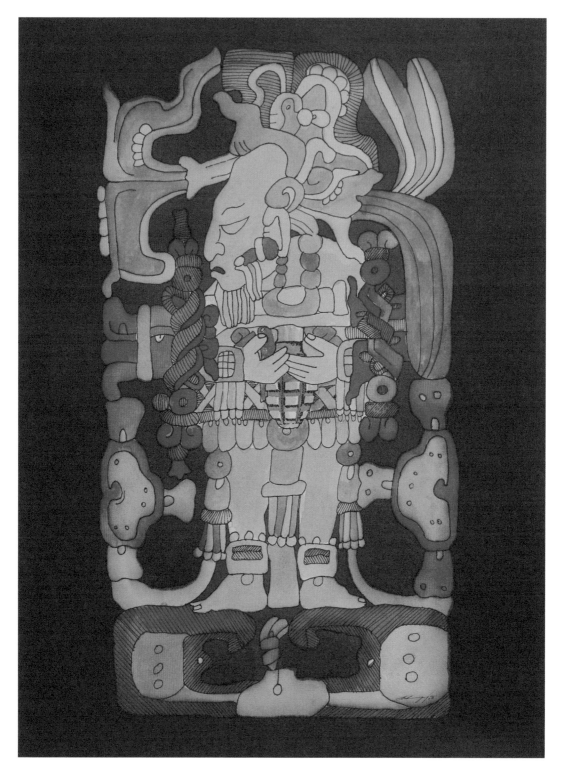

Manuel Chavajay, *Untitled*, from the series *Keme*, 2016 •
COURTESY THE ARTIST AND GALERÍA EXTRA, GUATEMALA CITY

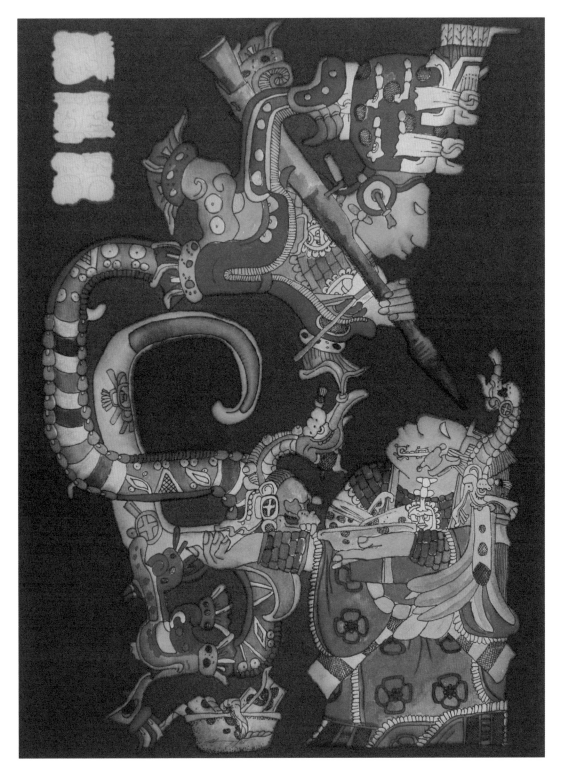

Manuel Chavajay, *Untitled*, from the series *Keme*, 2016 •
COURTESY THE ARTIST AND GALERÍA EXTRA, GUATEMALA CITY

Manuel Chavajay, *Untitled*, from the series *Keme*, 2016 •
COURTESY THE ARTIST AND GALERÍA EXTRA, GUATEMALA CITY

Manuel Chavajay,
Untitled, from the series
Iq'am, 2014
COURTESY THE ARTIST
AND GALERÍA EXTRA,
GUATEMALA CITY

Karrabing Film Collective, *Mermaids, Mirror Worlds* (film stills), 2018

White and black people will die
equally...equally.

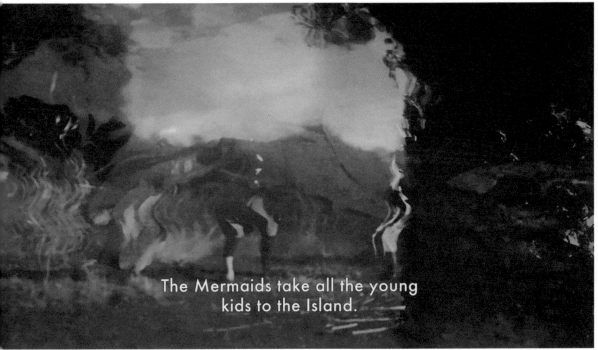

The Mermaids take all the young
kids to the Island.

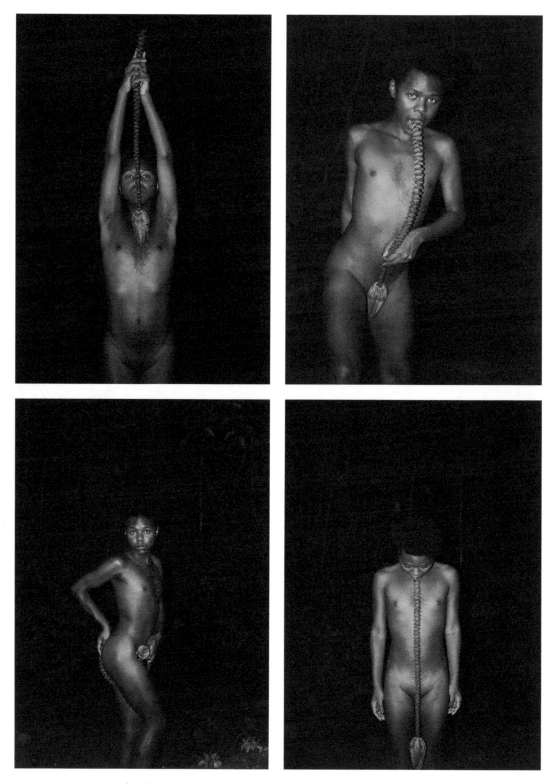

Castiel Vitorino Brasileiro, five photos from the series *Gastrite*, 2019 • COURTESY THE ARTIST

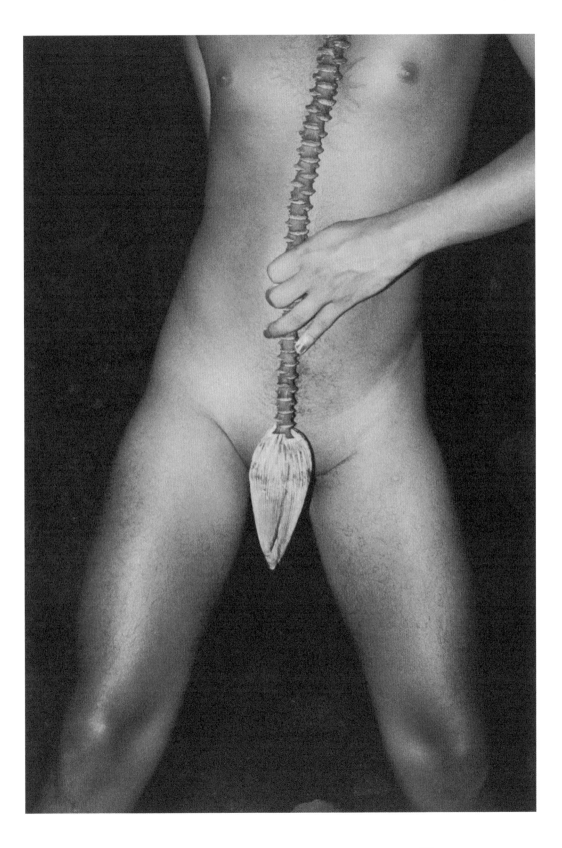

Salmo Suyo, *Disforia* [Dysphoria] #10, 2019; *Disforia* [Dysphoria] #11, 2019; *Disforia* [Dysphoria] #13, 2019; *Disforia* [Dysphoria] #14, 2019 • COURTESY THE ARTIST

153

Zapantera Negra, *Flower of the Word II: "Digna Rebeldía"* ["Dignified Rebellion"], 2016–21
Installation view: *And if I devoted my life to one of its feathers?*, Kunsthalle Wien, 2021

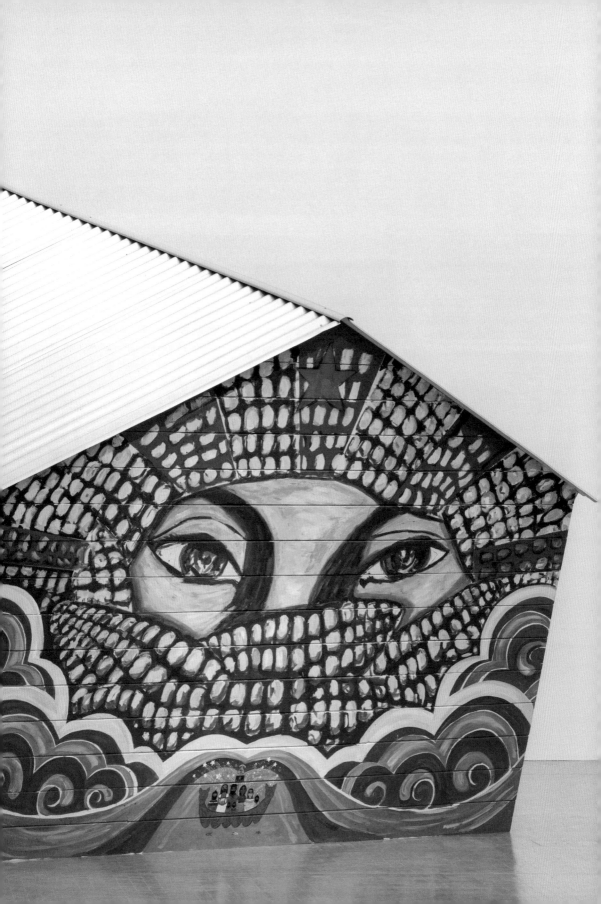

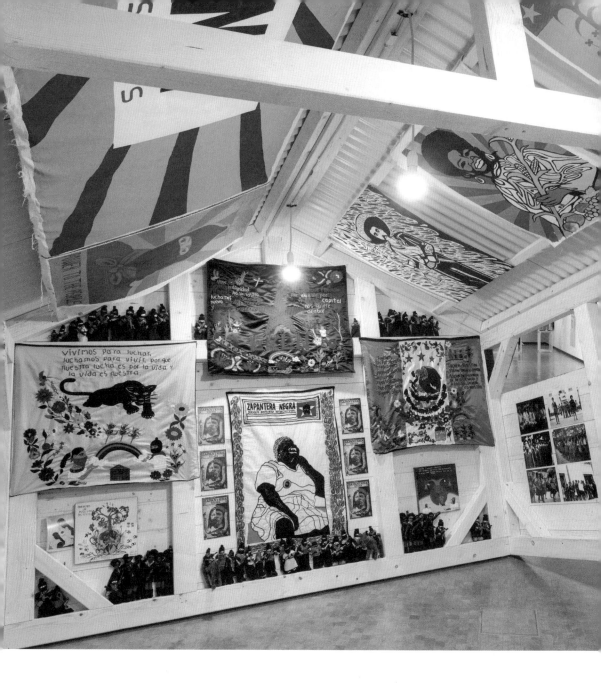

Zapantera Negra, *Flower of the Word II. "Digna Rebeldía"* ["Dignified Rebellion"], 2016–21
Installation view: *And if I devoted my life to one of its feathers?*, Kunsthalle Wien, 2021

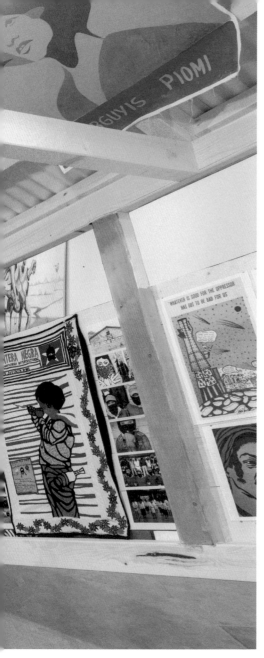

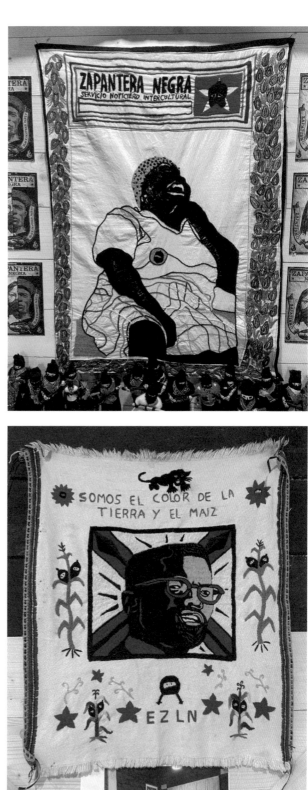

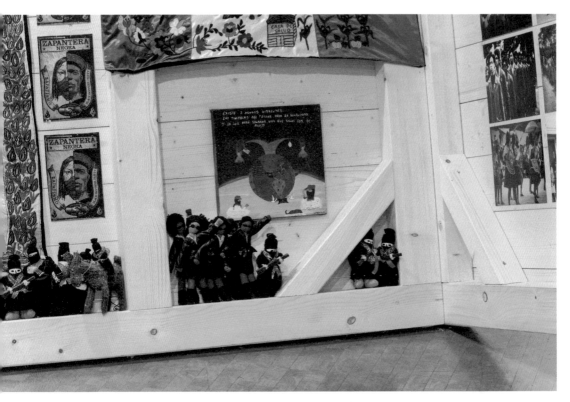

Zapantera Negra, *Flower of the Word II.* "Digna Rebeldía" ["Dignified Rebellion"], 2016–21
Installation views: *And if I devoted my life to one of its feathers?*, Kunsthalle Wien, 2021

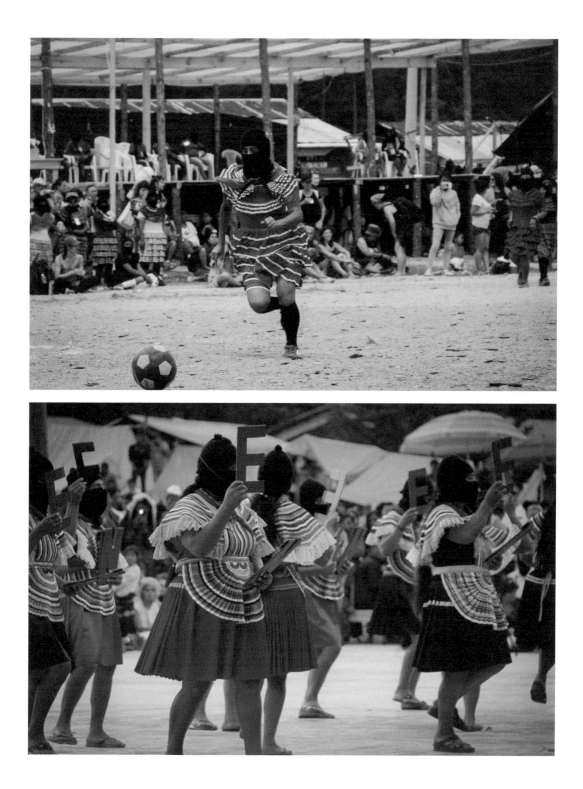

TOP: *First Encounter of Women in Struggle*, 2018

BOTTOM: *Share to Humanity*, 2017

SLOPE CATEGORIES

A 0°- 2°
B 2°- 5°
C 5°-10°
D 10°-20°
E 20°-30°
F Over 30°

R Re-formed Land

EROSION CATEGORIES

1 Slight erosion
2 Moderate erosion-perhaps 50% of topsoil lost
3 Severe erosion-all topsoil and some subsoil lost
4 Very severe erosion-most of subsoil lost
5 Extremely severe erosion-eroding parent material

Annalee Davis, *Woman Looking at Long Annelid Parasites of History*,
from *The Parasite Series*, 2018

Annalee Davis, *My Best Diamond Ring, Two Negroe Boys and two negroe wenches*, 2018;
Woman Expelling Long Annelid Parasite of History While Standing on Top of a Mill Wall, 2018;
Woman Wrestling with Long Annelid Parasite of History, 2018; *Woman Confronts a Long Annelid Parasite of History*, 2019; all from *The Parasite Series*, 2018–19

PHOTO BY ANNALEE DAVIS

Annalee Davis

How to Know a Land?

They trampled on it. It was a sacred place.[1]

I recall the annual fifteen-week crop season. Cane trash piled in recently cut fields that my younger brother and I played in, sliding on mounds of sourgrass with our agile young bodies. As a girl, I laid on my back looking up at the majestic mahogany trees with their craggy trunks, feeling enveloped and mesmerized by their kinetic gracefulness. Their woody pods bursting into perfect winged seeds, helicoptering to the ground, carpels refashioned into munitions for cockfighting games where victors broke the curved tips off their opponent's weapons. I followed the winds to the end of our gap, eavesdropping on the soul-stirring songs whistling through the casuarina tree's drooping needles.

Later, I learned to drive in cart roads delineating cane fields with names like Cabbage Tree, South Culpepper, Cistern Field, and Cholera Ground.

The islands roared into green plantations.[2]

My attachment to the seeming remoteness of the sugar plantation where I grew up was my whole world, a "natural" environment to which I felt deeply connected.

I was less aware of the larger carefully constructed colonial project that this 180-acre plantation was part of. Cycles of labor and trauma were carried out in bucolic fields— planting carefully bred varieties of canes, weeding and collecting meat (grass for animals), cutting and piling cane, spraying weeds, ploughing soil, the employing of migrant labor from St. Lucia and Guyana. All the while, I was experiencing this land as a playground.

1
Jean Rhys, *Wide Sargasso Sea* (London: Penguin, 1997), 109.

2
Extract from the poem "Calypso" by Barbadian poet Kamau Brathwaite, in Edward Kamau Brathwaite, *The Arrivants: A New World Trilogy—Rights of Passage | Islands | Masks* (Oxford: Oxford University Press, 1981), 48.

History produces geography.[3]

How to know a burdened place, love a land, walk in step with sites we have come to know through foreign measurements? How to listen with another ear, connect with grounds buried beneath ceaseless cadastrals, surveys, mappings, sweat, blood, and labor as though the profound depths of any land could ever be measured or owned?

"Beauty grows like a weed here," she said, "and so does disease."[4]

There was nothing natural about the landscape where I grew up. The plantation ricocheted across this archipelago infecting thousands of acres (and bodies) through its colonial machinery, fomenting disharmony with the natural cycles of earth through its protracted history of extractive economies.

History shaped the topography of this small isle, forcing alienation from the ground beneath our feet and from each other. Amnesia, shame, and doubt bury carnal truths about entanglements we continually deny.

Walking ... is how the body measures itself against the earth.[5]

How does a land grab hold of you? Coursing through these old lands at dawn is one way I have come to know this place. Measuring a less nimble body against this ground, I sense increasing fragility on steep inclines and hesitation in measured movements on downward slopes.

The wind meets my sweating skin as I rub black sage and cerasee leaves between my fingers, inhaling their sharp aromas. Later I lean into the slender scrambling ink vine shrub, swallowing a sweeter nectar from its fragrant white-petalled flowers. Stumbling over long grass, I clumsily regain my balance, slowly bending under electric fencing in this grassy terrain now populated by heifers.

This soil is a tomb, a repository of seeds, and a silent witness to an archive of lives listed without surnames. Listening to umpteen pods rattling on the Woman's Tongue tree, I come to rest here, to find a softer place inside, and to listen. With the onset of this year's dry season and its blustery winds, I ask myself, can you know a place through its breeze?

3
Arjun Appadurai, "Beyond Domination: The Future and Past of Decolonization," *The Nation* (March 22/29, 2021), https://www .thenation.com/article /world/achille-mbembe -walter-mignolo -catherine-walsh -decolonization/.

4
Spoken by Miss Stella in *The Orchid House* by Phyllis Shand Allfrey (London: Virago 1991).

5
Rebecca Solnit, *Wanderlust: A History of Walking* (London: Granta 2014), 31.

PHOTO BY JUSTIN WENT

6
George Lamming,
*Caribbean Reasonings
—The George Lamming
Reader: The Aesthetics
of Decolonisation,*
ed. Anthony Bogues
(Kingston: Ian Randle,
2011).

7
Cecilia Vicuña, "Untitled,"
included in the present
publication, 19.

History is not a time past but rather one in which the dead and living commingle.[6]

These haunted lands are the sediments of my birth. On my short walk today, I found two feathers while hiking through the gully that feeds into Two Acre field. A nomadic grey-tailed cockerel winds his way from the milking parlor, through the gully and back up the cart road, his feathers drifting back and forth on the gentle breeze before slowly falling to the soil. I brought them back to the studio to examine their "thousand tiny ribs."[7]

Nikolay Oleynikov (Chto Delat), *Untitled* from the series *Zhar-ptitsa. Variations*, 2022
• COURTESY THE ARTIST

Chto Delat

Zharptitsa of Our Struggles

In Russian fairy tales there is a mighty female
ornitho-morphed creature that consists of pure
heat. Similar to the phoenix, it is a firebird with
roots in pagan autochthonous Slavic cultures.
She emerged in prerevolutionary avant-garde
culture in Stravinsky's experimental ballet
The Firebird, written for the 1910 Paris season of
Ballets Russes. After 1917, Zharptitsa became a
metaphor for the people's uprising in popular
and agit-prop imagery. Frightful passion,
ferocious gaze, formidable cry of the oppressed
of the world, sizzling roar-hiss, a mile-wide
incinerating wingspan of imagination.
A New Life that revives itself from the ashes.

And if we dedicate our lives to one of her feathers.

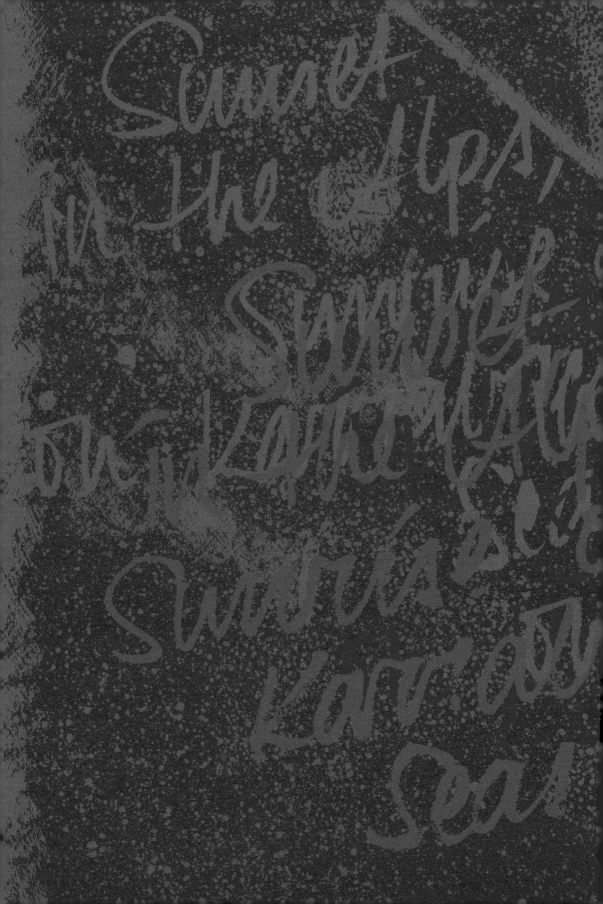

Sunset in the Alps, Sunrise on Karrabing Seas

Elizabeth A. Povinelli

TOP: Elizabeth Povinelli, *The Inheritance, A Visual Essay on Historical Accumulations* (film still), 2021. •
ALICE HENRY STUDIOS
BOTTOM: Plate 242 with drawings by H. L. Todd, taken from *Fisheries and Fishery Industries of the United States*, a multi-volume enterprise published by the U.S. Fish Commission from 1884–87

As the glaciers melt and the saltwater seas rise, there is no more avoiding the difference that humans have made on the more-than-human world, as well as on themselves.

> "The biggest boom means some mighty big hauls; and it doesn't come much bigger than this. Mount Whaleback two kilometers across six kilometers long"[1]

But what is this human difference? Or, who is this human difference? From what point of view, from what specific worlds, does this human difference emerge? What specific humans are making the patterns causing the glaciers to melt and saltwater seas to rise? For a while, I, alongside others, have been interested in the human difference that emerged during the long European colonial assault across the Atlantic and Pacific oceans and European enslavement of millions of West Africans—namely, a human that emerged as a back-formation of these assaults and enslavements in the form of a self-possessive, self-determining, and object-owning subject; a human that then attempts to submerge other human and more-than-human relations into its toxic spewing wake.

I want to reflect on the possibilities of other human differences, such as the attempts to create a transhumanist movement by Paul Gilroy and others in the wake of colonial spaces that excluded specific humans, in what Sylvia Wynter calls the overdetermination of a certain Man. In specific, I want to reflect on the forms and modes of water that have defined my life across colonial spaces and decolonizing practices—frozen water, liquid water, and water in its hot and steamy state. The first act of this watery reflection takes us to the hot environments of Shreveport, Louisiana, and the icy environments that have defined the upper reaches of Carisolo, my ancestral village in the Alps. The second act takes us to my Karrabing colleagues, whose lands lie along the saltwater seas of what is now called Anson Bay in the northwest of the Northern Territory of Australia.

** * **

I grew up in the sweltering heat of northwestern Louisiana. In the summer, the air was so humid that it mocked the distinction between liquid and gas. I felt a bodily relation to the phrase "a fish out of water," unable to breathe the air that constantly threatened to become liquid. My siblings and I prayed for the walls of rain that would concentrate themselves and rage across the landscape, dropping the temperature twenty degrees in their wake, then leaving behind more humidity rising off the blistering concrete streets.

During the long stifling summers, we would try to find relief in a local lake. It wasn't a huge body of water, maybe 400 meters long and fifty meters across. But it was large enough and deep enough to hold its cold and create multiple microenvironments for crawling crawfish, patrolling brim and bass, threatening poisonous snakes, for tadpoles and what they would become: toads and frogs. I never saw any alligators in that lake, but it was deep and opaque enough

1
Quote from reporter Liam Bartlett on the television news program *60 Minutes Australia* (episode "Billion Dollar Business: Aussies Striking It Rich in Iron Ore," aired August 5, 2020, https://www.youtube.com/watch?v=xFE1IAPhog4). The boom Bartlett is referring to is the iron ore mining boom in Western Australia ongoing since the early 2000s. Mount Whaleback is the biggest single iron ore pit in the world; it is majority-owned and operated by BHP, a multinational mining company with headquarters in Australia.

Elizabeth Povinelli, *The Inheritance, A Visual Essay on Historical Accumulations* (film still), 2021. • ALICE HENRY STUDIOS

for me to have ominous nightmares. Enormous prehistoric paddlefish, indigenous to the area, would emerge from its depths with wide, gaping mouths, filtering the ambient food in the lake water. These spectral paddlefish, which I don't believe I ever actually saw, signaled an excess to any definition of existence that I could externalize from the pattern of my own body.

Alongside the difference between how I experienced my body's relation to these lake-based bodies was another form of human difference operating along its shores and across the neighbors of Shreveport. My father built our home on the edge of a forest that had been designated to be developed as a white suburb. This suburb slowly displaced Black families who also used that lake, just as settler colonialism had previously violently dispossessed the same area from the Caddo for whom Caddo Parish had been named. This history of human racial and colonial difference was based on the radical indifference to the fates of Black Americans; and an intense interest in strictly policing the lines between races, governed by the framework of white supremacy. For Édouard Glissant, this form of human difference emerged from the cold Atlantic saltwater as three abysses emerged from within the slave ships, establishing a set of relations among humans and the worlds that were rampaged or dispossessed, a set of relations whose content may have changed but whose form has been terribly resilient.

What is terrifying partakes of the abyss, three times linked to the un-known. First, the time you fell into the belly of the boat. For, in your po-etic vision, a boat has no belly; a boat does not swallow up, does not devour; a boat is steered by open skies. Yet, the belly of this boat dis-solves you, precipitates you into a nonworld from which you cry out. [...]

The next abyss was the depths of the sea. Whenever a fleet of ships gave chase to slave ships, it was easiest just to lighten the boat by throwing cargo overboard, weighing it down with balls and chains. [...]

[T]he most petrifying face of the abyss lies far ahead of the slave ship's bow, a pale murmur; you do not know if it is a storm cloud, rain or driz-zle, or smoke from a comforting fire. The banks of the river have van-ished on both sides of the boat. What kind of river, then, has no middle? Is nothing there but straight ahead? Is this boat sailing into eternity to-ward the edges of a nonworld that no ancestor will haunt?[2]

No matter how hot the Shreveport summers were, I preferred them to the winters in Buffalo, New York, that we had left behind when my family moved south in 1964. I was born in Buffalo during a frig-id February. We'd often go back there to visit my father's parents and their siblings and cousins. Even in mid-August, it was too cold for me to consider cannonballing into my cousins' outdoor pool.

It was never cold enough for my paternal grandparents, who would regale us with stories of the deadly nature of the glaciers that hov-ered above our ancestral village of Carisolo in Trentino. They divid-ed the world into people who were from the Alps, who knew how to survive any condition, and those who were not. Within the Alps were other divisions. My grandparents clearly thought that their Alps, their creeks, their cascades, and their village was special and made them better than all their other neighbors in America and else-where, begging the question, of course, of why we were in America.

My Carisolean grandparents and great aunts and uncles seemed to measure humans according to the capacity to withstand ice, icy winds, icy water, ice in a perfectly soft condition as snow. When my parents took us camping in the American Rockies, my father would stop on the side of bridges to take my brothers down into the biting creeks filled by the summer melt. His father had taught him to withstand the shape contraction of flesh; my father would teach his sons the same. As I watched my brothers turn blue and shake uncontrollably, I experienced a rare moment in which I was glad my dad considered me a girl.

Perhaps it should not be surprising, then, that when I arrived in Darwin, Northern Territory, Australia, in the sweltering September of 1984, I found myself more at home environmentally than when I visited my ancestral village for the first time. No mountains emerged from the ground anywhere, and definitely no ice except for the kind that came from freezers. The top end of the Northern Territory was then characterized by three seasons: the suffocating Build-Up, when the temperature and humidity rise to unbearable

2
Édouard Glissant, *Poetics of Relation*, trans. Betsy Wing (Ann Arbor, MI: University of Michigan Press, 2010), 6–7.

Not until much later did I begin to wonder whether even the story of your eye was true. By then I had learned that truth slides across history like a sharp blade along flesh.

For all that was false in what you said, "Nothing I am telling you, Elizabeth, is a lie." It was the form of truth that slides down the valleys that define Trentino, Alto Adige. Truth consisted not of what was being said but of what was being left out in order to maintain one's sense of oneself or of what could no longer be said because the world had drained the words of their referential meaning.

For you, truth was not a light switch—up/down, on/off—but a way of conveying a horror that allowed your grandchildren to move into a deeper reality, a reality in which places and lives were sorted according to their relevance. People learned what to turn toward and what to turn away from, when the slightest mistake might mean the end of you and your family.

degrees; the Wet, a wild monsoonal season with periodic cyclones; and the glorious Dry, with crisp evenings and warm days. I felt a kinship with the storms that roamed across the flatlands, though they were larger and stronger than I had known in Shreveport, which was rife with tornados but not coastal cyclones. And the monsoons poured for months on end, until everything was in a state of mold and rot. Clothes, skin, building, books: the wretched humidity didn't discriminate. Those who were rich could huddle inside with their air-cooling machines, as they did in Shreveport, and also like my childhood home, those who were too poor just sweltered through the season.

But in addition to what my body knew well—humidity-saturated air and inland freshwater swamps—was a different kind of water and a pattern of existence that congregated there: saltwater seas, reefs, sands, birds, plants, fish, mammals, winds, and reptiles. As I came to know this new kind of water, I came to know a new way of thinking about the relationship between forms of water and categories of person from the Indigenous men and women who lived in a small community across the Darwin Harbor. They saw humans as divided by the mode that water took in their lands: saltwater people, freshwater people, and desert people.

Most members of the Karrabing Film Collective, who are the children and grandchildren of the women and men I met in 1984, are saltwater people. Most of their totems sit within or near the sea. And the travels and interactions of these ancestral totems define the geography of the land and seas, and thus the human and more-than-human worlds that now inhabit them —including immense freshwater swamps protected from the vast tides by coastal sands. Having been primed by my father's parents, I was not surprised that Karrabing believe that saltwater people have it best. And it was not long before we began playing games around kinds of people and forms of water. "Why is saltwater better than freshwater?" "Because saltwater has both." "Why are ice mountains better than swamps?" "Because you can see if an enemy is coming from one side and then quickly sled down the other." They are dumb jokes unless you are in love with the landed conditions that define your difference.

What became clear from my Karrabing colleagues and my grandparents is that pride in one's pattern of existence does not necessarily prompt the figures of Friend and Enemy, nor does it necessitate the citation of the dialectic of the same. One can revel in the patterns of existence that define difference and its constitutive relations without casting other patterns as one's adversary. Secure in where one's totems lie and the constitutive relations of each to others, obligating both to maintain their integrity and difference, one can believe one's own is better than another's and also know that one's own is dependent on the survival of an-other-as-different. Is it hard to notice that other patterns of existence subsist in a relation of difference? And that the differences and relations are necessary if one's own pattern of existence is to persist? Karrabing point to the inland freshwater wetlands and the saltwater seas

that, in order to remain as themselves, must be related and separated by the beaches.

In June 2012, my friend Millie Thrasher dips my neon yellow Nalgene bottle into a small tundra lake and fills it up with fresh, cold, and clear water. She hands it to me and says "here, drink this." I take a sip and the cold-water rushes down my throat and I note how crisp and how fresh it tastes. This is the last taste of unfiltered water I have tried without hesitation since my Dad stopped by a mountain spring on a summer road trip nearly thirty years ago and filled up his water cooler with water gushing next to the Yellowhead Highway. Even then, he warned, we had to know which springs to trust, because it was not that hard to get giardia (beaver fever). "Never drink from a stream or a spring below where people live," he warned my sisters and me. I hardly realized at the time that this was, in fact, a teaching, one warning me of the dwindling number of unpolluted waterways and water sources in Alberta. Here, in Paulatuuq in 2012, the water is clear and safe to drink. Hunters and fishers alike can drink water straight from the lakes and creeks and rivers outside of town without fear of bacteria, amoeba or parasites. As I drink the water, Millie talks about past fishing trips to this lake and we wait for the kettle of water to boil for our tea on the small fire her daughter Sandra has built next to the lake. I can hardly remember the last time I saw water this heart-achingly clear.[3]

> The politics and ethical content of this form of human difference was clear in how the parental and grandparental generations that gave rise to Karrabing treated other styles of human and ancestral relations. For instance, freshwater people do various mortuary rituals differently than do saltwater people—there is a recognizable relation of form in the different enactment of that form. The purpose was to hold one's one pattern of existence by holding in place its rapport with another pattern. Saltwater seas and freshwater swamps are not in an antagonistic relationship—a relation of contention, hostility, and opposition—even as they are assessed as better or worse. Mangroves are not at war with the saltwater that ebbs and rises within them. The parents and grandparents would think that their ways of doing ritual were more elegant and sensible, but never think to act with arrow-like evangelical nomadism. Here we go beyond the Nietzschean distinction between good and bad, and good and evil. Power is neither organized on the basis of ressentiment, nor on a struggle to the death in which one side is undergoing an "absolute liquefaction." This is necessary only if one conflates existence as constitutive relations, as pure Being-for-Itself.

Consciousness was afraid not for this or that, not for this moment or that, but for its [own] entire essential-reality: it underwent the fear of death, the fear of the absolute Master. By this fear, the slavish Consciousness melted internally; it shuddered deeply and everything fixed-or-stable trembled in it. Now, this pure universal [dialectical] movement, this absolute liquefaction of every stable-support, is the simple-or-undivided essential-reality of Self-Consciousness, absolute negating-negativity, pure Being-for-itself.[4]

3
Zoe Todd, "Refracting the State through Human-Fish Relations," *Decolonization: Indigeneity, Education & Society* 7, no. 1 (2018): 63.

4
Alexandre Kojève, *Introduction to a Reading of Hegel: Lectures on the Phenomenology of Spirit*, comp. Raymond Queneau, ed. Allan Bloom, trans. James H. Nichols Jr. (New York: Basic Books, 1969; Ithaca, NY: Cornell University Press, 1980), 21–22.

178

From the point of view of Karrabing, beings that relate only to themselves will have no place to inhabit. Indeed, such Beings-for-Themselves were already pounding the earth into a form that no current being would be able to inhabit. Even as our boastful riddles expressed a joy in comparing without seeking to reduce or conquer difference (freshwater, saltwater, and water in its icy state), the material conditions of our dumb jokes and riddles were being submerged under the weight of the form of human difference that emerged from colonialism and the Black Atlantic—a militant, devouring, and proselytizing One World Order based on the hierarchy of beings and the subsequent actions that could be done to all things beneath one's rank. In Vine Deloria Jr.'s words, this One World Order is the form of revelation to settlers dragged across the earth. This death machine placed into the world the antagonism between those who understood that to keep their difference in place, they had to make space for other modes of differing and relating, and those who demanded that all existence conform to their logic of existence. Those who understood that other humans and the more-than-human world needed spaces for their own patterns of existence, intensions, and designs versus those who saw any difference that did not conform to the hierarchy of Oneness as its enemy.

As the glaciers melt and the saltwater seas rise, there is no more avoiding that the problem isn't human difference, but the harmful—though this is much too weak a word—effect that a form of human difference has had on other ways of enacting and celebrating human differences and on the more-than-human world. This injurious form of human difference stages all relations, whether fashioned through ressentiment or power, within the justificatory framework of actual or potential, implicit and explicit antagonism. If precious minerals lie in the sunken environments of freshwater lakes and ocean beds, or in the ancient formations of mountains and earth beds, then those forms of existence that are in the way— that become "in the way"—are blasted to oblivion.

> White people think that just because no person is living somewhere that that place is being wasted. But that place is not waste. That place is where the turtles live and the wetlands that keep them fed so we can eat them. Turtles need their own place for themselves or how can we find them later.
> — Natasha Bigfoot Lewis, Emmiyangel Karrabing

As the great pounding of capitalism compresses the earth, leaving little room for the rains to be absorbed, new jokes and riddles emerged in our Karrabing banter that pointed to the insanity of the colonial difference and showed how small plants can crack its concrete surface. Why is saltwater better than freshwater? Because there's not going to be any freshwater soon. Why are ice mountains better than freshwater? Because mountains are going to be the new coastline. ●

Based on the video *Melting Glaciers, Rising Seas* (Elizabeth A. Povinelli, 2020) commissioned for "The Shape of a Circle in the Mind of a Fish," Serpentine Galleries, London.

Jim Denomie, *Oz, the Emergence*, 2017 •
COURTESY THE JIM DENOMIE ESTATE AND MINNESOTA MUSEUM OF AMERICAN ART

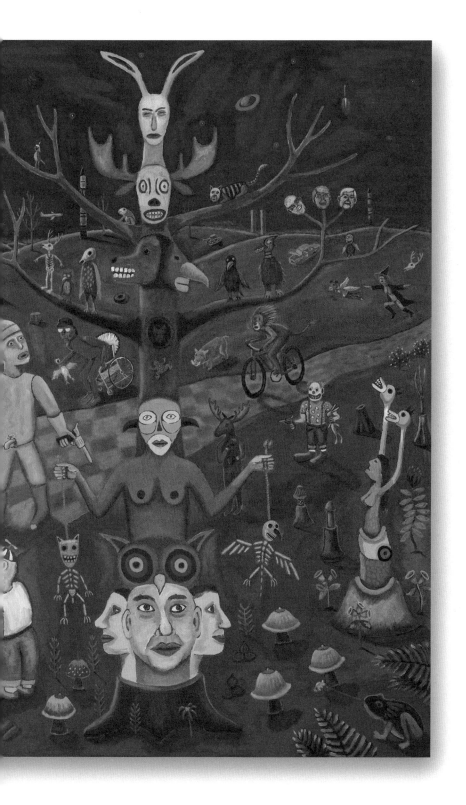

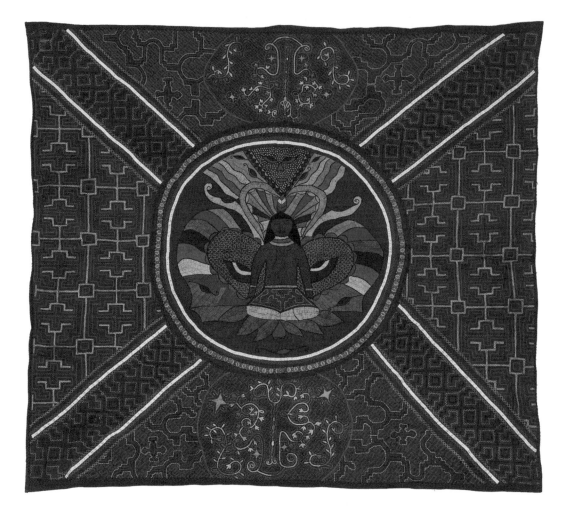

TOP: Olinda Silvano / Reshinjabe, *The Spirit of the Mother Plants*, 2020 •
COURTESY PRIVATE COLLECTION

RIGHT: Olinda Silvano / Reshinjabe, *The Spirit of the Mother Plants*, 2020 •
COURTESY PRIVATE COLLECTION

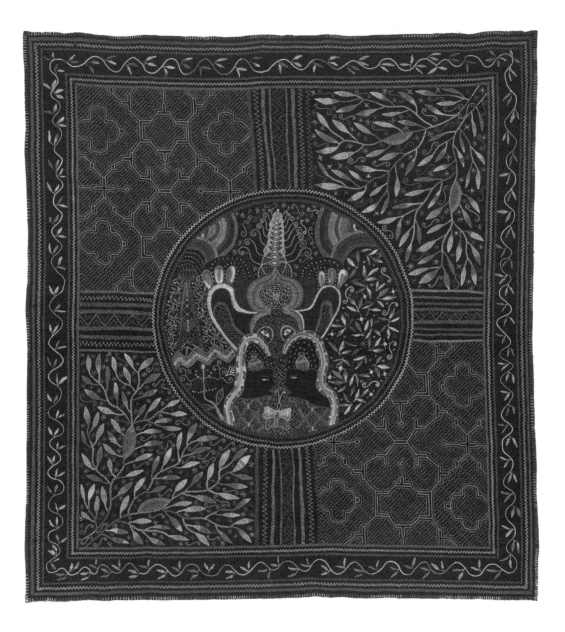

The third night I forgot about food.

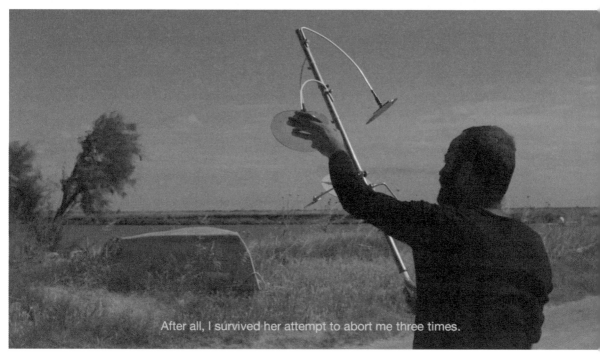

After all, I survived her attempt to abort me three times.

Hiwa K, *Pre-Image* (*Blind as the Mother Tongue*) (film stills), 2017 •
COURTESY THE ARTIST AND KOW, BERLIN

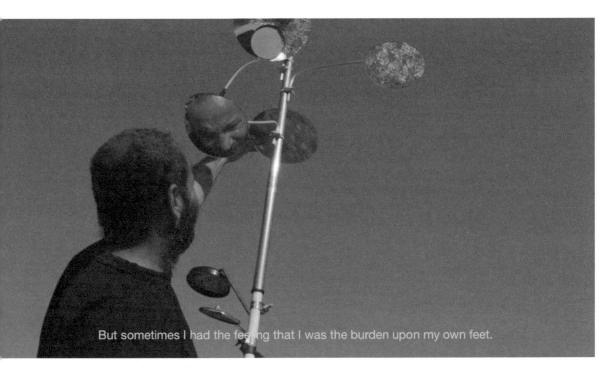

But sometimes I had the feeling that I was the burden upon my own feet.

I was still numb from my journey,

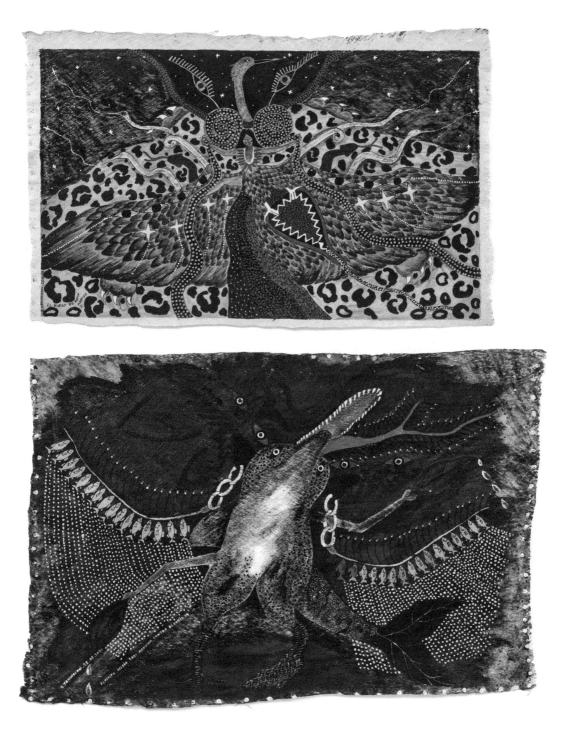

TOP: Santiago Yahuarcani, *El vuelo de Mamá Martha II* [The Flight of Mother Martha II], 2020 •
COURTESY THE ARTIST AND CRISIS GALLERY, LIMA

BOTTOM: Santiago Yahuarcani, *Espíritu Delfín trae medicina contra el Covid-19* [The Dolphin Spirit
Guardian Bringing Medicine to Fight Covid-19], 2020 • COURTESY THE ARTIST AND ATAHUALPA EZCURRA
COLLECTION

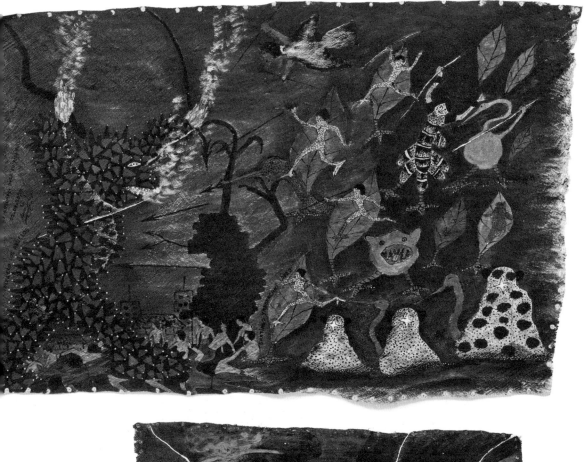

TOP: Santiago Yahuarcani, *Covid-19 pelea con los abuelos* [Covid-19 Fights the Grandparents], 2020 • COURTESY THE ARTIST AND CRISIS GALLERY, LIMA

BOTTOM: Santiago Yahuarcani, *Bancos cashimberos pidiendo a los abuelos la medicina más fuerte contra el Covid-19* [Bancos Cashimberos Asking the Grandparents for the Strongest Covid-19 Medicine], 2020 • COURTESY THE ARTIST AND CRISIS GALLERY, LIMA

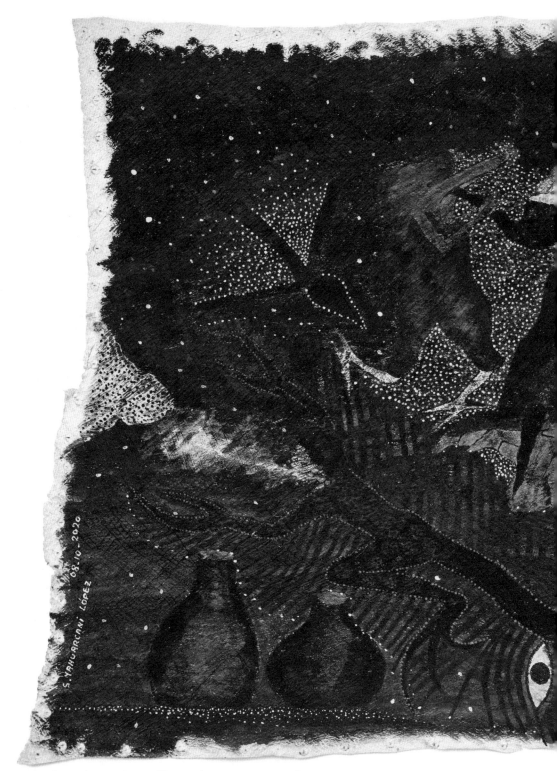

Santiago Yahuarcani, *Curación con ajo sacha a Santiago* [Healing of Santiago with Garlic Vine], 2020
• COURTESY THE ARTIST AND CRISIS GALLERY, LIMA

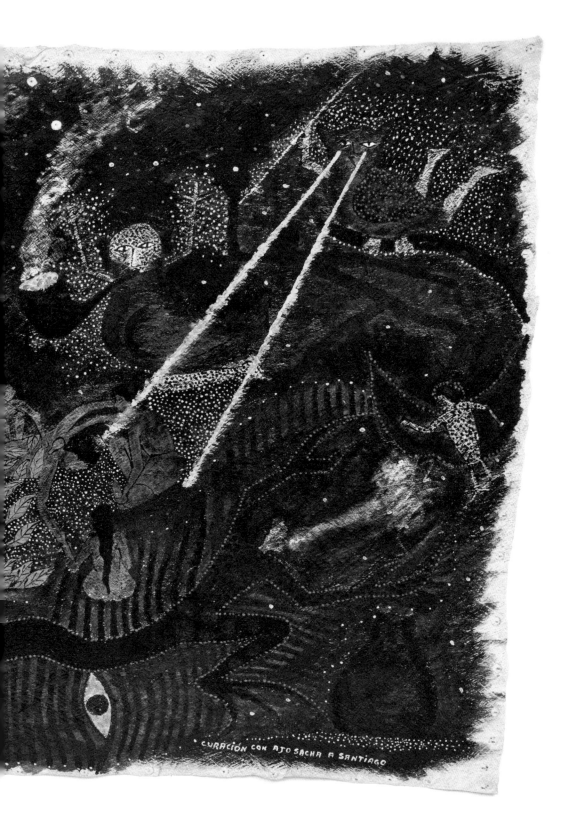

CURACIÓN CON AJO SACHA A SANTIAGO

189

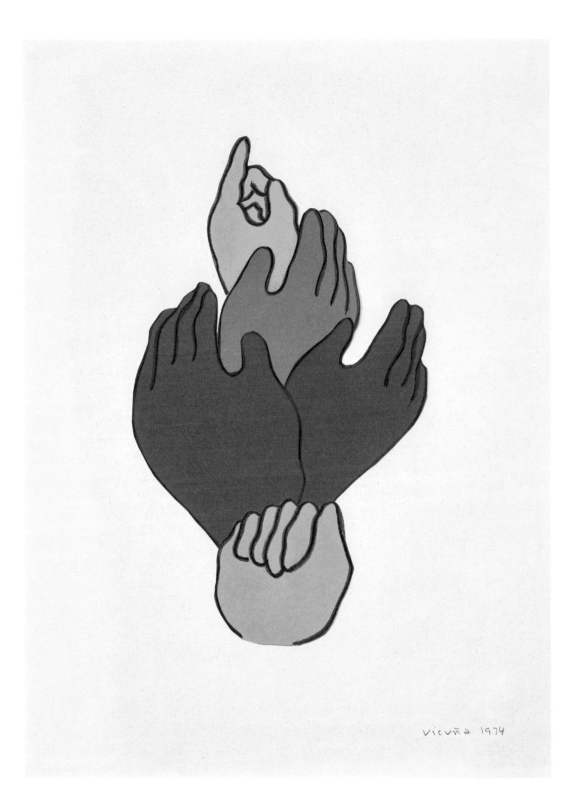

Cecilia Vicuña, *Árbol de manos* [Tree of Hands], 1974 •
COURTESY THE ARTIST AND PRIVATE COLLECTION

Cecilia Vicuña, *Burnt Quipu*, 2018 •
COURTESY THE ARTIST AND
LEHMANN MAUPIN, NEW YORK,
HONG KONG, SEOUL, AND LONDON
Installation view: *And if I devoted
my life to one of its feathers?*,
Kunsthalle Wien, 2021

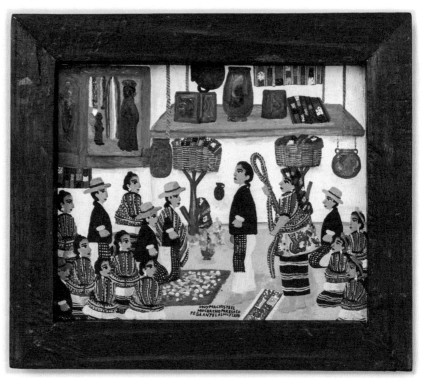

Rosa Elena Curruchich, *Rosa Elena pintando caserío Chosij* [Rosa Elena Painting the Chosij Village], ca. 1980s •
Muy machista el muchacho por eso lo pega ante las mujeres [The Boy Is Very Macho, That Is Why He Is Being
Beaten in Front of the Women], ca. 1980s • ALL COURTESY PRIVATE COLLECTION

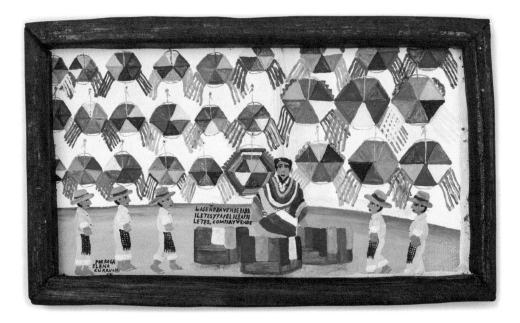

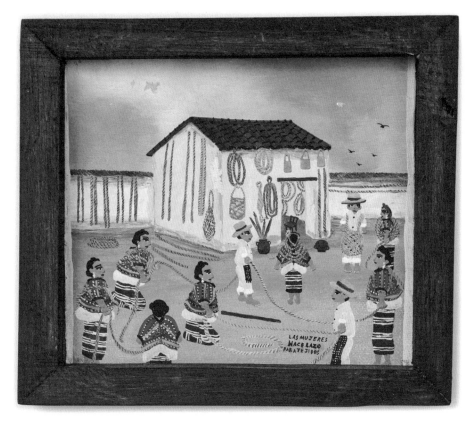

Rosa Elena Curruchich, *La señora vende barriletes y papel de barriletes* [The Lady Sells Kites and Kite Paper], ca. 1980s • *Las mujeres hacen lazo para tejidos* [Women Make Loops for Weaving], ca. 1980s •
ALL COURTESY PRIVATE COLLECTION

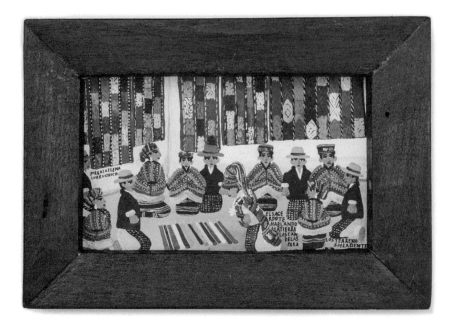

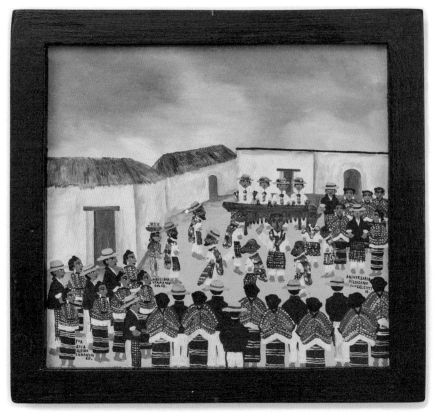

Rosa Elena Curruchich, *El sacerdote hablando a la tierra y las candelas para los terrenos de la gente* [The Priest Speaking to the Soil and the Candles for the Lands of the People], ca. 1980s • *Rosa Elena vendiendo dulce. Aniversario del caserío San Balentin* [Rosa Elena Selling Candies: Celebration of San Balentin Village], ca. 1980s • ALL COURTESY PRIVATE COLLECTION

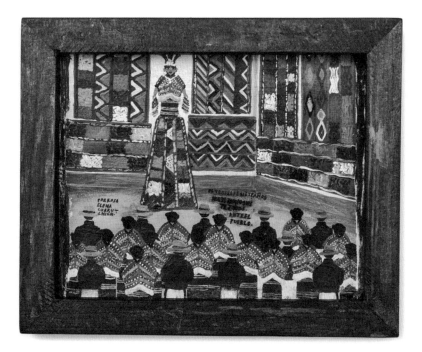

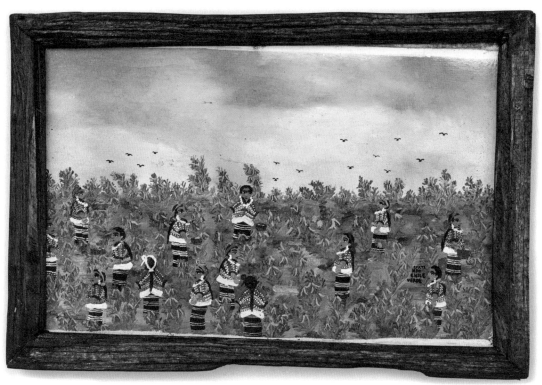

Rosa Elena Curruchich, *Patojita de siete años presentando sus tejidos ante el pueblo* [Seven-Year-Old Girl Presenting Her Textiles to the Community], ca. 1980s • *Recogiendo chile verde* [Picking Green Chili], ca. 1980s • ALL COURTESY PRIVATE COLLECTION

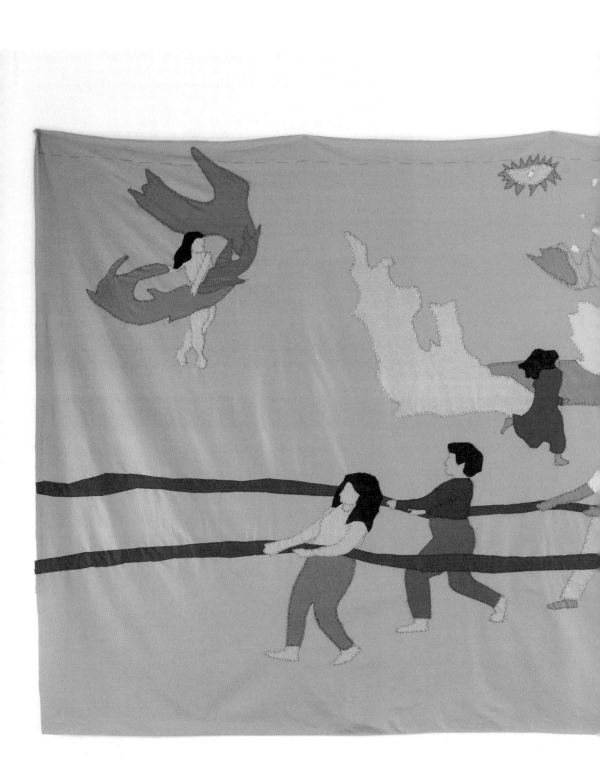

Sophie Utikal, *A New World Is Coming*, 2021 • COURTESY THE ARTIST

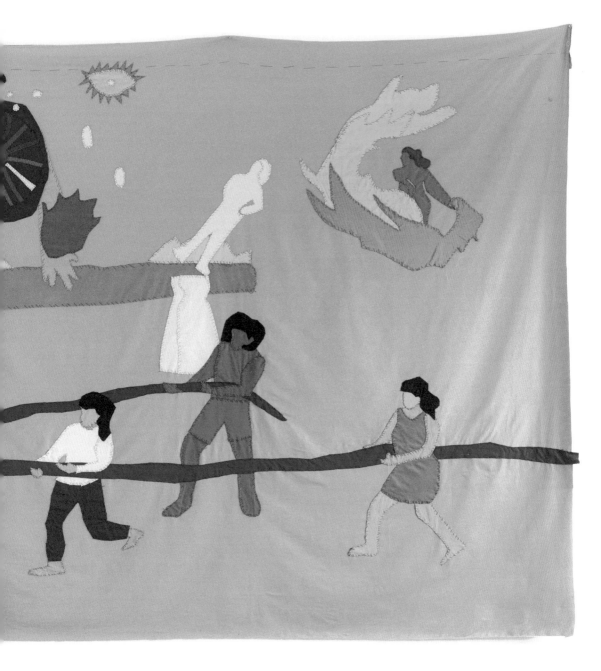

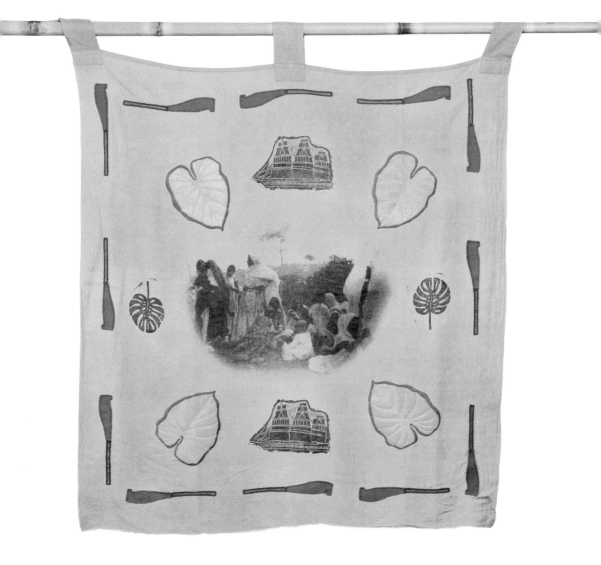

Quishile Charan, *Ee ghaoo maange acha ho jai* [These Wounds Must Heal], 2019

Quishile Charan, *Company Ka Raj* [Company Is King], 2021

We the sodomites, the perverts, the inverts, the faggots, the deviants, the queers, the keepers of spoiled identities, the tribadists, the promiscuous, the popper sniffing fist fuckers, the bottoms and the tops, the vers, the queens and the fairies, the nellies, the nancies and the fannies, the lady boys, the butch lesbians, the leather angels, the dykes, the daddies and the bulldaggers, the crossdressers and the drag queens, the auntie men, the Kikis, the trannies, the celesbians, the clones, the dykes on bikes, the sissies, the bone smugglers, the muscle marys, the jocks, the twinks, the bears and the otters, the sex pigs, the handballers, the gym queens, the hung, the carpet munchers, the pussy punchers, the fudge packers, the fruits, those who are light in the loafers, those who have sugar in the tank, the cocksuckers, the daffies, the friends of Dorothy, the bent, the poofs, the poofters, the buggers, the Uranians, the pillow biters, the sisters of Sappho, the silver foxes, the temperamental, the homophiles, the masters and the slaves, the tatted and pierced queens, the tightly-bound, the Lavender Menace, the pansies, the go-go boys, the hustlers, the trades, the chapstick lesbians, the lucky Pierres, the rough trades, the lacies, those who are queer as a three dollar bill, the mother superiors, the ring snatchers, the kissing fish, the tinkerbelles, the Ursulas, the vampires, the punks, the agfays, the ass bandits and the butt pirates, the beefcakes, the yard boys, the Zanies, the muff divers, the golden boys, the ten percenters, the sperm burpers, the boys in the band, the disordered, the dysfunctional, the diseased and the destructive, the bitches, those on the down low and the low down, the drag kings, the Tammies, the he-shes, the fishy girls, the cunts, the cut and the uncut, the bum bandits, the lipstick lesbians, the hard and the soft butches, the flamers, the gender benders, the butt huggers, the chicken hawks, the femme, the fuck boys, the gaylords, the masc for mascs, the no pic no chats, the tranny chasers, the homos, the baby dykes, the gold stars, the gender queers, the pillow princesses, the studs, the bug chasers, the barebackers, those who PnP, the campy queens, the sword swallowers, the confirmed bachelors, the members of a Boston marriage, the shims, those who read Playboy for the articles, the Rosies, the people who are batting for the other team, the AIDS carriers, the undetectables, the pozzies, those on PrEP, the weak and morally sick wretches, the deplorables, the sinners, the hedonists, those with the aristocratic vice, those who enjoy the bourgeois decadence, the Catamites and the Calamites, the cake eaters, the chubby chasers, the midnight cowboys, the daffodils, the fey, the Ganymedes, the limp-wristed, the salad tossers, the ponces, those who are swishy, those of the reprobate mind, the hermaphrodites, the chicks with dicks, the chemsexers, the bearded ladies, the serodiscordants, the heartthrobs, the theatrical types, the admirers, those who aren't 'clean', the freaks, the cum guzzlers, the cumdumps, the tea dancers, the momma's boys, the hot messes, the batty bois, the degenerates...are and will always be the enemy.

Author: SPIT! (Sodomites, Perverts, Inverts, Together!)
Year: 2017

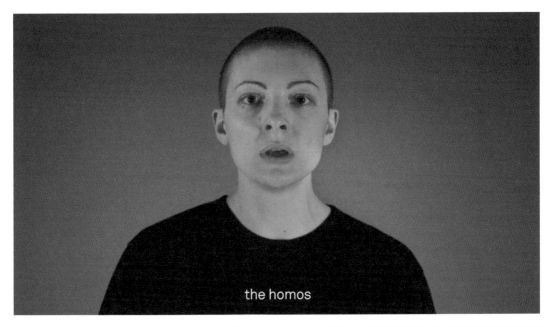

the homos

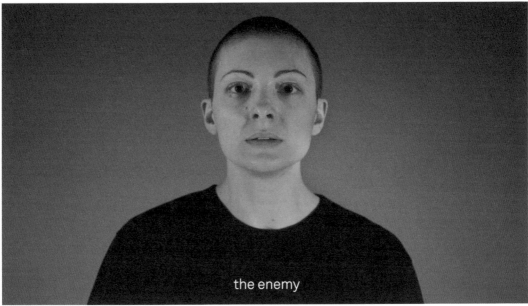

the enemy

ABOVE: SPIT! (Sodomites, Perverts, Inverts Together! / Carlos Maria Romero, Carlos Motta & John Arthur Peetz), *We The Enemy* (film stills), 2017
LEFT: SPIT! (Sodomites, Perverts, Inverts Together! / Carlos Maria Romero, Carlos Motta & John Arthur Peetz), *We The Enemy* (poster), 2017 • COURTESY THE ARTISTS

Manuel Chavajay

Feathers under the Sun

Popol Vuh:[1] our ancestors tell us that energies created all the things of our Mother Earth and each animal, tree, rock was given a task to fulfill. But when they had finished, they noticed that there was no-one to carry the desires and thoughts from one place to another. As there was no more mud or maize to create another animal, they took a Jade stone and carved a very small arrow. When it was done, they blew over it and the arrow began to fly, turning into a hummingbird. These were so fragile and light that they could approach the most delicate flowers without moving their petals. Their feathers glistened under the sun like raindrops, reflecting all colors.

Our language, Tz'utujil, comes from sounds, the affirmation of moments, ancestral thoughts. While working, I am always thinking in my language, and in my dreams, the messages of my ancestors complement my artistic production.

I can see myself in Lake Atitlán, in the mountains, in the clouds. Changes have taken place in such short time. It's unbelievable. I was lucky to have grown up on the shores of the lake, playing on the stretches of the beach, and then drinking water from the shore of the lake. As the sun sets, the game continues on the docks and in the lake. I can remember seeing our Mother Moon come out as she illuminated these moments. Many times we would also go fishing and my father told us about when they had gone fishing and that there was an abundance of fish.

1
The name "Popol Vuh" translates as "Book of the Community." It was originally preserved through oral tradition until 1550 when it was recorded in written. The text recounts the history of the Maya K'iche' people.

At times, they would throw themselves directly into the tiny canoe. It makes me very sad to know that new generations won't get to experience this because of buildings that were beginning to get constructed near the shore and because of privatization and polluting of the shores in various other ways. Landscapes are an element present in my artistic production as well as the capitalist system, which causes us to move backwards every day. The invasion of megaprojects and other issues that are killing us. There are violent evictions of Indigenous communities, femicides, extreme poverty, problems of education and health.

As the jade arrow was blown into a hummingbird, an act was left behind that some of our grandmothers and grandfathers continue to do to this day for our ancestors. To blow means jub'aaj in our language. For example, when harvesting maize, the first cob is blown on, acknowledged, and respected because it is holy. The same is being done to stones, fire, medicinal plants, harvests, pain, holy sites. If our grandmothers and grandfathers tell us not to touch something because it is holy, we don't ask questions. As we grow up, we realize what it is that they have been talking about and that the dialogue is constant. Currently, respect is being lost for the holy. Another example: before going into the lake, we have to give it a kiss and ask for its permission. A dialogue for every action. The same goes for medicinal plants. You ask them for permission when cutting them and we ask the plant to heal the person who is ill.

Manuel Chavajay, *Untitled*, from the series *Keme*, 2016 • COURTESY THE ARTIST AND GALERÍA EXTRA, GUATEMALA CITY

TRANSLATED BY Daphne Nechyba

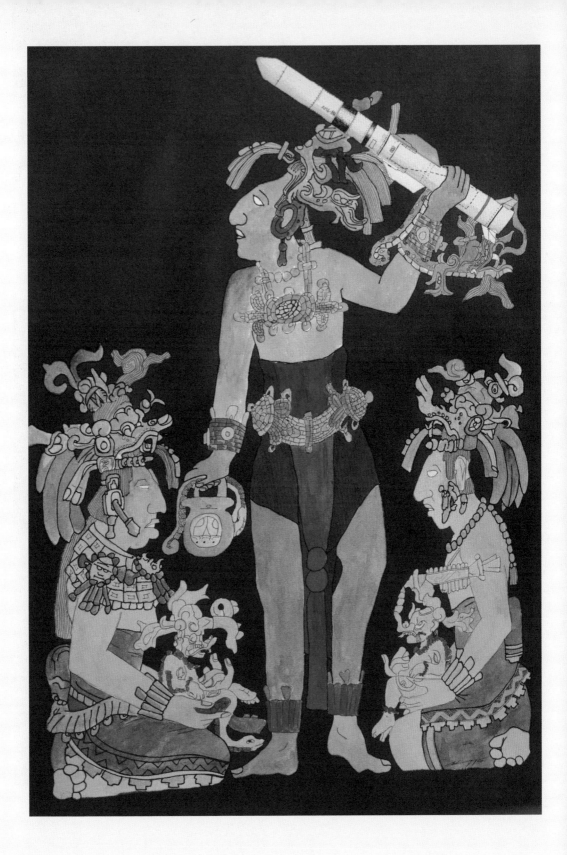

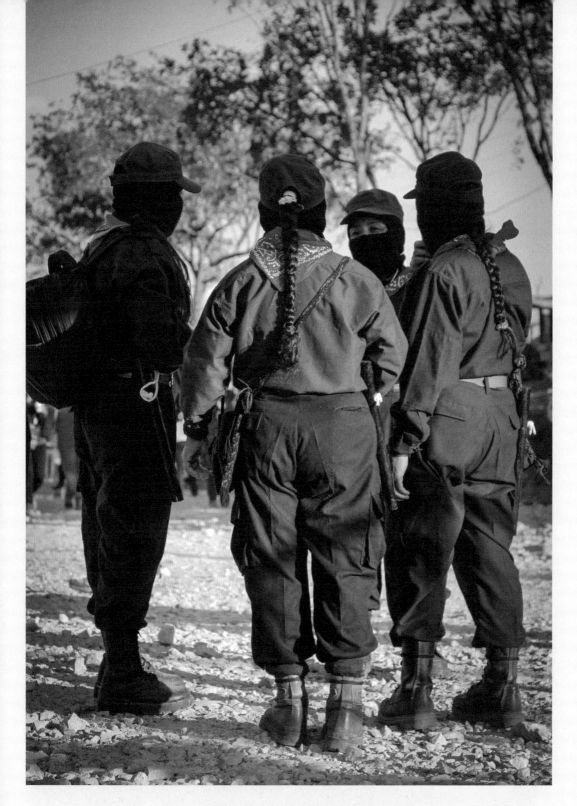

Insurgents in the *First Encounter of Women in Struggle*, 2018

Mia Eve Rollow (Zapantera Negra)

and if I devoted myself to one of its feathers? a zapantera negra prayer

We flew over war cries, the land eyes looked up and recognized our sign, pain became less strong as liberation flies.
Freedom is in the air, in the heartbeat of the earth, in the rhythm of our wings as we glide straight, in the rhythm of the drums of all the keepers of truth. In this beat we bask in our sol roots, to the veins of life that flow through the trees, and the silk mineral water that flows upon the land. We fly to the heart-beat of the middle of the earth, of the time before times, when matter didn't exist, and names were nameless. Our wings knew the First Nations way, they heard the whispers of the ancient mammoth's herd galloping Comandanta Ramona footprints upon the land, I sat on their ivory tusks and looked into their soul eyes, and knew all.

Our feathered wings knew many faces.
We were the midnight darkness in the feathered Black Panther, empress of all beings staring through rebellious horizons as rainbow slides. We were the feathered dragon's flight, Quetzal-coatl, made of myth and magic, swallowed the sun and used its rays as our witchcraft. We were the feathered dinosaurs, older and outliving any cage, we laid eggs that mimicked the moons, soft silver glowing over all the galaxy's millions of lightless nights. We formed a bridge to earth; spirits rode our backs to visit the living, invisible, we were made of all the luminescent colors that exist, dignity on our back.

Ancient bird, pyramid of my sky, why do you sing blazing the distance with your song? Sweet one, our song sings to the web of life, to the day which is night, we chant to raise the blood flow of the earth, to the greenness of leaves, to the wolves' howl, and the reindeers' horns. We chant throughout the jungle, the desert, the forest, el barrio and la isla's edge. We chant with copal spiraling up for rebirth and union of aguila and condor, for the lost stories to be found. We chant for Mother Earth's wisdom that the original people felt, the guardians of the feather, the head-dressed whale of the land and sea that spoke a tongue of life. We flew with our umbilical cord rooted in the earth, to outer space and could still hear the song from Grandmother Earth's tribes, her tonka rocks glowing like stars from the amber fire's belly. Our wings flew us, we swayed through the air over your poison, in trance by the billion suns that rose over our iridescent feathers. Devoted, in love, flying like an arrow in memory and prayer of all that is we.

Black, Black, Blac

Victoria Santa Cruz, *Me gritaron negra* [They Called Me Black] (film still), 1978 •
COURTESY ODIN TEATRET FILM, HOLSTEBRO

ack, Black, Black!

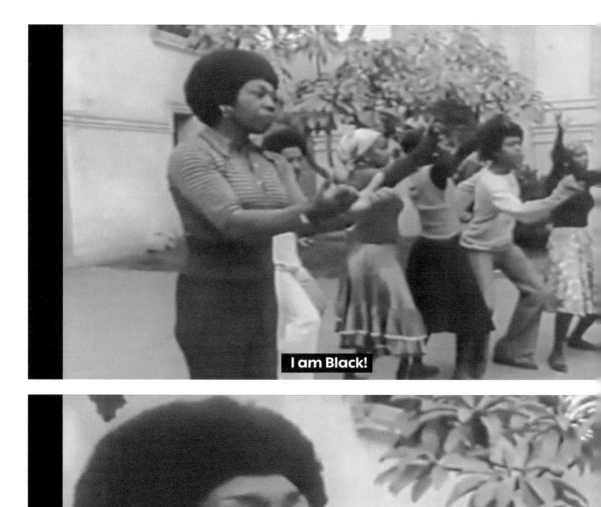

Victoria Santa Cruz, *Me gritaron negra* [They Called Me Black] (film stills), 1978 •
COURTESY ODIN TEATRET FILM, HOLSTEBRO

"They Called Me Black"

A rhythmical poem by **Victoria Santa Cruz**

ANNOTATION: The chorus is set in italics.

I was only seven years old, only seven,
What am I saying,
I wasn't even five!

♩♩♩♪♩♩♪♩♩♩♪♩♩ (CLAPPING)

Suddenly, some voices on the street called me *Black girl!*
Black girl! Black girl! Black girl! Back girl!
Black girl! Black girl! Black girl!
"Perhaps I am Black?," I asked myself
YES!
"What does it mean to be Black?"
Black!
I couldn't fathom the sad truth behind what this meant.
Black!
And I felt Black,
Black!
As they said,
Black!
And I recoiled,
Black!
As they wanted me to,
Black!
And I hated my hair and my full lips and I looked at my dark skin
with sorrow
And I recoiled
Black!
And recoiled ...
Black! Black! Black! Black!
Black! Black! Blaaack!
Black! Black! Black! Black!
Black! Black! Black! Black!

And time passed,
I was always bitter,
I kept carrying this heavy load on my shoulders

♩♩♩♪♩♩♪♩♩♩♪♩♩ (CLAPPING)

How heavy it was! ...
I straightened my hair,
powdered my face,
and the same word resounded through my insides
Black! Black! *Black! Black!*
Black! Black! *Blaaack!*
Until one day of my recoiling,
I did so until I almost fell
Black! Black! *Black! Black!*
Black! Black! *Black! Black!*
Black! Black! *Black! Black!*
Black! Black! *Black!*
So what?

♪♪♪♪— (PERCUSSION)

So what?

Black!
Yes
Black!
I am
Black!
Black
Black!
I am Black

Black!
Yes
Black!
I am
Black!
Black
Black!
I am Black

From today on I don't want to straighten my hair
I don't want to
And I will laugh at those who — in trying to avoid distaste —
Call Blacks "colored"[1]
And what color!
BLACK
And how sweet the sound!
BLACK
And what a rhythm it has!
BLACK BLACK BLACK BLACK
BLACK BLACK BLACK BLACK
BLACK BLACK BLACK BLACK
BLACK BLACK BLACK
Finally
Finally, I understood

[1] The Spanish term *"gente de color"* is not equivalent to its literal translation "people of color." The latter is a political self-designation that also includes Black people. For this reason, the colonial term "colored" was chosen as it represents a label that was ascribed to Black people in the United States. During the civil rights movement of the 1960s, "colored" was reappropriated and changed to "people of color" by Black and Brown communities.

214

FINALLY
I don't recoil anymore
FINALLY
I move forward with confidence
FINALLY
I walk and I hope
FINALLY
I bless the skies because God created my Black skin
And I now understand
FINALLY
I now have the key
BLACK BLACK BLACK BLACK
BLACK BLACK BLACK BLACK
BLACK BLACK BLACK BLACK
BLACK BLACK
I am Black!

TRANSLATED BY Daphne Nechyba

Language
Is Migrant

Cecilia Vicuña

Language is migrant. Words move from language to language, from culture to culture, from mouth to mouth. Our bodies are migrants; cells and bacteria are migrants too. Even galaxies migrate.

What is then this talk against migrants? It can only be talk against ourselves, against life itself.

Twenty years ago, I opened up the word "migrant," seeing in it a dangerous mix of Latin and Germanic roots. I imagined "migrant" was probably composed of *mei*, Latin for "to change or move," and *gra* [heart] from the Germanic *kerd*. Thus, "migrant" became "changed heart,"

> a heart in pain,
> changing the heart of the earth.

The word "immigrant" says, "grant me life."

"Grant" means "to allow, to have," and is related to an ancient Proto-Indo-European root: *dhe*, the mother of "deed" and "law." So too, *sacerdos*, performer of sacred rites.

What is the rite performed by millions of people displaced and seeking safe haven around the world? Letting us see our own indifference, our complicity in the ongoing wars?

Is their pain powerful enough to allow us to change our hearts? To see our part in it?
I "wounder," said Margarita, my immigrant friend, mixing up wondering and wounding, a perfect embodiment of our true condition!

Vicente Huidobro said, "Open your mouth to receive the host of the wounded word."
The wound is an eye. Can we look into its eyes?

> my specialty is not feeling, just
> looking, so I say:
> (the word is a hard look.)
> —Rosario Castellanos

> I don't see with my eyes: words
> are my eyes.
> —Octavio Paz

In 1980, I was in exile in Bogotá, where I was working on my *Palabrarmas* project, a way of opening words to see what *they* have to say. My early life as a poet was guided by a line from Novalis: "Poetry is the original religion of mankind." Living in the violent city of Bogotá, I wanted to see if anybody shared this view, so I set out with a camera and a team of volunteers to interview people in the street. I asked everybody I met: "What is Poetry to you?" I got great answers from beggars, prostitutes, and policemen alike. But the best was, "*Que prosiga*," "That it may go on"—how can I translate the subjunctive, the most beautiful *tiempo verbal* [time inside the verb] of

the Spanish language? "Subjunctive" means "next to" but under the power of the unknown. It is a future potential subjected to unforeseen conditions, and that matches exactly the quantum definition of emergent properties.

If you google the subjunctive you will find it described as a "mood," as if a verbal tense could feel: The subjunctive mood is the verb form used to express a wish, a suggestion, a command, or a condition that is contrary to fact. Or the "present" subjunctive is the bare form of a verb (that is, a verb with no ending).

I loved that! A never-ending image of a naked verb! The man who passed by as a shadow in my film saying "*Que prosiga*" was on camera for only a second, yet he expressed in two words the utter precision of Indigenous oral culture.

People watching the film today can't believe it was not scripted, because in thirty-six years we seem to have forgotten the art of complex conversation. In the film people in the street improvise responses on the spot, displaying an awareness of language that seems to be missing today. I wounder, how did it change? And my heart says it must be fear, the ocean of lies we live in, under a continuous stream of doublespeak by the violent powers that rule us. Living under dictatorship, the first thing that disappears is playful speech, the fun and freedom of saying what you really think. Complex public conversation goes extinct, and along with it, the many species we are causing to disappear as we speak.

The word "species" comes from the Latin *speciēs*, "a seeing." Maybe we are losing species and languages, our joy, because we don't wish to see what we are doing.
Not seeing the seeing in words, we numb our senses.

I hear a "low continuous humming sound" of "unmanned aerial vehicles," the drones we send out into the world carrying our killing thoughts.

Drones are the ultimate expression of our disconnect with words, our ability to speak without feeling the effect or consequences of our words. "Words are acts," said Paz.

Our words are becoming drones, flying robots. Are we becoming desensitized by not feeling them as acts? I am thinking not just of the victims but also of the perpetrators, the drone operators. Tonje Hessen Schei, director of the film *Drone* (2014), speaks of how children are being trained to kill by video games: "War is made to look fun, killing is made to look cool ... I think this 'militainment' has a huge cost," not just for the young soldiers who operate them but for society as a whole. Her trailer opens with these words by a former aide to Colin Powell in the Bush/Cheney administration:

> OUR POTENTIAL COLLECTIVE FUTURE. WATCH IT
> AND WEEP FOR US. OR WATCH IT AND DETERMINE TO
> CHANGE THAT FUTURE
> —Lawrence Wilkerson, Colonel U.S. Army (retired)

In "Astro Noise", the 2016 exhibition by Laura Poitras at the Whitney Museum

of American Art in New York, the language of surveillance migrates into poetry and art. We lie in a collective bed watching the night sky crisscrossed by drones. The search for matching patterns, the algorithms used to liquidate humanity with drones, is turned around to reveal the workings of the system. And, we are being surveyed as we survey the show! A new kind of visual poetry connecting our bodies to the real fight for the soul of this Earth emerges, and we come out woundering: Are we going to dehumanize ourselves to the point where Earth itself will dream our end?

The fight is on everywhere, and this may be the only beauty of our times. The Quechua speakers of Peru say, "beauty is the struggle."

Maybe darkness will become the source of light. (Life regenerates in the dark.)

I see the poet/translator as the person who goes into the dark, seeking the "other" in him/herself, what we don't wish to see, as if this act could reveal what the world keeps hidden.

Eduardo Kohn, in his book *How Forests Think: Toward an Anthropology Beyond the Human* (2013) notes the creation of a new verb by the Quichua speakers of Ecuador: *riparana* means "darse cuenta," "to realize or to be aware." The verb is a Quichuan transfiguration of the Spanish *reparar* [to observe, sense, and repair]. As if awareness itself, the simple act of observing, had the power to heal.

I see the invention of such verbs as true poetry, as a possible path or a way out of the destruction we are causing.

When I am asked about the role of the poet in our times, I only question: Are we a "listening post," composing an impossible "survival guide," as Paul Chan has said? Or are we going silent in the face of our own destruction?

Subcomandante Marcos, the Zapatista guerrilla, transcribes the words of El Viejo Antonio, an Indian sage: "The gods went looking for silence to reorient themselves, but found it nowhere." That nowhere is our place now, that's why we need to translate language into itself so that IT sees our awareness.

Language is the translator. Could it translate us to a place within where we cease to tolerate injustice and the destruction of life?

Life is language. "When we speak, life speaks," says the Kaushitaki Upanishad. Awareness creates itself looking at itself.

It is transient and eternal at the same time.

Todo migra. Let's migrate to the "wounderment" of our lives, to poetry itself. ●

This text was first published by *Harriet Blog*, Poetry Foundation, 18 April 2016.
Online: www.poetryfoundation.org/harriet/2016/04/language-is-migrant/.

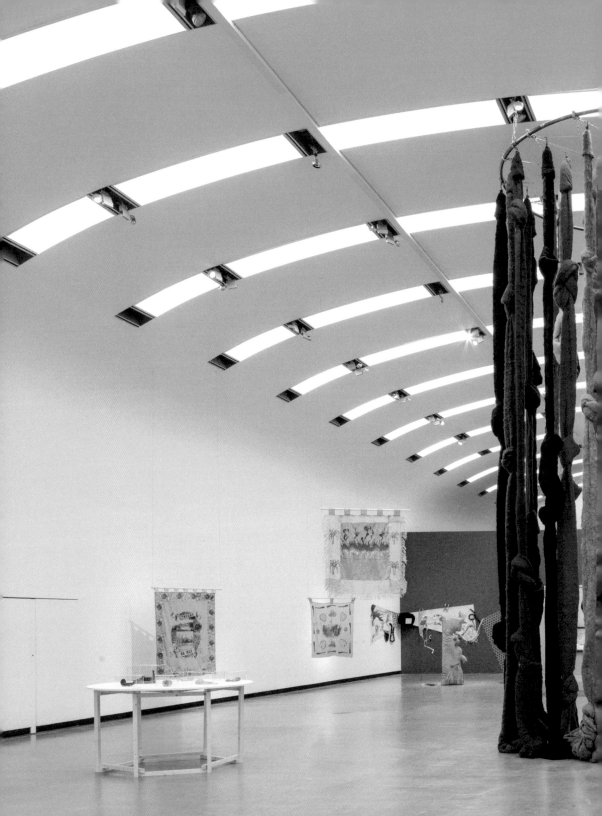

Installation view: *And if I devoted my life to one of its feathers?*, Kunsthalle Wien, 2021

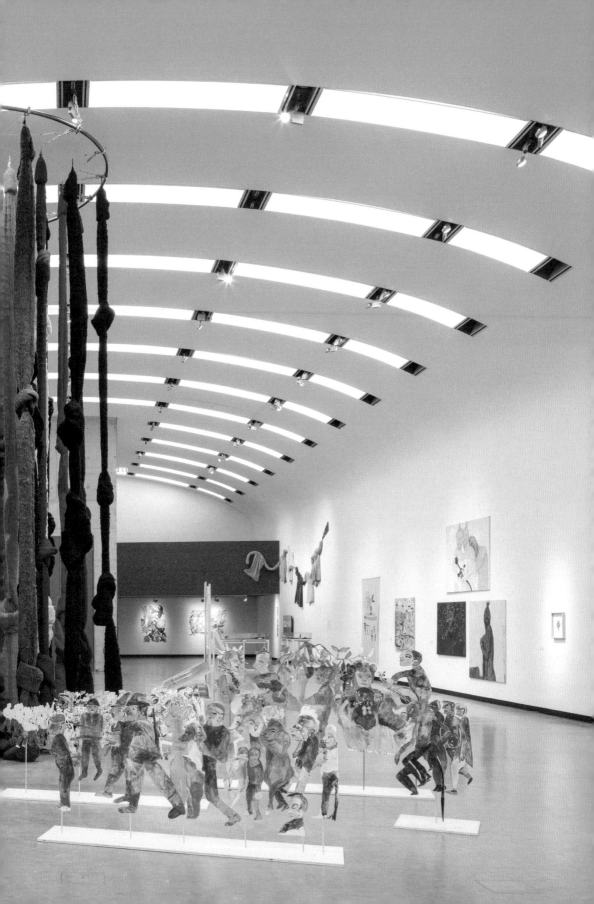

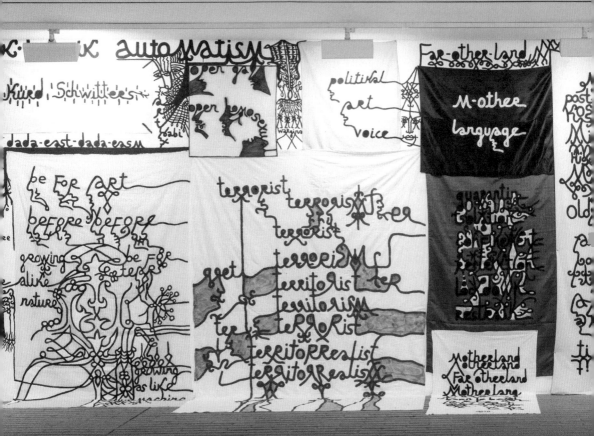

Babi Badalov, *M—otherland*, 2021
Installation view: *And if I devoted my life to one of its feathers?*, Kunsthalle Wien, 2021

K'apitalism
Kills
Kulturalism

BB sea
sea nn

born arti RACIST arti Fashist sreisuti

here he are
here hee are
she are hi are
we are via
You are U are

now future
hally-See-Nation
M
war scream
war CRY-M

living
leaving

you are
he are
we are
perukee
Welcome
refugees
will
come

spieders
spieders
spieders

all wars are made by men

born to be
born born

WhoManEast
WhoManEas
poetixal politikers
Visual art

blue bleu blu blah bla bla bla blue blue blue blah blah bl

stay at

make

Castiel Vitorino Brasileiro, *Gastrite* [Gastritis], 2019
Installation view: *And if I devoted my life to one of its feathers?*, Kunsthalle Wien, 2021

TOP: Denilson Baniwa, *Qual Limite da Amazônia* [What Limit of the Amazon], 2020; *Bye Bye Brazil*, 2020
BOTTOM: Castiel Vitorino Brasileiro, *Gastrite* [Gastritis], 2019
Installation views: *And if I devoted my life to one of its feathers?*, Kunsthalle Wien, 2021

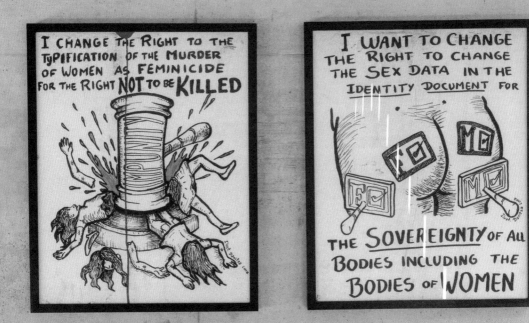

María Galindo & Danitza Luna, *La piel de la lucha, la piel de la historia*
[The Skin of the Fight, the Skin of History], 2019
Installation view: *And if I devoted my life to one of its feathers?*, Kunsthalle Wien, 2021

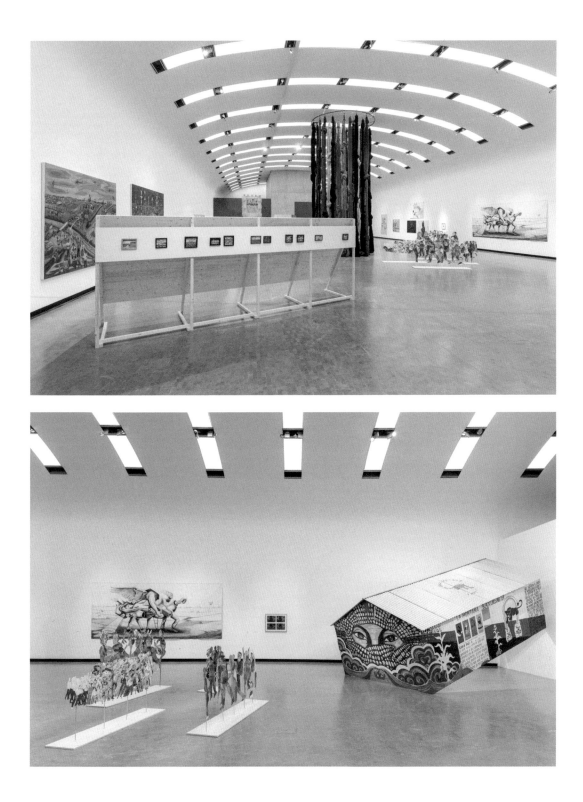

Installation views: *And if I devoted my life to one of its feathers?*, Kunsthalle Wien, 2021

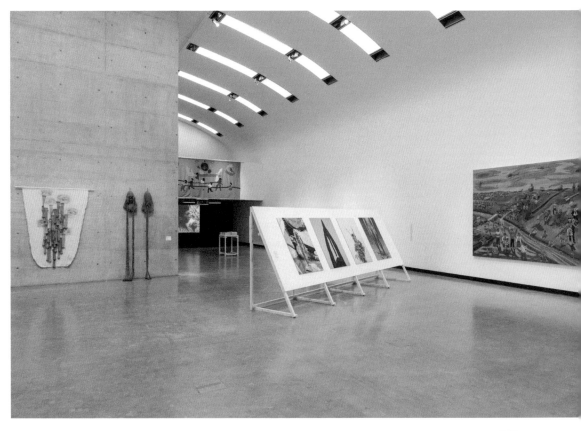

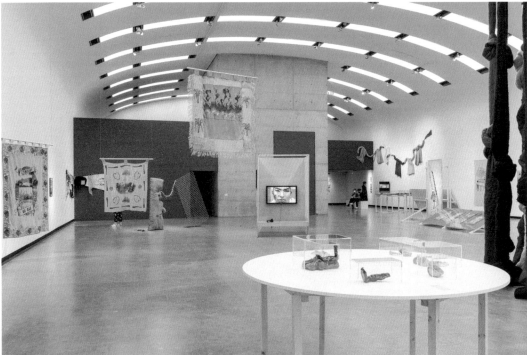

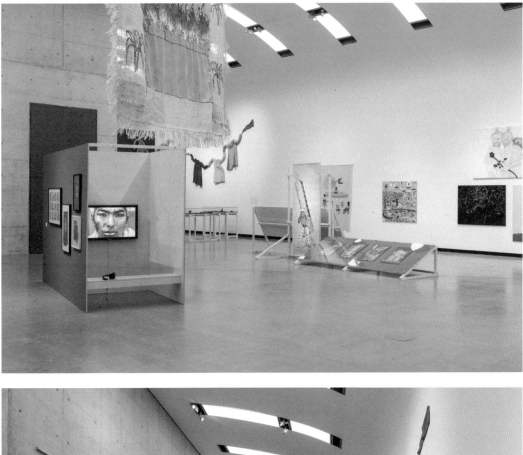

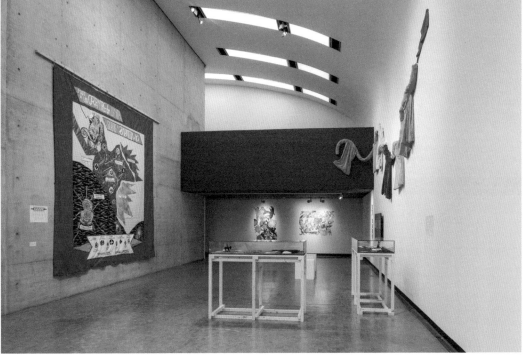

Installation views: *And if I devoted my life to one of its feathers?*, Kunsthalle Wien, 2021

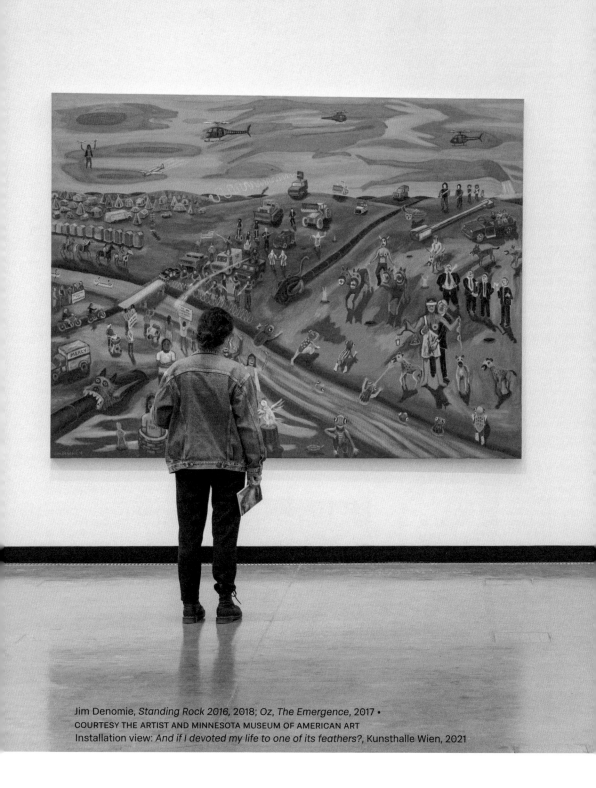

Jim Denomie, *Standing Rock 2016*, 2018; Oz, *The Emergence*, 2017 •
COURTESY THE ARTIST AND MINNESOTA MUSEUM OF AMERICAN ART
Installation view: *And if I devoted my life to one of its feathers?*, Kunsthalle Wien, 2021

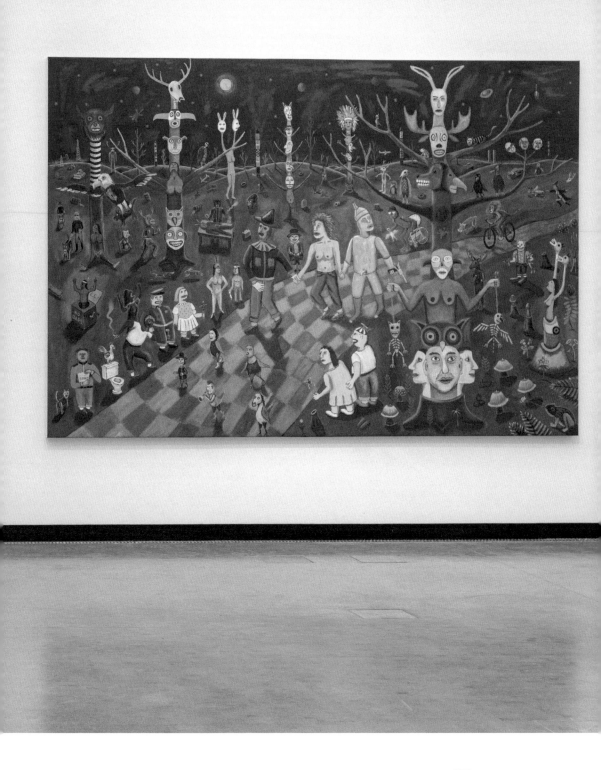

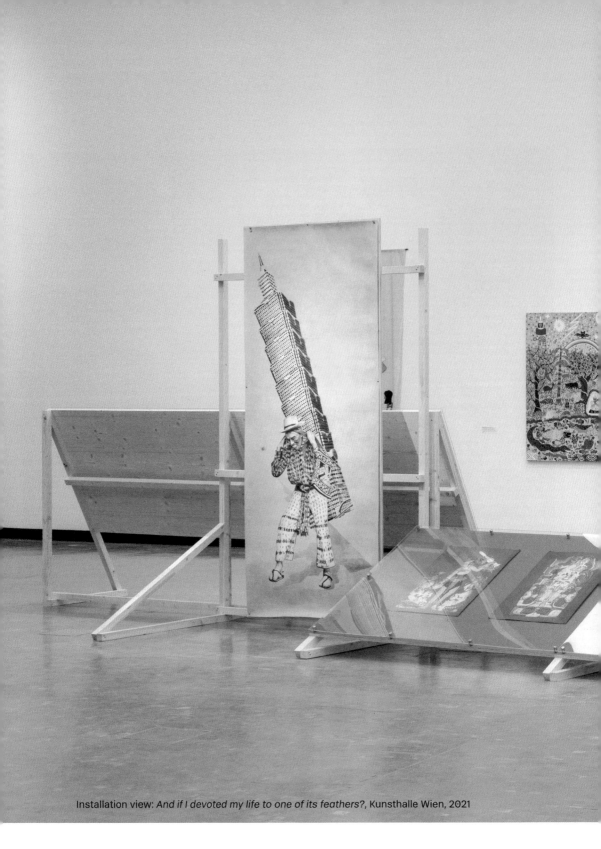

Installation view: *And if I devoted my life to one of its feathers?*, Kunsthalle Wien, 2021

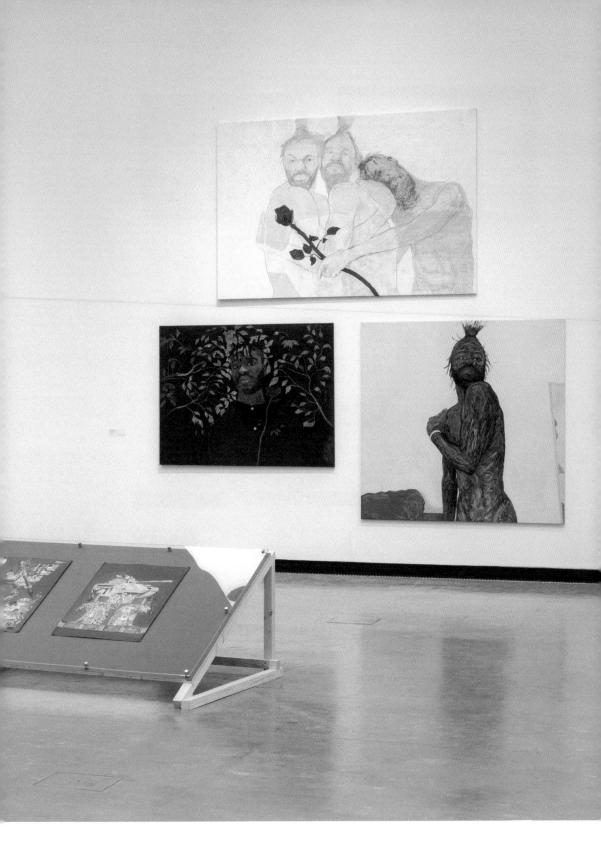

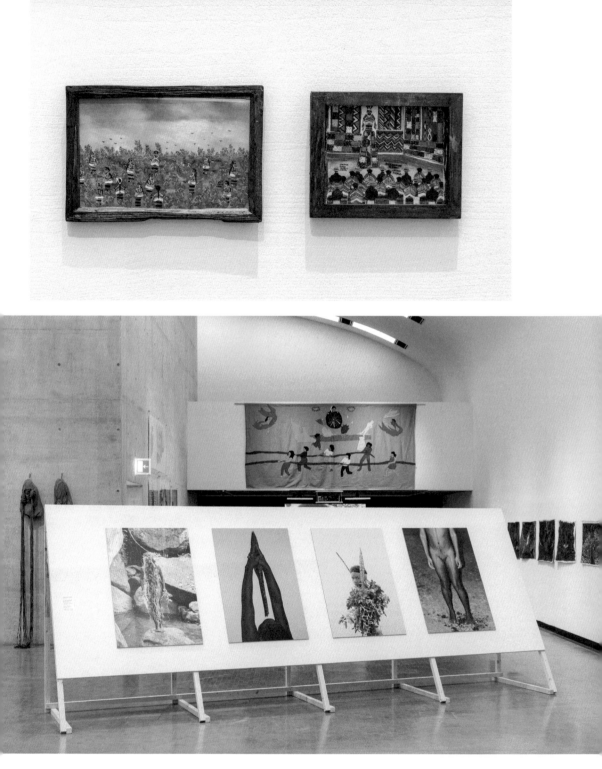

Installation views: *And if I devoted my life to one of its feathers?*, Kunsthalle Wien, 2021

TOP: Rosa Elena Curruchich, *Recogiendo chile verde* [Picking Green Chili], ca. 1980s; *Patojita de siete años presentando sus tejidos ante el pueblo* [Seven-Year-Old Girl Presenting Her Textiles to the Community], ca. 1980s • COURTESY PRIVATE COLLECTION

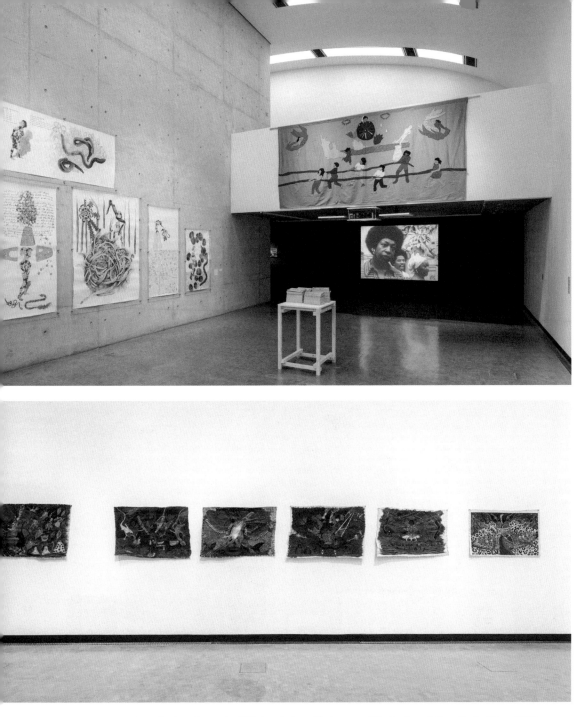

Installation views: *And if I devoted my life to one of its feathers?*, Kunsthalle Wien, 2021

BOTTOM: Santiago Yahuarcani, *Covid-19 pelea con los abuelos* [Covid-19 Fights the Grandparents], 2020; *Bancos cashimberos pidiendo a los abuelos la medicina más fuerte contra el Covid-19* [Bancos Cashimberos Asking the Grandparents for the Strongest Covid-19 Medicine], 2020; *Sesión de ajo sacha* [Garlic Vine Session], 2020; *El vuelo de Mamá Martha II* [The Flight of Mother Martha II], 2020 • COURTESY THE ARTIST AND CRISIS GALLERY, LIMa; *Espíritu Delfín trae medicina contra el Covid-19* [The Dolphin Spirit Bringing Medicine to Fight Covid-19], 2020 • COURTESY THE ARTIST AND ATAHUALPA EZCURRA COLLECTION

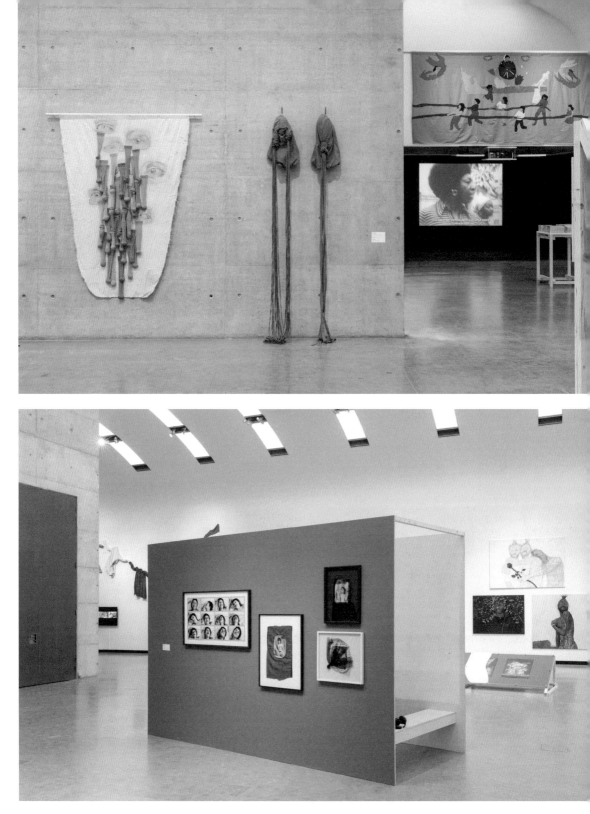

Installation views: *And if I devoted my life to one of its feathers?*, Kunsthalle Wien, 2021

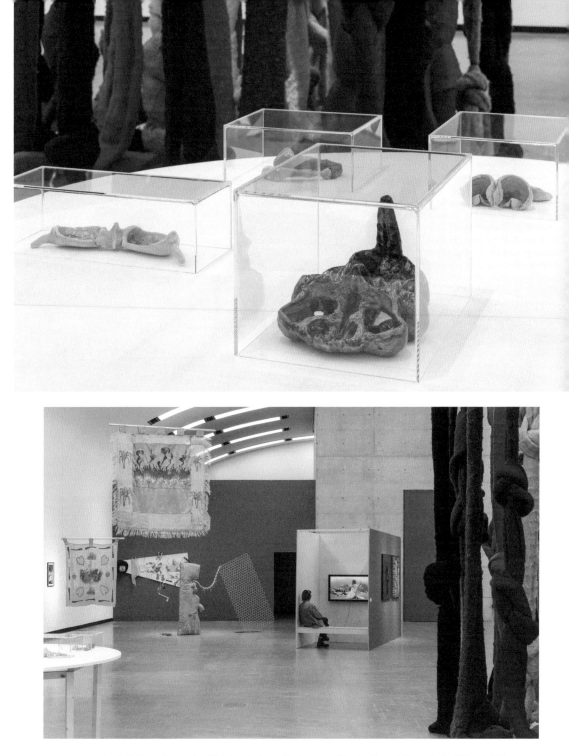

Installation views: *And if I devoted my life to one of its feathers?*, Kunsthalle Wien, 2021

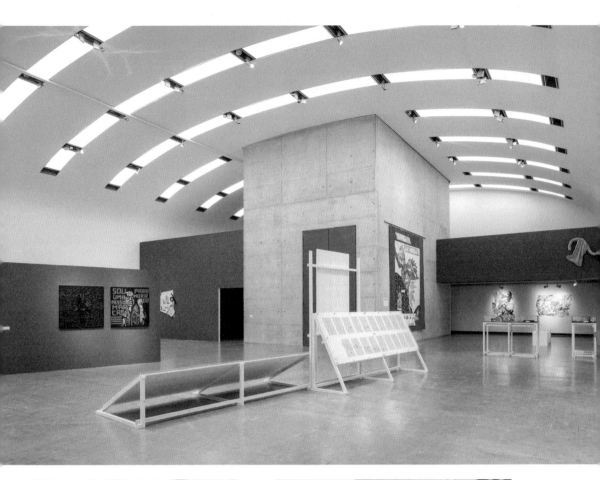

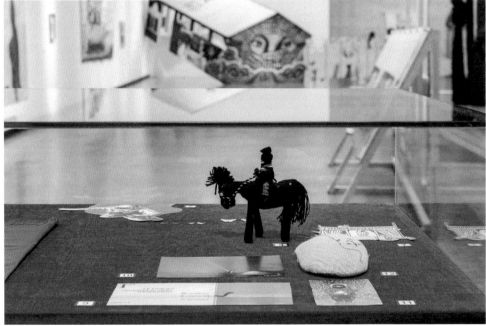

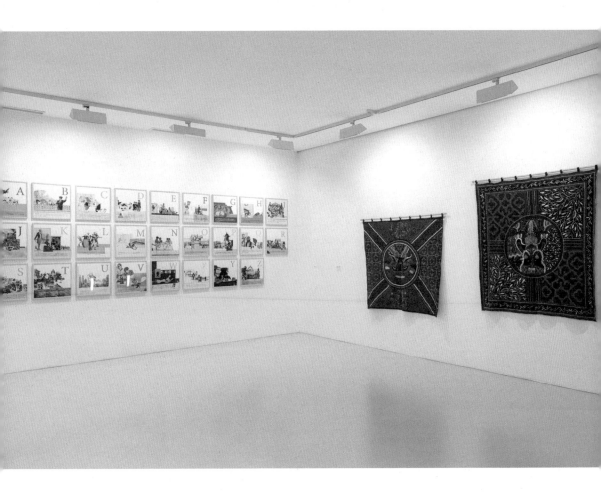

Installation views: *And if I devoted my life to one of its feathers?*, Kunsthalle Wien, 2021

LEFT: Chto Delat, *The New Dead End #17: Summer School of Slow Orientation in Zapatism*, 2017; Zapantera Negra, *Flower of the Word II. "Digna Rebeldía"* ["Dignified Rebellion"], 2016–21

ABOVE: Daniela Ortiz, *The ABC of Racist Europe*, 2017; Olinda Silvano / Reshinjabe, *El espíritu de las madres plantas* [The Spirit of the Mother Plants], 2020; *El espíritu de las madres plantas* [The Spirit of the Mother Plants], 2020, COURTESY THE ARTIST AND PRIVATE COLLECTION

THE MERMAIDS
...AIDEN THROUGH WONDERLAND...

Karrabing Film Collective, *Mermaids, Mirror Worlds*, 2018
Installation view: *And if I devoted my life to one of its feathers?*, Kunsthalle Wien, 2021

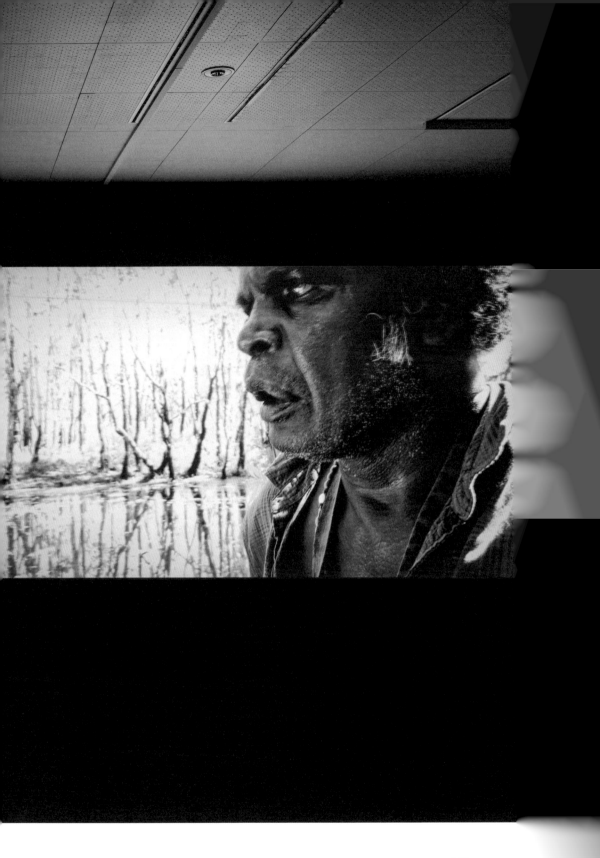

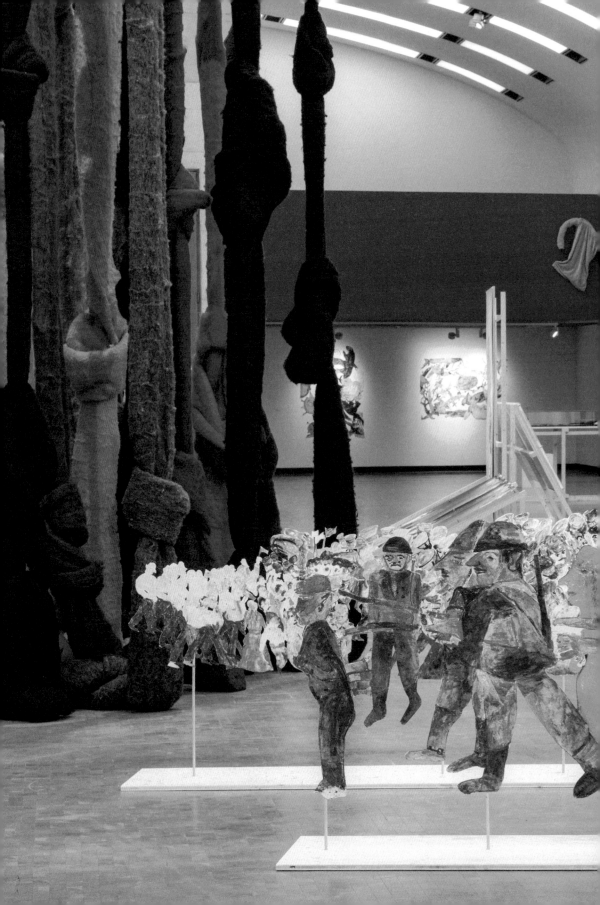

Installation view: *And if I devoted my life to one of its feathers?*, Kunsthalle Wien, 2021: Anna Boghiguian, *The Unfaithful Replica*, 2016; *The Unfaithful Replica*, 2016; *Procession*, 2017; *Untitled*, 2017 • COURTESY THE ARTIST AND KOW, BERLIN; Cecilia Vicuña, *Burnt Quipu*, 2018 • COURTESY THE ARTIST AND LEHMANN MAUPIN, NEW YORK, HONG KONG, SEOUL, AND LONDON

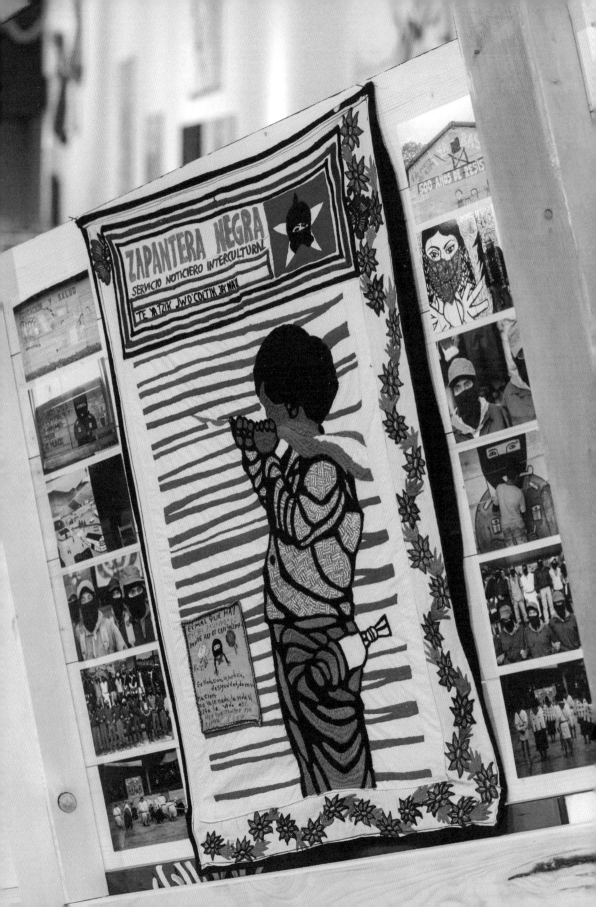

List of Artists and Exhibited Works

Zapantera Negra, *Flower of the Word II. "Digna Rebeldía"* ["Dignified Rebellion"], 2016–21 Installation view: *And if I devoted my life to one of its feathers?*, Kunsthalle Wien, 2021

Babi Badalov
Born in 1959, lives and works in Paris (France)

M – otherland, 2021
Site-specific mixed-media installation, variable dimensions
COURTESY THE ARTIST AND GALERIE JÉRÔME POGGI, PARIS

Automatic Electronic Algorithmic Predictive Poetry, 2021
Performance at the Kunsthalle Wien (May 15)

Denilson Baniwa
Born in 1984, lives and works in Rio de Janeiro (Brazil)

Bye Bye Brazil, 2020
Acrylic on fabric, two pieces, 30 × 40 cm each

Marçal Tupã´Y, 2017
Acrylic on fabric, 100 × 100 cm

Mártires Indígenas 2 [Indigenous Martyrs 2], 2021
Acrylic on fabric, 100 × 100 cm

Qual Limite da Amazônia [What Limit of the Amazon], 2020
Collage on fabric, two pieces, 60 × 80 cm each

Patricia Belli
Born in 1969, lives and works in Managua (Nicaragua)

Máscara boca [Mouth Mask], 2004
Sewn fabric, 56 × 38 × 120 cm

Máscara ojos [Eye Mask], 2004
Sewn fabric, 57 × 34 × 120 cm
COURTESY THE ARTIST AND CARLOS MARSANO, LIMA

Nidos de lágrimas [Nests of Tears], 1997
 Fabric, photo emulsion painting, stockings,
 filling, 200×130×14 cm
 COURTESY THE ARTIST AND PRIVATE COLLECTION

Amoako Boafo
Born in 1984, lives and works in Accra (Ghana)

Blue Band, from the series *Detoxing Masculinity*,
 2017
 Oil on canvas, 160×160 cm

Gold Plant, from the series *Detoxing Masculinity*,
 2017
 Oil on canvas, 160×180 cm

Me, Me and Me, from the series
 Detoxing Masculinity, 2017
 Oil on canvas, 170×210 cm

COURTESY AMOAKO BOAFO STUDIO, ACCRA

Anna Boghiguian
Born in 1946, lives and works in Cairo (Egypt),
Asia, and Europe

Procession, 2017
 Pencil, paint, and encaustic on paper,
 108×200×25 cm

The Unfaithful Replica, 2016
 Pencil, paint, and encaustic on paper,
 76×67×25 cm

The Unfaithful Replica, 2016
 Pencil, paint, and encaustic on paper,
 102×205 cm

Untitled, 2016
 Pencil, paint, and encaustic on paper,
 103.5×57 cm

Untitled, 2016
 Pencil, paint and encaustic on paper,
 162×110 cm

Untitled, 2016
 Pencil, paint, and encaustic on paper,
 110×155 cm

COURTESY THE ARTIST AND KOW, BERLIN

Victoria Cabezas
Born in 1950, lives and works in San José
(Costa Rica)

Sin título [Untitled], 1973
 Framed polyptych, hand-colored gelatin
 silver prints, 65×80 cm overall
 COURTESY THE ARTIST AND PRIVATE COLLECTION

Quishile Charan
Born in 1994, lives and works in Tāmaki Makaurau
/ Auckland (Aotearoa / New Zealand)

Burning Ganna Khet [Burning Sugarcane Farm],
 2021
 Cotton, textile ink, natural dye, 153×152 cm

Company Ka Raj [Company Is King], 2021
 Cotton, textile ink, natural dye, 164×125.5 cm

Ee ghaoo maange acha ho jai [These Wounds
 Must Heal], 2019
 Archival image, textile ink, bamboo, cotton,
 embroidery thread, appliqué, and naturel dye
 with kumkum seeds, 150×100 cm

Manuel Chavajay
Born in 1982, lives and works in
San Pedro La Laguna (Guatemala)

Untitled, from the series *Iq'am*, 2014
 Petroleum on paper, 170×104 cm

Untitled, from the series *Keme*, 2016
 Petroleum and watercolor on paper,
 71×50.5 cm

Untitled, from the series *Keme*, 2016
 Petroleum and watercolor on paper,
 72×50.5 cm

Untitled, from the series *Keme*, 2016
 Petroleum and watercolor on paper,
 73×50.5 cm

Untitled, from the series *Keme*, 2016
 Petroleum and watercolor on paper,
 74×50.5 cm

COURTESY THE ARTIST AND GALERÍA EXTRA,
GUATEMALA CITY

Chto Delat
Founded in 2003

***The Map for the Slow Orientation in Zapatism,
Version 3**, 2021*
Textile piece realized by Nikolay Oleynikov
with assistance from Anna Tereshkina and
Anastasia Makarenko (made in Leningrad),
color table, objects, pictures, and Zapatista
ephemera

***The New Dead End #17: Summer School of
Slow Orientation in Zapatism**, 2017*
Realized by Nina Gasteva, Tsaplya Olga
Egorova, Nikolay Oleynikov, and
Dmitry Vilensky
Director and editor: Tsaplya Olga Egorova
Choreography: Nina Gasteva
Single-channel video, color, sound, 90'38"

Rosa Elena Curruchich
1958–2005, lived and worked in
San Juan Comalapa (Guatemala)

La casa de una curandera [The House of the
Healer], ca. 1980s
Oil on canvas, 16.2 × 16.5 cm

Las mujeres hacen lazo para tejidos [Women
Make Loops for Weaving], ca. 1980s
Oil on canvas, 14.2 × 15.8 cm

***Muy machista el muchacho por eso lo pega
ante las mujeres*** [The Boy Is Very Macho,
That Is Why He Is Being Beaten in Front of the
Women], ca. 1980s
Oil on canvas, 18.7 × 20.3 cm

***Patojita de siete años presentando sus
tejidos ante el pueblo*** [Seven-Year-Old Girl
Presenting Her Textiles to the Community],
ca. 1980s
Oil on canvas, 13.4 × 16.2 cm

***Presentando a las mujeres que construyen
casitas*** [Introducing the Women Who Build
Houses], ca. 1980s
Oil on canvas, 18.7 × 20.3 cm

Recogiendo chile verde [Picking Green Chili],
ca. 1980s
Oil on canvas, 14.5 × 21 cm

Rosa Elena pintando caserío Chosij [Rosa Elena
Painting the Chosij Village], ca. 1980s
Oil on canvas, 15.7 × 20 cm

***Rosa Elena vendiendo dulce. Aniversario del
caserío San Balentin*** [Rosa Elena Selling
Candies: Celebration of San Balentin Village],
ca. 1980s
Oil on canvas, 15.8 × 16.6 cm

***El sacerdote hablando a la tierra y las candelas
para los terrenos de la gente*** [The Priest
Speaking to the Soil and the Candles for the
Lands of the People], ca. 1980s
Oil on canvas, 18.2 × 19.1 cm

***La señora enferma, las mujeres de Patzun
curaban de oración*** [A Lady Is Sick, Women
from Patzun Village Are Healing Her with
Prayer], ca. 1980s
Oil on canvas, 18.2 × 18.9 cm

La señora vende barriletes y papel de barriletes
[The Lady Sells Kites and Kite Paper],
ca. 1980s
Oil on canvas, 12.1 × 19.3 cm

COURTESY PRIVATE COLLECTION

Annalee Davis
Born in 1963, lives and works in St. George
(Barbados)

***My Best Diamond Ring, Two Negroe Boys
and Two Negroe Wenches**, 2018*
Mixed media on paper, 186 × 92 cm

***Woman Confronts a Long Annelid Parasite
of History**, 2019*
Mixed media on paper, 134.6 × 91.5 cm

***Woman Wrestling with Long Annelid Parasites
of History**, 2018*
Mixed media on paper, 188 × 152.5 cm

***Woman Expelling Long Annelid Parasite of
History While Standing on Top of a Mill Wall**,
2018*
Mixed media on paper, 177 × 91.5 cm

***Woman Looking at Long Annelid Parasites
of History**, 2018*
Mixed media on paper, 92 × 210 cm

All from *The Parasite Series*, 2018–19

Vlasta Delimar
Born in 1956, lives and works in Zagreb (Croatia)

Dick on the Tongue, 1983
Collage, B/W vintage gelatin silver print, lace, tempera, tulle, 40 × 33 cm

Fuck Me, 1981
Collage, B/W vintage photo, lace, tempera, metal cross, badge, 35 × 75 cm

Untitled, 1981
Collage, B/W vintage gelatin silver print, lace, 40 × 21 cm

Visual Orgasm, 1981
Performance, B/W photo, 60 × 110 cm

COURTESY THE ARTIST AND GALERIE MICHAELA STOCK, VIENNA

Jim Denomie
1955–2022, lived and worked in Franconia (MN, USA)

Oz, the Emergence, 2017
Oil on canvas, 248 × 355 cm
COURTESY THE JIM DENOMIE ESTATE AND MINNESOTA MUSEUM OF AMERICAN ART

Standing Rock 2016, 2018
Oil on canvas, 233 × 304 cm
COLLECTION OF MINNEAPOLIS INSTITUTE OF ART
• COURTESY OF THE JIM DENOMIE ESTATE AND BOCKLEY GALLERY

María Galindo & Danitza Luna
María Galindo lives and works in La Paz (Bolivia)
Danitza Luna lives and works in La Paz (Bolivia)

La piel de la lucha, la piel de la historia [The Skin of the Fight, the Skin of History], 2019, made as part of "Parliament of Bodies: Parliament of Bitches," Bergen Assembly, 2019, curated by Paul B. Preciado and Viktor Neumann
Drawings by Danitza Luna, produced by Mujeres Creando
Lithographs on paper, six pieces, 60 × 47 cm each

Nilbar Güreş
Born in 1977, lives and works in Vienna (Austria) and Istanbul (Türkiye)

Angry Palm, 2020
Oil on canvas, 40 × 30 cm

Breasts by Rose, 2020
Oil on linen, 30 × 40 cm
COURTESY THE ARTIST AND GALERIST, ISTANBUL

Hydra, 2020
Diptych, oil on pressed canvas, 15 × 15 cm each
COURTESY THE ARTIST AND BEREN AND EMIR ARGÜN

Monitor Head, 2021
Mixed media on fabric, felt, two pieces of felt wings: 38 × 125 × 378 cm; one piece of black fabric monitor: 38 × 48 cm

Unmasking, 2021
Fabric piece, mixed media on fabric, 190 × 61 × 10 cm
COURTESY THE ARTIST AND GALERIE MARTIN JANDA, VIENNA

Sheroanawe Hakihiiwe
Born in 1971, lives and works in Pori Pori, Yanomami community in El Alto Orinoco (Venezuela)

21 drawings from the series **Hihiipere himo wamou wei** [These Trees Give Fruits to Eat], 2018
Acrylic on sugarcane bagasse paper, 35 × 25.5 cm each
COURTESY THE ARTIST, ABRA GALLERY, CARACAS, AND MALBA, BUENOS AIRES

Hiwa K
Born in 1975, lives and works in Sulaymaniyah (Iraqi Kurdistan)

Pre-Image (Blind as the Mother Tongue), 2017
Single channel HD video, color, sound, 17'40"
COURTESY THE ARTIST AND KOW, BERLIN

Karrabing Film Collective
Founded in 2008

Mermaids, Mirror Worlds, 2018
Two-channel video installation, 34'50"

Germain Machuca
Born in 1970, lives and works in Lima (Peru)

Las dos Fridas – Sangre/Semen – Línea de vida
[The Two Fridas – Blood/Semen – Lifeline],
2013
Inkjet print on paper, 47×31.3 cm
Photo by Claudia Alva

Daniela Ortiz
Born in 1985, lives and works in Cusco (Peru)

Papa, with P for Patriarchy, 2020
Children's book, 1000 copies

El ABC de la Europa racista [The ABC of Racist
Europe], 2017
26 fine art prints on Hahnemühle paper,
30×30 cm each

COURTESY THE ARTIST AND ÀNGELS BARCELONA,
BARCELONA

Prabhakar Pachpute
Born in 1986, lives and works in Pune (India)

A Plight of Hardship II, 2021
Acrylic paint and pencil on canvas,
213×487 cm
COURTESY THE ARTIST AND EXPERIMENTER,
KOLKATA

Amanda Piña
Born in 1978, lives and works in Vienna (Austria)
and Mexico City (Mexico)

Danzas Climáticas [Climatic Dances], from
the series *Endangered Human Movements*,
2019–21
Single-channel video installation, variable
dimensions
© nadaproductions

Roldán Pinedo / Shöyan Sheca
Born in 1971, lives and works in Lima (Peru)

La cosmovisión de los tres mundos Shipibos
[The Cosmovision of the Three Shipibo
Worlds], 2018
Acrylic on dyed fabric with mahogany bark,
130×128 cm
COURTESY THE ARTIST AND PRIVATE COLLECTION

Salmo Suyo
Born in 1989, lives and works in Lima (Peru)

Histerectomía I [Hysterectomy I], from the series
Genitales [Genitals], 2016–17
Glazed ceramic sculpture, 40×35 cm

Histerectomía II [Hysterectomy II], from the
series *Genitales* [Genitals], 2016–17
Glazed ceramic sculpture, 25×40 cm
COURTESY THE ARTIST AND JUAN CARLOS VERME
AND PROYECTOAMIL, LIMA

Disforia [Dysphoria] **#10**, 2019
Glazed ceramic sculpture, 19×16×6 cm

Disforia [Dysphoria] **#11**, 2019
Glazed ceramic sculpture, 10.5×10×7 cm

Disforia [Dysphoria] **#13**, 2019
Glazed ceramic sculpture, 30×9.5×4 cm

Disforia [Dysphoria] **#14**, 2019
Glazed ceramic sculpture, 26×21×6.5 cm

Disforia [Dysphoria] **#15**, 2019
Glazed ceramic sculpture, 27×19.5×16 cm

Disforia [Dysphoria] **#17**, 2019
Glazed ceramic sculpture, 17×8×8.5 cm

Victoria Santa Cruz
1922–2014, lived and worked in Lima (Peru)

Me gritaron negra [They Called Me Black]
As performed in the film *Victoria:
Black and Woman*
Directed by Torgeir Wethal, produced by
Odin Teatret Film, Peru/Denmark, 1978
EXCERPT OF THE FILM COURTESY ODIN TEATRET
FILM AND ODIN TEATRET ARCHIVES, HOLSTEBRO
3'58"

Olinda Silvano / Reshinjabe
Born in 1969, lives and works in Lima (Peru)

El espíritu de las madres plantas [The Spirit
of the Mother Plants], 2020
Natural dyes and embroidery on fabric,
152×140 cm

El espíritu de las madres plantas [The Spirit
of the Mother Plants], 2020
Natural dyes and embroidery on fabric,
137×152 cm

COURTESY THE ARTIST AND PRIVATE COLLECTION

SPIT!
(Sodomites, Perverts, Inverts
Together! / Carlos Maria Romero,
Carlos Motta & John Arthur Peetz)
Founded in 2017

We The Enemy, 2017
Single-channel video, color, sound, 3'49"
Performed by Despina Zacharopoulou
Camera and sound: Will Hazel

Sophie Utikal
Born in 1987, lives and works in Berlin (Germany)

A New World Is Coming, 2021
Mixed media on fabric, 200×400 cm

What Was, Is Gone, 2020
Mixed media on fabric, 200×150 cm

Cecilia Vicuña
Born in 1948, lives and works in New York
(USA) and Santiago (Chile)

Árbol de manos [Tree of Hands], 1974
Collage on paper, 30.5×23 cm
COURTESY THE ARTIST AND PRIVATE COLLECTION

Burnt Quipu, 2018
Unspun wool, site-specific installation,
variable dimensions
COURTESY THE ARTIST AND LEHMANN MAUPIN,
NEW YORK, HONG KONG, SEOUL, AND LONDON

Castiel Vitorino Brasileiro
Born in 1996, lives and works in Vitória
and São Paulo (Brazil)

Comigo-ninguém-pode [Nobody-Beats-Me],
2018
Color photograph, 120×80 cm

Descarrega [Discharge], 2018
Color photograph, 120×80 cm

*Eu arranquei com desespero. Percebi meu
desequilíbrio* [I Ripped It Out with Despair.
I Noticed My Imbalance], 2019
Color photograph, 120×80 cm

Sagrado feminino da merda [Sacred Feminine
of Shit], 2019
Color photograph, 120×80 cm

Gastrite [Gastritis], 2019
Color photograph, five pieces, 120×80 cm
each

Anna Witt
Born in 1981, lives and works in Vienna (Austria)

Das Radikale Empathiachat [The Radical
Empathiarchy], 2018
Produced in collaboration with Maria Bujanov,
Phillip Borchert, Anja Engelhardt, Belve
Langniss, Blandia Langniss, Chiara Rauhut,
and Lena Schubel
Two-channel HD video, color, sound, 20'09"
COURTESY THE ARTIST AND
GALERIE TANJA WAGNER, BERLIN

Bartolina Xixa
Born in 2017, lives and works in Jujuy (Argentina)

Ramita Seca, La colonialidad permanente
[Dry Twig, The Permanent Coloniality], 2017
Choreography and interpretation:
Bartolina Xixa
Photography and production by Elisa Portela
Video, color, sound, 16:9, 5'07"
COURTESY MAXIMILIANO MAMANI /
BARTOLINA XIXA

Santiago Yahuarcani

Born in 1961, lives and works in Pebas,
Iquitos (Peru)

*Bancos cashimberos pidiendo a los
 abuelos la medicina más fuerte contra el
 Covid-19* [Bancos Cashimberos Asking the
 Grandparents for the Strongest Covid-19
 Medicine], 2020
 Natural dyes on vegetable bark, 70 × 97 cm

Covid-19 pelea con los abuelos [Covid-19 Fights
 the Grandparents], 2020
 Natural dyes on vegetable bark, 71 × 104 cm

Curación con ajo sacha a Santiago [Healing of
 Santiago with Garlic Vine], 2020
 Natural dyes on vegetable bark, 70 × 102 cm

Sesión de ajo sacha [Garlic Vine Session], 2020
 Natural dyes on vegetable bark, 65 × 97 cm

El vuelo de Mamá Martha II [The Flight of Mother
 Martha II], 2020
 Natural dyes on vegetable bark, 64 × 100 cm

COURTESY THE ARTIST AND CRISIS GALLERY, LIMA

Espíritu Delfín trae medicina contra el Covid-19
 [The Dolphin Spirit Guardian Bringing
 Medicine to Fight Covid-19], 2020
 Natural dyes on vegetable bark, 69 × 98 cm

COURTESY THE ARTIST AND ATAHUALPA EZCURRA
COLLECTION

Zapantera Negra

An artistic encounter between Black Panthers
and Zapatismo. Guided by Emory Douglas,
former minister of culture for the Black Panther
Party and EDELO (En Donde Era La ONU)
artist residency in San Cristobal De Las Casas
Chiapas Mexico founded by Caleb Duarte and
Mia Eve Rollow in 2012.

Flower of the Word II: "Digna Rebeldía"
 ["Dignified Rebellion"], 2016–21
 Site-specific mixed-media installation
 including paintings, posters, photographs,
 textile works, and objects, created in
 Zapatista territories and other encounters
 by local, global and intercommunal artists,
 variable dimensions.

And if I devoted my life to one of its feathers?

A joint exhibition of Kunsthalle Wien and Wiener Festwochen
May 15 – September 26, 2021
CURATED BY Miguel A. López

Kunsthalle Wien

ARTISTIC DIRECTORS
What, How & for Whom/WHW
(Ivet Ćurlin • Nataša Ilić •
Sabina Sabolović)

MANAGING DIRECTOR
STADT WIEN KUNST GMBH
Wolfgang Kuzmits

ASSISTANT TO
THE ARTISTIC DIRECTORS
Asija Ismailovski

ASSISTANT TO
THE MANAGING DIRECTOR
Manuela Wurth

OFFICE MANAGEMENT
Maria Haigermoser

SPONSORING / FUNDRAISING
Maximilian Geymüller

HEAD OF CURATORIAL
AND PROGRAMMING
Astrid Peterle

CURATORIAL ASSISTANTS
Laura Amann
Hannah Marynissen
Andrea Popelka

PUBLISHING
Ramona Heinlein
Nicole Suzuki

EXHIBITION MANAGEMENT
Amelie Brandstetter
Sofie Mathoi
Martina Piber
Flora Schausberger

EVENT PRODUCTION
Johanna Sonderegger

TECHNICAL MANAGEMENT
Michael Niemetz
Danilo Pacher

ART EDUCATION
Wolfgang Brunner
Carola Fuchs
Andrea Hubin
Michaela Schmidlechner
Michael Simku
Martin Walkner

COMMUNICATIONS
David Avazzadeh
Katharina Baumgartner
Adina Hasler
Wiebke Schnarr
Katharina Schniebs

VISITOR SERVICES / SHOP
Daniel Cinkl
Kevin Manders
Christina Zowack

ACCOUNTING
Karin Ciml
Leonhard Rogenhofer
Natalie Waldherr

FACILITY MANAGEMENT /
INFRASTRUCTURE
Beni Ardolic
Osma Eltyeb Ali
Frank Herberg (IT)
Baari Jasarov
Mathias Kada

Wiener Festwochen

ARTISTIC DIRECTOR
Christophe Slagmuylder

EXECUTIVE DIRECTOR
Artemis Vakianis

DRAMATURGY
Carolina Nöbauer

and the team of
Wiener Festwochen

Thank you

Miguel A. López, Kunsthalle Wien, and Wiener Festwochen would like to express their gratitude to all participating artists, lenders, galleries, authors, translators, editors, the teams of Kunsthalle Wien and Wiener Festwochen, and in particular the following people for their work on the exhibition:

CURATORIAL ASSISTANT
Laura Amann

EXHIBITION MANAGEMENT
Hektor Peljak

EXHIBITION DESIGN
Germen Estudio

CONSTRUCTION MANAGEMENT
Johannes Diboky
Danilo Pacher

EXTERNAL TECHNICIANS
Harald Adrian
Hermann Amon
Dietmar Hochhauser
Bruno Hoffmann
Alfred Lenz

ART HANDLING
Marc-Alexandre Dumoulin
Parastu Gharabaghi
Scott Hayes
Luiza Margan
Andreas Schweger
Johann Sommer-Grobner
Sara Sofia Strutt
Stephen Zepke

Our thanks also go to:
Esvin Alarcón Lam
Gala Berger
Todd Bockley
Imayna Caceres
Marisol de la Cadena
Giacomo Castagnola
Hans D. Christ
Comunidad Zapatista
Ursula Davila-Villa
Lilah Dougherty
Iris Dressler
Cecilia Fajardo-Hill
Denise Ferreira da Silva
Cristobal Garcia
Renzo Gianella
Jimena Gonzalez
Nina A. Gyasi
Maxim Holland
Ronin Koshi
Carlos Marsano
Harry Pinedo / Inin Metsa
Alejandra Monteverde
Juan Pablo Murrugarra
Viktor Neumann
Pedro Neves Marques
Silvia Obiols
Eliana Otta
Elizabeth A. Povinelli
Luis Romero
Octavio Santa Cruz
Mariana Silva
Rember Yahuarcani
angels barcelona
Bockley Gallery
Experimenter, Kolkata
Galeria ABRA, Caracas
Galeria Crisis, Lima
Galeria EXTRA, Guatemala City
Galerie Poggi, Paris
Galerie Martin Janda, Vienna
Galerie Michaela Stock, Vienna
Galerie Tanja Wagner, Berlin
Galerist gallery, Istanbul
KOW, Berlin
Minnesota Museum of American Art
Odin Teatret – Nordisk Teaterlaboratorium
proyectoamil

And if I devoted my life to one of its feathers?
Aesthetic Responses to Extraction, Accumulation, and Dispossession

PUBLISHED BY
Kunsthalle Wien /
Stadt Wien Kunst GmbH
Sternberg Press

EDITOR
Miguel A. López

MANAGING EDITOR
Nicole Suzuki

CURATORIAL ASSISTANT
Laura Amann

TRANSLATION
Daphne Nechyba (ESP > EN: poem by Victoria Santa Cruz; texts by Olinda Silvano / Reshinjabe and by Manuel Chavajay)
Eliot Weinberger (ESP > EN: poem by Cecilia Vicuña)

COPYEDITING
Julia Monks

DESIGN
Dejan Kršić

TYPEFACES
KhW Ping • Brioni Text • Brenner [TYPOTHEQUE]

LETTERING
Tina Božan

PRINT
Donau Forum Druck GesmbH, Vienna, Austria

Printed in Austria

PHOTOGRAPH CREDITS
INSIDE COVER (FRONT AND BACK), p. 1, 42/43, 72/73, 80/81, 102, 103, 104, 105, 112, 113, 114, 116, 120/121, 122, 126/127, 154/155, 156, 158 top, 191, 222/223, 224/225, 226, 227, 228, 229, 230, 231, 232/233, 234/235, 236, 237, 238, 239, 240, 241, 242/243, 244/245, 246: PHOTO: Kunst-Dokumentation.com
p. 2: PHOTO: Dodd Demas
p. 4, 157, 158 BOTTOM: PHOTO: Miguel A. López
p. 16/17, 28, 86, 182, 183, 186, 187, 188/189, 190, 192, 193, 194, 195: PHOTO: Juan Pablo Murrugarra
p. 32, 40/41: PHOTO: Kunsthalle Wien
p. 34: PHOTO: Josue Samol
p. 38: PHOTO: Prabhakar Pachpute & Amol K Patil
p. 39: PHOTO: Abiona Esther Ojo
p. 59: PHOTO: Claudia Alva
p. 66, 67: PHOTO: Charlie Quezada (Cohete Studio)
p. 68, 69, 117, 130: © Bildrecht, Vienna 2022
p. 82, 115: © nadaproductions
p. 92: PHOTO: Thomas Müller
p. 98 TOP: PHOTO: Jessica Segall, © HAWAPI 2019
p. 98 BOTTOM: PHOTO: Gianine Tabja, © HAWAPI 2019
p. 110, 111: PHOTO: Reha Arcan
p. 132, 152, 153: PHOTOS: Salmo Suyo
p. 140, 141: PHOTO: Željko Jerman
p. 142/143: PHOTO: Željko Jerman, Milan Božić
p. 144, 145, 146, 147, 205: PHOTO: Manuel Chavajay
p. 159, 206: PHOTO: Carla Astorga
p. 164: PHOTO: Annalee Davis
p. 167: PHOTO: Justin Went
p. 196/197: PHOTO: Bahar Kaygusuz
p. 198, 199: Seth Siope

COVER (FRONT AND FLAP):
Jim Denomie, *Standing Rock 2016* (detail), 2018.
Oil on canvas, 233 × 304 cm.
Courtesy the artist and Bockley Gallery, Minneapolis.

INSIDE COVER (FRONT AND BACK): Cecilia Vicuña, *Burnt Quipu* (detail), 2018. Unspun wool, site-specific installation, variable dimensions. Courtesy the artist and Lehmann Maupin, New York, Hong Kong, Seoul, and London.
Installation view: *And if I devoted my life to one of its feathers?*, Kunsthalle Wien, 2021

All images are courtesy of the artists unless otherwise indicated.

We thank all copyright holders for their kind permission to reproduce their material. Every effort has been made to contact the rightful owners with regard to copyrights and permissions. We apologize for any inadvertent errors or omissions.

ISBN 978-3-95679-637-1

DISTRIBUTED BY
The MIT Press • Art Data • Les presses du réel • Idea Books

Stadt Wien Kunst GmbH
Kunsthalle Wien
Museumsplatz 1
A–1070 Vienna
www.kunsthallewien.at

Sternberg Press
71–75 Shelton Street
UK–London WC2H 9JQ
www.sternberg-press.com

kunsthalle wien
is the city of Vienna's institution for international art and discourse.